Immortal Images

IMMORTAL

IMAGES

A Personal History of
Two Photographers and the
Flag Raising on Iwo Jima

TEDD THOMEY

NAVAL INSTITUTE PRESS
Annapolis, Maryland

Naval Institute Press
291 Wood Road
Annapolis, MD 21402

First Naval Institute Press paperback edition published in 2008.

ISBN-13 978-1-59114-854-8

The Library of Congress has cataloged the hardcover edition as follows:
Thomey, Tedd
 Immortal Images: a personal history of two photographers and the
Flag raising on Iwo Jima / Tedd Thomey.
 p. cm.
 Includes bibliographical references (p.) and index.
 ISBN-10 1-55750-807-0
 1. Rosenthal, Joe, 1911- . 2. Genaust, William H. 3. Iwo Jima,
Battle of, 1945. 4. World War, 1939-1945—Photography. 5. War
Photographers—United States—Biography. I. Title.
940.54'25—dc20
 95-46457

Printed in the United States of America on acid-free paper ∞

14 13 12 11 10 09 08 9 8 7 6 5 4 3 2
First printing

In memory of the nearly seven thousand

In June 1983, at the annual conference and banquet of the Fourth Marine Division Association, Major Weinberger displayed a print of the Rosenthal picture. He asked the audience if they knew the name of the photographer. There was a great voluminous reply of "JOE ROSENTHAL!" This was before an audience of approximately 1,000, most of whom were Fourth Division veterans. The major then asked if they knew the name of the movie photographer. . . . There was absolute silence. And this was a Marine audience.

It is our belief that the Marine Corps, by its silence, has contributed to this mass ignorance. Marine and civilian publications have published scores of stories about the flag-raising. Many made mention of Sergeant Lowery. All credited Joe Rosenthal. Except for a few news stories generated by this campaign, none of the stories brought to our attention has ever mentioned Sergeant Genaust.

—Portion of a resolution adopted 24 September 1983 by the Marine Corps Combat Correspondents Association.

CONTENTS

A 556-Foot Climb into History

Two ordinary, decent men. Two brave men.

They stood side by side on the rocky rim of an unknown volcano on an obscure Lilliputian island in the Pacific and did something extraordinary. They pressed the shutters of their cameras and—within a split second—became a part of world history.

In a strange way, these two ordinary Americans did as much as many great and famous men to hasten the end of World War II. Their pictures of Old Glory taken that day, 23 February 1945, lifted the war-weary spirits of not only their nation but those of others united against powerful enemies in Europe and Asia. The war, which had already cost many millions of lives, was in its sixth horrendous year, and it was projected to go on for two, perhaps three more years.

As men and women have died in American wars since then—in Korea, Vietnam, and the Persian Gulf—memories of the scope of World War II tend to dim, but it was, by far, the Gargantua of all wars ever fought by the United States. We had 16 million men and women in our armed forces from 1941 to 1946. U.S. casualties were the worst this country has experienced. Battle deaths were nearly 300,000.[1] Almost 700,000 military personnel were wounded. In a million American homes, mothers, fathers,

wives, and young brothers and sisters read telegrams from Washington that broke their hearts.

By the winter of 1944–45, the United States had been at war for more than three years. Americans were sick of war and reading daily headlines of more dead and wounded. Every week, they watched more fine young people go off somewhere far away to be killed.

And then, in February, something happened on an island so tiny that Americans could not find it on their maps. It was a bit of volcanic rock that they had never heard of until 19 February 1945. That day, the newspapers and airwaves were filled with dramatic stories of the first contingent of U.S. Marines, who would eventually number 75,000, landing on Iwo Jima to battle an army of 23,000 Japanese, most of whom were hidden underground.

On that day, Joe Rosenthal, a civilian photographer working for Associated Press, went ashore with thousands of Marines of the 4th Division. Joe was a civilian because his poor eyesight prevented his entering the service. Half a mile to the southwest, close to Mount Suribachi, Sgt. William H. ("Bill") Genaust, a Marine movie cameraman, went ashore with the Marine 5th Division.

These two men were friends. Rosenthal was thirty-three years old and Genaust thirty-eight, almost twice as old as the Marines, mostly in their teens and early twenties, whom they accompanied. On board the small invasion boats bearing them shoreward, Genaust and Rosenthal looked at those youthful faces with the knowledge that, before the day ended, some of them and hundreds more like them would be dead or wounded.

Hundreds? It was to be worse than that. When night finally came on that first day, U.S. casualties were about 2,600—more than 550 Marines were killed or died later of wounds, 18 were missing, and the rest were wounded. About 100 were psychiatric victims, suffering combat fatigue.[2]

Iwo Jima was death island. It was so tiny, only $4\frac{1}{2}$ miles long, that every inch of it was reachable by Japanese artillery and mortars. No matter where Rosenthal, Genaust, and other men walked or ran, they were in danger of being killed or wounded. All the safe places were occupied by the Japanese. Because they were deep underground, in tunnels sometimes sixty feet down, they could not be reached even by the monster sixteen-inch shells, as heavy as Jeeps, hurled at them by U.S. battleships. The Japanese underground concrete fortifications were models of fine engineering and construction.

In Japanese, Iwo Jima means *sulfur island*. Eons before, Mount Suribachi had been a roaring volcano. Here and there on the island, minor volcanic life still existed in the form of bubbling sulfurous hot springs that steamed and stank like rotten eggs. Of all the islands in the Pacific, Iwo Jima was considered the ugliest.

Although Rosenthal and Genaust went ashore on different sections of the beach, they encountered the same type of obstacles. Looming ahead were steep, slanting terraces of black volcanic sand and ash, equal to three stories high in some places. As soon as a man stepped onto a terrace, his boots sank ankle deep into soft coarse granules. Climbing up a terrace was extremely difficult.

With the temporary lifting of the naval barrage, hundreds of Japanese emerged from their tunnels. They rained down fire on the Marines from atop Suribachi and from mortar and artillery positions on other parts of the island. Japanese infantry spewed from the tunnels with one goal—hurling the U.S. Marines back into the sea.

The Japanese barrages were so relentless that legendary battle veteran Gunnery Sgt. "Manila John" Basilone, age twenty-nine, of Company C, 27th Marines, lasted less than two hours on the beach. Winner of the Medal of Honor for his heroics on Guadalcanal almost three years earlier, Basilone was destroyed by an exploding mortar round that also killed four other Marines.

The shifting sands made digging foxholes nearly impossible and gave the Marines no place to conceal themselves. As men struggled up the terraces, they saw horror on all sides. The massacre is described by veteran correspondent Robert Sherrod, who landed with the troops on D-day, in words that are perhaps too graphic:

> Whether the dead were Japs or Americans, they had died with the greatest possible violence. Nowhere in the Pacific war had I seen such badly mangled bodies. Many were cut squarely in half. Legs and arms lay fifty feet from a body. In one spot on the sand, far from the nearest cluster of dead, I saw a string of guts fifteen feet long. Only legs were easy to identify. They were Japanese if wrapped in khaki puttees, American if covered by canvas leggings. The smell of burning flesh was heavy.[3]

On D-day, I witnessed horrors similar to what Sherrod describes after coming ashore at 0905 with the third wave of the 28th, the regiment that

would raise two flags on Mount Suribachi. A second lieutenant operations-liaison officer, I landed on Green Beach 1, so close to Suribachi that I could smell it. Acrid black smoke and clouds of brown dust drifted down on us, and the island quivered beneath our feet as the mountain was pulverized by shellfire from warships and bombs from U.S. Navy planes.

On the thronged black beach, I was too busy to look for Genaust, Rosenthal, or another of my photographer friends, Pvt. Robert ("Bob") Campbell, who had leaped ashore with me from the same landing craft. Everyone was busy.

Within thirty minutes, more or less, 10,000 Marines were struggling under bulky equipment on the seven designated landing beaches—one named Green; two, Red; two, Yellow; and two, Blue. Each of us was trying to move inland, far from the deep, clutching sand where multitudes were dead and more multitudes would soon die.

After climbing the high terraces, I ran several hundred yards inland with more than 1,000 men of the reinforced 1st Battalion. We had an awesome mission: to race across the narrowest neck of the island to the west beaches and cut off Suribachi from the rest of the island. The assault platoons made the crossing in ninety quick minutes but suffered massive casualties.

None of us knew that the Japanese had outwitted us. Suribachi was not isolated. In tunnels directly below us, the Japanese moved back and forth at will between the mountain and the rest of the island.

Felled by small arms fire, I didn't complete the crossing. A nearly spent slug penetrated the arch of my foot horizontally, bruising the bone without breaking it. Hot blood filled my field boot and overflowed. Unable to walk, I crawled back to the landing beach and, after several hours, was evacuated to a hospital ship.

D-day was my first and only taste of battle. I left the island in pain and depression. After eighteen months of intense training from Parris Island to Quantico, Pendleton, and Hawaii, I had been prevented from doing what I was trained to do. But I also felt something else—admiration for the Marines who survived two days, ten days, twenty days, or thirty-six days in the hellfire of Iwo Jima to win the bloodiest victory in U.S. Marine history. Half a century later, now knowing far more about the battle, I find my admiration has turned into awe. I write this book to make a permanent record of the sacrifices and courage of these men.

Another reason for this book is to right the wrongs inflicted on photographers Rosenthal and Genaust. They received high praise for their film masterpieces but, for decades, were also castigated by people who did not seek out the truth.

Day after day, as Marines fell in increasing numbers, Genaust and Rosenthal never knew how they managed to stay alive. Their cameras recorded practically everything they saw: Marines dashing inland in a thick haze of smoke and dust, two miles of black sand and white surf littered with the wreckage of dozens of small and large landing boats, burning Sherman tanks foundering in rocky shell craters, brawny men carrying seventy-pound flamethrowers on their backs as they incinerated cave entrances, Marines, armed only with rifles and grenades, storming concrete blockhouses protected by far more guns.

On the fourth day, 23 February, Rosenthal and Genaust made the 556-foot climb that would take them into the history books. Earlier that day, Mount Suribachi had been captured by a patrol of forty Marines who had fought their way up against Japanese gunfire and grenades. When they reached the top, the Marines had raised a small flag.

This was a historic moment, the first time in World War II that an American flag was raised over Japanese territory.

Genaust and Rosenthal arrived too late to film the flag raising, but they decided to make the climb up Suribachi anyway. That was the first of their lucky decisions that day. Avoiding paths that were mined and finding no enemy opposition, they reached the top to discover that the Marines were preparing to raise a second, much larger flag.

Joe Rosenthal, small and pudgy, piled up some rocks and stood on them to get a better view of the scene. Bill Genaust, a six-footer, stood at his elbow. As five Marines and one Navy corpsman raised the heavy pipe and the flying colors, both men followed the action simultaneously. Joe's camera was a big, heavy Speed Graphic that shot a four-by-five-inch negative. Bill's motion picture camera was a heavy but compact 16-mm Bell & Howell Automaster.

Afterward, Rosenthal described his shot as a one-in-a-billion lucky break that unexpectedly turned out to be a masterpiece.

Because Genaust was at the end of his movie reel, he was not sure that he had filmed the whole scene. He was killed in combat nine days later and never knew that he had also shot a masterpiece almost identical to Rosenthal's.

Their pictures and the Stars and Stripes immortalized that day were a unique inspiration to the nation. The photo and motion picture of our nation's flag being raised above that brutal and bloody battle impressed upon Americans the greatness of their country and, because of men like the six flag raisers, reaffirmed their knowledge that the United States would win its greatest war.

Rosenthal's still photo and Genaust's movie film were used as symbols of the Seventh War Bond Drive that helped to pay for the war. Because of the flag symbolism, this drive was far more successful than the preceding bond campaigns. Americans dug deep and generously to purchase $220 million worth of war bonds. In today's dollars, that sum would equal billions.

As a result of the Rosenthal and Genaust pictures, Americans flew more flags than ever before—hundreds of thousands more—from their homes and businesses; in schools, universities, movie theaters, parks, and civic centers; and on cars, streetcars, buses, boats, and trains.

The Iwo Jima flag took its place with the beloved Old Glories of American history: the flag carried by George Washington during his crossing of the Delaware in 1776, Old Glory at besieged Fort McHenry in 1812 that inspired Francis Scott Key to write the "Star Spangled Banner," the battle-tattered Stars and Stripes that flew in 1861 at Fort Sumter, and the Red, White, and Blue carried by the Rough Riders when Col. Theodore Roosevelt led them up San Juan Hill in 1898.

Today, more than half a century later, the photos of the Iwo Jima flag raising are still an inspiration to millions of Americans of all ages. It has been predicted that these pictures will live forever in the hearts and minds of the American people.

Perhaps they will. But what will be said about the two men who took them? What kind of man is Joe Rosenthal? What kind of man was Bill Genaust? They are my friends, and this is their story.

It always will be part of that legend of nearly 7,000 Americans who died on that ugliest of islands.

After he tripped his shutter at noon on that February day in 1945, Joe Rosenthal's life was never the same. Although he escaped unhurt from Iwo Jima, he was badly damaged by the furor and controversy that erupted around his photo in the weeks, months, and even years afterward.

He suffered the curse of instant celebrity. The press gave him no peace. Because he avoided publicity, particularly the ordeal of being interviewed, some reporters wrote lies about him and his unique photo. They claimed that his photo was a fake. They accused him of organizing the raising of the second flag and posing the men who hoisted it into the air because he had missed the first flag raising.

Rosenthal was so hurt by the lies, accusations, and unfairness of such people that, for ten years, he remained silent, avoided the media, and kept the details of his achievement to himself. Not until 1955 did he consent to reveal the facts of how, just by luck, he happened to be at the right place at the right time—on top of Mount Suribachi at noon on 23 February 1945. He gave his story to a trusted friend and gifted journalist. W. C. Heinz interviewed Rosenthal for days and carefully analyzed each of the many published lies that clouded the truth about the second flag raising and its aftermath. The lengthy interview, illustrated by several classic battle photos taken by Rosenthal while he was under fire on Iwo Jima, appeared in *Collier's* magazine on 18 February 1955, one day short of a decade after the U.S. Marine invasion force of 75,000 had landed on the black beaches.

The interview revealed Rosenthal's deepest feelings about himself, the United States, and the photo. It also revealed, perhaps more significantly, his feelings about the multitudes of Marines who had died on that tiny island. For these reasons, Heinz chose to tell the story in Rosenthal's own, unusually perceptive words. I also choose Rosenthal's words to introduce the book.

ACKNOWLEDGMENTS

Without the support and encouragement of many people, this book would have remained unwritten. I am indebted to the following for their ideas, good will, and patience: Joe Rosenthal; Tom Mechling; Harrold Weinberger; Adelaide Genaust Dobbins; Jack Gallant; Milt Reppert; Bob Amaral; Terry Belanger; Capt. Mark Roberts, USMC; Lt. Robert L. Dunsmore, USN; PO Brent Saucerman, USN; Gunnery Sgt. David Vergun, USMC; Mark Lambert; Bill Lee Shelton; Stanley O. Shelton; Julia H. Leigh; Doris Lowery; Randy B. Maas; Susan Genaust Naber; and the librarians at the Main Library and El Dorado Branch Library, Long Beach, California, and at the Angelo M. Iacaboni Library, Lakewood, California. No one supported me more or contributed more to this work than Patricia Thomey, my wife of more than fifty years.

Immortal Images

INTRODUCTION

In Joe Rosenthal's Own Words

Ten years ago, I stood just inside the rim of an extinct volcano on a small island in the Pacific and snapped a photograph. In twenty-five years as a news photographer, I have taken thousands of pictures, each depicting the passage of a moment in time. This one picture recorded a mere 1/400th of a second in the lives of six men—five Marines and a sailor.

It was shortly, however, to outlive three of them, who were killed in combat, and it will outlive the three who survived and the man who took it. It will outlive our children's children, for something occurred in that small fraction of a second, as the American flag was raised on Mount Suribachi on Iwo Jima, of which we were only accidental parts.

This is the first opportunity I have had to tell it all for the record, and to recount what went before it. Now I can tell what made it possible and I can also tell what I know of what has happened since then to those of us associated with that picture who still live.

When two of the survivors married, for example, it was news of national importance. The life of the third has been greatly disrupted. I have been accused to my face of not having taken the picture and of having appropriated someone else's film, and less than three months ago a Chicago newspaper reported erroneously on Page One that I directed a re-enactment of the first flag-raising on Iwo in order to get this shot of the second.

For a time such misstatements angered and depressed me, but when, five years ago, the World Almanac stated in discussing the picture that "Rosenthal also died later" I realized a truth had inadvertently been written. Joe Rosenthal, who is really just another news photographer, who did no more than any competent news photographer would have done, and a great deal less than some, no longer lives—at least not as the unknown private citizen he once was.

Because of this picture I have been made one with the celebrities who are customarily on the other side of my camera. I have been introduced as "Joe Rosenberg who raised the flag on Okinawa." Only the picture—characterized as everything from "phony" to, in the eyes of a Rochester, N.Y., art critic, comparable to Leonardo da Vinci's Last Supper—remains as it was.

It has been, it is said, the most widely reproduced photograph of all time. An engraving from it appeared on an issue of three-cent postage stamps. A painting of it was used as a symbol of the Seventh War Loan Drive, and appeared on 3,500,000 postcards, 15,000 outdoor panels and 175,000 car cards.

It has been done in oils, water colors, pastels, chalk and matchsticks. A float based on it won a prize in a Rose Bowl parade, and the flag-raising has been re-enacted by children, by gymnasts of the University of Maryland, and as part of an Orange Bowl pageant in Miami.

It has been sculptured in ice and in hamburger and, by the Seabees, in sandstone on Iwo Jima.[1] A New Milford, Connecticut, man spent ten months making a wood inlay of it using 10,000 pieces of veneer. A Washington, D.C., sculptor devoted nine and a half years to the $850,000, one-hundred–ton bronze statue that was derived from it and was dedicated as a memorial to all Marines last November 10 near the northern end of Arlington National Cemetery.[2]

How did all this come about?

The immediate succession of events began on March 27, 1944, when I left San Francisco, after a stretch as a warrant officer in the Maritime Service in the Atlantic, to cover the war in the Pacific for the Associated Press on assignment with the Wartime Still Pictures Pool. The pool was an arrangement by which the photographers of the various photo services shared their pictures.

Before Iwo I shot pictures of the D-day landings in Europe and the Pacific campaigns on Guam, Peleliu and Angaur, and in January of 1945 I was at Pearl Harbor again, waiting while the big names of journalism gathered. For three weeks, men whose bylines awed me kept coming in, and then, just before we loaded on transports, we were told that the next target in the American advance toward the Japanese homeland would be Iwo Jima.

I was assigned to a battalion of the 24th Regiment of the Fourth Marine Division, but on our way to Saipan, where we were to rendezvous, I learned that this outfit might not land until D-day afternoon. At Saipan I went ashore and told the public relations officer that I had to get onto the beach earlier. "It's the difference," I said, "of getting the pictures I want—and not getting them."

The fighting man has no choice of when he will be committed to battle. The photographer or correspondent can make up his own mind when he will go in, and at Guam I had learned that the best time to shoot landing pictures is from H Hour plus 1 to H plus 3. If you land earlier, you are only pinned down and in the way.

At Saipan, I was transferred to the Second Battalion of the 25th Regiment, which was scheduled to land within an hour of H hour, and it was there that we had our final big briefing. After thirty correspondents gathered with the top Marine and naval brass in the officers' wardroom and heard Iwo described as the most heavily fortified island we had ever encountered.

"But the Marines haven't failed yet," Lieutenant General Holland M. (Howlin' Mad) Smith said finally. "Are there any questions?"

"Yes," said one of the correspondents. "When's the next boat back to Pearl?"

That eased the tension and broke up the briefing. Two days later I was in a transport off Iwo, talking with a Marine captain about a place in a landing craft.

"Do you want to go in my boat?" he asked. "We're carrying mortar ammo."

"It's all right with me," I said. "If you guys are going, I'll go."

At 6:30 A.M., just as it was getting light, we loaded into LCVPs. H-hour was 9 o'clock, but in the early light of a clear day and through the smoke haze we could see the island, 4,000 yards away, erupting under the heavy naval and aerial bombardment. I looked around at the others in the landing craft with me. There were fifteen of them, in their late teens and early twenties. I was then thirty-three, not much of a physical specimen and turned down by the armed forces because my natural vision is about one-twentieth of normal.

"Here are guys who haven't lived yet," I thought. "I'm not ancient in wisdom, but I've been around a little and I lived some. I have tried to conduct myself decently, and I think I can face my god, and if I'm killed it will be no great loss. But these kids haven't had a fair chance, and we know the odds. The odds mean that three of four of them are not coming back and that some of the others will be permanently injured."

I mention this now because that is what the picture means to me. To me it is not alone a snapshot of five Marines and a naval corpsman raising the flag. It is the kids who took that island and got that flag there. They knew the percentages, because Americans don't send their fighting men in blind. They tell them what they're going against, and still the traffic is only one way.

We were scheduled to go in at about ten o'clock, but as that time passed it was obvious that the chaos on the beach had disrupted the landing schedule. In addition to the intense artillery, mortar and small arms fire from the Japanese, heavy seas were piling up the Higgins boats, one on another, and the amtracs that were not hit were becoming bogged down in the loose dark sand.

It was just about noon when we came in. In the more than five hours that we had been in the boat, circling and waiting, I had avoided becoming too friendly with any of the kids. This was pure selfishness on my part, because I was afraid that if I made friends it would only be to lose them, but as we moved in through the choppy seas and the grimness weighed even heavier, I saw several of the kids looking at me, and I stuck my index fingers up in front of my glasses and moved them like windshield wipers as if to clear the spray. The kids smiled, and then we ducked our

heads and the boat beached. I stood up and the ramp went down and I snapped two shots of the kids racing off onto the beach, lugging two-wheeled mortar ammo carriages behind them.

That is part of the flag-raising picture, too, because in a way it is a picture of a miracle. No man who survived that beach can tell you how he did it. It was like walking through rain and not getting wet, and there was no way you can explain it.

I remember clearly the deep, loose, dark-gray volcanic sand terracing up about fifteen feet at a time, and the parts of bodies and the larger darker patches of blood seeping into that sand. I remember shooting some pictures of the Marines plowing across the beach, and then I moved off to the left behind a smashed blockhouse. There I tried, unsuccessfully, to get a picture of an ammo jeep that was burning, and then I took off behind two Marines for a shell hole.

It was hard running in the sand and we were in a file, about four feet apart, when I heard a clang and I saw the helmet of the man ahead of me go up into the air about two feet, and then he went about two more steps and dropped. The other Marine and I made it to the hole, and as I lay there, getting my breath back, I saw to the left a dead Marine lying up on the side of a shell crater with his gun ready and in the attitude of charging forward.

The scene seemed to me to be symbolic, but I couldn't take it from where I was because the picture would lack composition. In war photography, as in much news photography, you compose a picture by moving yourself, so I made a wide circle, running from crater to crater, and by then I saw a second man lying not far from the first. Now I stood up and focused my camera and waited until a Marine running up the beach entered the scene before I snapped it.

I will accept that the flag-raising shot, for which I can take only such a small part of the responsibility, is the best picture I ever made. The tremendous impact it has had throughout this country establishes that. Yet I have a special fondness for this other picture of the two dead Marines and the living one.

The flag-raising picture, as I shall explain, was largely accidental. In taking this other, I had to make an effort to create out of honest ingredients, as much as you can under fire, a truth, and to me it is a representation of man's struggle, of the living taking over for the fallen dead because the battle must go on.

In the eleven days that I was on Iwo I took sixty-five pictures. From time to time, when I was through shooting, I would work my way back to the beach and then hitchhike out to the commanding ship. There I would write captions for the pictures, hoping to finish in time to have my package go off with the day's official mail by seaplane to Guam.

One day at Iwo, it took me nineteen hours, moving from one landing craft to another, to get to the command ship just three miles offshore. I traveled from the beach to a hospital ship on an amtrac loaded with wounded on stretchers, and it was dusk and a cold rain was falling and the sea was rough, yet I never heard one complaint. On the hospital ship, the surgeons were working around the clock, and still this terrible backlog of wounded kept piling up.

It was on the morning of D-plus-4, the day the Marines reached the top of Suribachi, that I fell into the water between the command ship and an LCVP. After I had been fished out, I took a picture of Secretary of the Navy James V. Forrestal and the Marine commander, General Smith, looking toward the beach with Mount Suribachi in the background. Then Bill Hipple, a magazine correspondent, and I got aboard an LCT (Landing Craft Tank) heading for the southern part of the beach, and it was here that I heard about the flag-raising for the first time.

"We just heard on our radio," the boatswain said, "that a patrol is going up the mountain with a flag."

"The hell you say," Hipple said.

"That's what we heard," the sailor said.

I had been working the north end of the beach with the Fourth Marine Division because there was another pool photographer—Paige Abbott of the International News Service—working the southern beach with the Fifth Marine Division. I didn't know where he was or if he had heard about the flag. It turned out that he was shooting the fighting elsewhere at the time, but if he had been around I would certainly have yielded to him.

Hipple and I started toward Suribachi, picking our way through the marked mine fields until we got to the command post of the 28th Regiment. There they told us a forty-man detachment had already started off with a flag, following two patrols that had reached the top at 9:40 A.M. There we also found Bob Campbell, who is now on the photographic staff of the *San Francisco Chronicle,* as I am.

Bob, at the time, was a Marine private and combat photographer. With him was Sergeant Bill Genaust, of Minneapolis, who was to take the fine color movie sequence of the flag-raising, and was killed nine days later on Hill 362.

"I think we'll be too late for the flag-raising," Genaust said.

"I'd still like to go up," I said, "and you two guys are carrying guns and I'm not. How about coming along?"

We started up the hill, stopping a half dozen times to take cover while Marines tossed grenades and set off demolition charges in cave openings where Japanese were still holed in. About halfway up, we met four Marines coming down the slope.

One of them was Staff Sergeant Lou Lowery, then of Pittsburgh, a photographer for *Leatherneck,* the Marines' magazine, and now photographic director for it. Lowery and the others said the patrol had raised a flag at the summit, and that he had photographed the flag-raising.

This flag had been carried off the U.S.S. *Missoula,* an attack transport, in the map case of the battalion adjutant. It was raised around 10:30 A.M. on the length of iron pipe, part of the wreckage of a radar station at the summit, but it measured only fifty-four by twenty-eight inches, and that is why, although we did not know it at the time, it was to be replaced shortly with a larger flag that would be visible at a greater distance northward on the island and by ships offshore.

When we heard that the flag had already been raised, we almost decided not to go on, but I made up my mind to shoot a picture of it anyway. Campbell and Genaust went along to give me protection, and it was shortly before noon that we came over the brow of the hill and saw the flag.

As I got closer, I saw a group of our men hauling another long iron pipe, and then I noticed still another Marine holding a neatly folded flag.

"What are you doing?" I asked.

"We're gonna put up this bigger flag," one of them said, "and keep the other one for a souvenir."

The larger flag, it turned out, had been taken off LST 779, which was beached near the base of Suribachi. It measured eight feet by four feet eight inches.

I thought of trying a shot of the two flags, one coming down and the other going up, but although this turned out to be a picture Bob Camp-

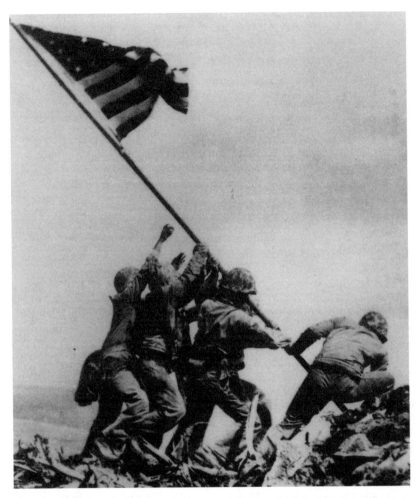

The second flag raising on Iwo Jima, as photographed by Joe Rosenthal. From left, Pfc. Ira H. Hayes, Pfc. Franklin R. Sousley, Sgt. Michael Strank (barely visible on Sousley's left), Navy Corpsman John H. Bradley, Pfc. Rene A. Gagnon (his helmet barely visible beside Bradley), and Cpl. Harlon H. Block (at foot of pole). (Courtesy of Associated Press)

bell got, I couldn't line it up. Then I decided to get just the one flag going up, and I backed off about thirty-five feet.

Here the ground sloped down toward the center of the volcano crater, and I found that the ground line was in my way. I put my Speed Graphic down and quickly piled up some stones and a Japanese sandbag to raise

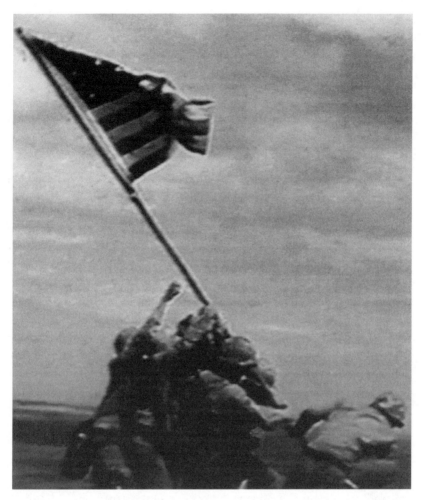

Frame from Sgt. William H. Genaust's motion picture of the second flag-raising on Iwo Jima. (U.S. Marine Corps photo)

me about two feet (I am only five feet four and a half inches tall). I picked up the camera and climbed up on the pile. I decided on a lens setting between f/8 and f/11, and set the speed at $\frac{1}{400}$th of a second.

At this point, First Lieutenant Harold G. Schrier, who was in on the first flag-raising, stepped between me and the men getting ready to raise the flag. When he moved away, Genaust came across in front of me with his movie camera and then took a position about three feet to my right.

"I'm not in your way, am I, Joe?" he asked.

"No!" I shouted, "and there it goes!"

Out of the corner of my eye, as I had turned toward Genaust, I had seen the men start the flag up. I swung my camera and shot the scene.

That is how the picture was taken, and when you take a picture like that you don't come away saying you got a great shot. You don't know, and within the next few minutes I made another shot of some of the men putting guy ropes on the pipe and still another of a group that I got together to wave and cheer under the flag.

On the way down, Campbell and I took gag shots of each other sitting in a chair that was left strangely exposed on the mountainside, and I also took a picture of a Marine with an abandoned kitten and another of a group of Marines holding up a sign they had painted, reading "Weehawken, N.J."

When we got to the 28th Regiment command post, I looked at my watch. It was 1:05 P.M., and that is the reason I know the picture was shot at about noon.

I took eighteen exposures that day, and when I got back to the command ship later that afternoon I captioned one film pack of these and a pack from the day before and they went off on the mail plane to Guam. The caption I wrote for the flag-raising shot read: "Atop 565-foot Suribachi Yama, the volcano at the southwest tip of Iwo Jima, Marines of the Second Battalion, 28th Regiment, Fifth Marine Division, hoist the Stars and Stripes, signaling the capture of this key position."

On the mountain top, I had made some effort to identify the men in the picture, but in the confusion I had failed. Following the overwhelming reception the picture received in the States, however, the Marine Corps went to work, and by checking out the arms and leg, as well as the bodies, and by referring to Genaust's motion picture strip, they determined that there were six men in the shot.

Initially, the first figure on the left was identified as that of Pfc Franklin Sousley of Ewing, Kentucky, subsequently killed in action, and the second figure as that of Pfc Ira Hayes of Bapchule, Arizona. Later it was determined that Hayes was the first figure and Sousley the second and when, in December of 1946, Hayes complained that one of his buddies was not being given credit, a Texas congressman initiated an investigation, and in April 1947 another change was made.

The figure on the right, at the base of the pole, was not, it was decided, that of Sergeant Henry O. Hansen of Somerville, Massachusetts.

Hansen had been present at the first flag-raising. Several days later, he was killed by attacking Japanese as he was being treated by Pharmacist's Mate Second Class John Bradley of Appleton, Wisconsin, who is the second figure from the right. The figure bending near the base of the pole, it was decided, was Corporal Harlon H. Block of Weslaco, Texas, killed on D-plus-10.

If the fact that I took this picture is important, then I deem it important to recognize the part played in the handling of it by many people. At Guam the picture-pool coordinator, Murray Befeler, had to see that my films were processed. The darkroom men had to do their jobs well to get good negative results. The censor had to pass the picture and Murray had to decide it was good enough to be scheduled via radiophoto, or it would have been passed over and been nothing but a piece of film.

As a result of the contributions of all these people and many others, millions of Americans saw this picture five or six days before I did, and when I first heard about it I had no idea what picture was being talked about. I had just arrived at Guam, two days after leaving Iwo and nine days after the picture was taken.

When I walked into press headquarters, a correspondent walked up to me. "Congratulations, Joe," he said, "on that flag-raising shot on Iwo."

"Thanks," I said.

"It's a great picture," he said. "Did you pose it?"

"Sure," I said.

I thought he meant the group shot I had arranged with the Marines waving and cheering, but then someone else came up with the picture and I saw it for the first time.

"Gee," I said, "that's good all right, but I didn't pose it. I wish I could take credit for posing it, but I can't."

Had I posed the shot, I would, of course, have ruined it. I would've picked fewer men, for the six are so crowded in the picture that of one of them—Sergeant Michael Strank of Conemaugh, Pennsylvania, who was subsequently killed—only the hands are visible.

I would also have made them turn their heads so they could be identified for AP members throughout the country, and nothing like the existing picture would've resulted.

I have thought often in these later years of the things that happened quite accidentally to give the picture its qualities. The sky was overcast, but just enough sunlight fell from almost directly overhead, because it

happened to be about noon, to give the figures a sculptural depth.

The twenty-foot pipe was heavy, which meant the men had to strain to get it up, imparting the feeling of action. The wind just whipped the flag out over the heads of the group, and at their feet the disrupted terrain and the broken stalks of the shrubbery exemplified the turbulence of war.

Of the twelve pictures in that film pack, two had light streaks across them. The picture, Number Ten, might have been one of those, but it wasn't.

At Guam, the first congratulatory wires from the States were waiting, and the misunderstandings that have persisted throughout a decade were starting. One of the correspondents had overheard the opening part of the conversation when I was first asked about the picture, and he wrote that the shot was a phony and I had posed it.

"How about that guy Rosenthal?" said another photographer who did not know me. "He picked up somebody's else's film, and he's taking credit for it!"

"I'm Rosenthal, you _____!" I shot back—and there's no point in trying to clear up what I said after that.

I had already been ordered by the Associated Press to return to the States, and now I was requested to file my answer to the correspondent's charges. I wrote to say that it was correct to say that this was a picture of the second flag-raising, and that I had never said otherwise, but that the shot had not been posed, that I had not picked the site, the men, nor the moment, and that I had not directed the flag-raising in any fashion.

As I left for home I had the fear that, through no fault of my own, I was in the doghouse. But when I arrived in San Francisco, I found that I was now a celebrity.

I, who had never been asked for an autograph in my life, was now being asked to sign dozens of the pictures. My draft board had changed my classification from 4-F (because of defective vision) to 2-AF (essential deferment). I was being asked questions and photographed and then I was dispatched to New York. There at the AP office—although I was just another bureau photographer—I was being received by executives. And it was there, of all things, a Rosenthal desk was being set up to handle requests for interviews and appearances.

Later I went to Washington, where I met President Truman. From the AP I had received a raise in salary for the D-Day Europe landing pictures, and now I received a bonus of a year's salary in War Bonds. With the

Pulitzer Prize, I received five hundred dollars, and with the award from *U.S. Camera* magazine there came another thousand.

I was presented three wrist watches as awards, as well as numerous scrolls, plaques and medals. And I was offered $200,000 for the statuette rights to the picture.

I never, of course, owned any rights to the picture. It was, and is, the property of the Associated Press. Although a New York congressman introduced a bill to give the Navy Department exclusive ownership of the photograph, there was no need for that, as the AP has turned over all proceeds from it to the Navy Relief Society, amounting in ten years to $12,941.84.

What was happening to me was also naturally happening to the three surviving Marines of the flag-raising.

—Hayes, the Pima Indian, who is now thirty-two years old, lives in Sacaton, Arizona, and is a warehouse supervisor for the Bureau of Indian Affairs.

—Bradley, the Navy medical corpsman, now thirty-one, is a furniture dealer in Antigo, Wisconsin, married and the father of four children.

—Gagnon, now twenty-nine, a contractor living in Hookset, New Hampshire, is married and the father of one son.

In 1945, all three were brought back at President Roosevelt's request to raise their flag over the Capital in Washington, and then to tour the United States for the Seventh War Loan Drive.

I met Hayes for the first time in October of 1953 in a television studio in Los Angeles. I saw him again briefly some three months ago when the huge memorial sculpture was dedicated in Washington—and there I met Bradley and Gagnon.[3]

They were sitting across the hotel dining room at breakfast when I recognized Ira from having met him and the other two from having seen their pictures in newspapers. I went over and we shook hands, but suddenly our table of four became a table of twelve and I had no chance to talk with them.

I think I know how they feel from what Hayes has said of how he feels, and from what I know of combat men and myself. Certainly I am grateful for having been fortunate enough to take this picture. But as a photographer I think of Lou Lowery, who went up Suribachi with the forty-man detachment.

At one point, Lowery had to tumble about fifty feet down the side of the mountain to avoid an enemy grenade, injuring himself and smashing

his camera. And then my one shot overshadowed the fine series he took of the climb and the first flag-raising.

Why didn't my good luck fall to Bob Campbell, who—with Bill Genaust—gave me cover? Bob was the father of five kids when he enlisted in the Marine Corps as a private.

"When I see you working in the darkroom, still having to make prints of that picture," says Bob, because we understand one another, "I'm damn glad I wasn't the guy who took it."

I can name a lot of photographers who were better than me and who better deserved good fortune. I think of Frank Prist of Acme, who was killed on Leyte, of John Bushemi of *Yank,* who was killed at Eniwetok, and of Damien Parer, the Paramount newsreel man who lost his life at Peleliu.

There were others, but these were men I knew. They projected themselves to get their pictures and their pictures showed it. Parer was moving behind our tanks when a machine gun opened up on him, and his last films proved he knew where the bullets were coming from, because he swung the camera toward the gun, and on his film you can see the ground spinning and finally the empty sky.

Raise no shouts for Joe Rosenthal, who became a photographer because as a kid of twelve growing up in Washington, D.C., he had saved cigar-store coupons and, looking through the catalogue, realized he couldn't get some of the prizes he wanted because he did not have enough coupons. So he took a camera instead.

When, in 1930, and a year out of high school, I got a job with the Newspaper Enterprise Association in San Francisco, I thought that N.E.A. probably stood for the National Education Association.

In 1953, Hayes, the Indian, was picked up on Chicago's Skid Row, drunk, barefooted and with his clothes torn. He was without money, and so was locked up in the House of Corrections until the *Chicago Sun-Times* paid his way and then established a fund for him to which the public subscribed.

Hayes, who has since been winning a brave battle with himself, said his trouble had started when he had been called back to the States to go on the bond tour. He had not wanted to come, but it had been an order, and he had only lasted two weeks.

"People shoved drinks in our hands and said we were heroes," he said. "I was sick. I guess I was about to crack up, thinking of those guys who

were better men than me not coming back at all, much less to the White House. On the reservation, I got hundreds of letters and I got sick of hearing about the flag-raising and sometimes I wished the guy had never made the picture."

When I met Hayes, he tried to apologize, saying he had not meant that about the picture. I told him it was not important, for I knew what he meant when he said it, and I know what Bradley and Gagnon must have thought as the requests have poured in and the attention has been focused on them down through the years.

Now the flag rests in the Marine Corps Museum at Quantico. On the site atop Suribachi stands a memorial and another flagpole and another flag. The camera with which I took the picture is still in service in the Tokyo bureau of the Association Press. The original 4-by-5–inch negative is locked in a drawer in the AP office in New York and I am a photographer on the *Chronicle* in San Francisco, shooting pictures of fires and society functions, auto accidents and football games.

The only reproduction of that picture that I have hanging in the six-room house where I live in San Francisco (with my wife Lee and two children, seven and five) is a 2½-by-3–inch etching made by Matthew D. Fenton of The Bureau of Engraving and Printing in Washington, D.C.

I guess that I have made over 2,000 prints of that picture off a couple of negatives that were made from original prints. I have answered hundreds of letters and turned down dozens of requests for personal appearances because, frankly, it became too physically and financially exhausting.

At least two dozen relatives of Marines killed on Iwo, each certain that his or her boy is in the picture, have written to me. I remember one letter from a mother who was hoping so much that her son was one of those shown, because he was killed the day the picture was snapped.

I remember another mother writing that one of these must have been her son because he wore that kind of helmet.

I can best sum up what I feel by saying that of all the elements that went into the making of this picture, the part I played was the least important. To get that flag up there, America's fighting men had to die on that island and on other islands and off the shores and in the air.

What difference does it make who took the picture? I took it, but the Marines took Iwo Jima.

Mistakes and Misjudgments

The waging of war is an imperfect art. Men die because mistakes are made at all levels, low and high, but some mistakes cannot be avoided.

During the battle for Iwo Jima, a Marine sergeant, too near exhaustion to think straight, made a mistake that cost his life. He went into a dark cave, turned on a flashlight, and was riddled by bullets from Japanese rifles.

What appeared to be more of a misjudgment was made by five-star Fleet Adm. Chester William Nimitz, highest-ranking of the brilliant admirals and generals who directed and won the island war in the Pacific. On 14 March 1945, with weeks of combat yet to come, Admiral Nimitz issued a formal proclamation that Iwo Jima was conquered and "all powers of government of the Japanese Empire in these islands . . . are hereby suspended."

Exhausted Marines, both officers and enlisted, were divided in their reactions. Some welcomed the news as indicating that the end was in sight. Others, closer to the front lines where men were dying every minute, decided that the admiral was dead wrong and his proclamation was bad for morale. They complained that Nimitz, in his headquarters thousands of

miles away, was out of touch with the reality of what remained to be done on Iwo Jima.

After being punished by the enemy for twenty-three days, the Marines knew that thousands of combat-ready Japanese were still hiding in deep tunnels, many directly beneath them, and that the enemy would fight to the death. Aware of this, some staff officers and master sergeants passed the word that Admiral Nimitz might issue a second statement clarifying his first one.

The clarification never came. Instead, three days later, Nimitz issued another proclamation stating that Iwo Jima was "officially secured" and that organized Japanese resistance had ended.[1] When a private in the badly shot-up 4th Marine Division heard the news, he spoke in disbelief to Marine combat cameraman Pvt. Bob Campbell: "No longer organized? Who does the admiral think he's kidding? We're still getting killed!"

Although morale dipped in some sectors, the Marines never stopped fighting and advancing. In a series of vicious battles during the final phases of the operation, casualties for the period 11–26 March totaled nearly 3,000, including 1,071 killed or dead of wounds, 1,586 wounded, and 227 suffered battle fatigue. Statistics compiled years later greatly increased these figures.

Survivors who saw their friends destroyed needed someone beside the Japanese to curse, so they cursed Nimitz and his proclamations. I was one of the wounded junior officers who cursed. I wasn't alone. At Tripler Army Hospital in Honolulu, Hawaii, where I recuperated, officers up to the rank of major joined us in disputing the strategies laid down by Nimitz and his staff. Because Oahu's Navy hospitals overflowed with Iwo wounded, many of us Marines were sent to Tripler.

Wounded on D-day, I didn't learn about the Nimitz proclamations until I reached the hospital weeks later. Whether they had been hit before or after the proclamations did not matter to some of the badly wounded; they just wanted to go home. Others, struck down late in the fighting, belabored the Nimitz controversy as often as anyone would listen. Criticizing the brass was a tonic for us. With time on our hands, we ambulatory survivors sat around in bull sessions and griped day and night.

It took years of informal military studies for some of us to change our opinions of Nimitz and his staff. We were right about some matters but dead wrong about the admiral. What could young officers (I was twenty-

four years old) possibly know about the "big picture"? (See chapter 15 for an analysis of the admiral's successful Iwo Jima strategies.)

One of our second lieutenant friends, who died at Tripler, had suffered a neck wound that did not seem serious, but it killed him. Before he became terminal, he took the anti-Nimitz side of our debates and did well because he was a former law student. He had been wounded a couple of days before 26 March, when a well-organized group of about 300 Japanese soldiers launched a sneak attack in the morning darkness. The battle lasted more than three hours. When it was over, 53 Americans were dead and 119 were wounded. The toll included Marines, Seabees, and airmen stationed near the island's newly completed airstrip. Sprawled across the battlefield were the corpses of 262 Japanese soldiers.

During April and May, Marines and Army garrison troops killed 1,600 more Japanese soldiers and officers. That was up to $2\frac{1}{2}$ months after Admiral Nimitz had declared that all organized resistance had ended. Throughout June, July, and August, Japanese were still being killed and some were taken prisoner as they emerged from their tunnels and caves to surrender.[2]

To place the Iwo battle in perspective, it should be understood that the Japanese, even that late in the war, still directed one of the world's mightiest military forces. On 7 December 1941, Japan's military consisted of 2.4 million well-trained regulars and 3 million well-equipped reserves. Although Japan had substantial losses in dozens of Pacific battles from 1942 through 1944, its military was still greatly feared in early 1945 because of its size, training, and fight-to-the-death Samurai code.

Iwo Jima (only one-third the size of Manhattan island) was so heavily defended because it was closer to Japan, 650 miles south, than any other island captured by the Americans thus far in the war. Along with the larger island of Okinawa, even closer to Japan, it was to be used as a base for some of the millions of American troops needed for the coming invasion of Japan.

The might of the Japanese military fist had been demonstrated in its accomplishments immediately after the attack on Pearl Harbor. Within only months, the Japanese had overrun and captured Hong Kong and Thailand, advanced into Burma, captured Singapore, invaded the Philippines, captured the oil and rubber riches of the Dutch East Indies, and threatened Australia, thus controlling a major portion of Southeast Asia.

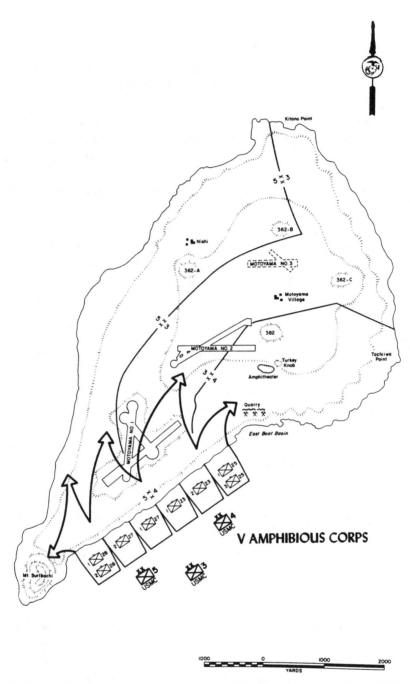

Marine landing forces and directions of D-day assaults on Iwo Jima. (U.S. Marine Corps map)

The tenacity of the Japanese fighting man was well understood by the U.S. military, but not even the most pessimistic of our analysts foresaw the extent of American losses on Iwo Jima. Rivers and rivulets of red ran everywhere on the tiny island, above and below ground. Total deaths, Japanese and American, were estimated at close to 30,000.

Nearly 7,000 Americans died. Total casualties of U.S. Marines, Navy, and Army personnel were 28,686, including 19,217 wounded and 2,648 cases of battle fatigue. The number of Marines, 5,931, who were slain on Iwo Jima equaled one third of the total number of Marines killed in battle during World War II. One of every three Americans who fought on Iwo was killed or wounded.[3] During the early days of the fighting, a Marine was struck down every twenty seconds.

An estimated 22,000 to 23,000 Japanese soldiers and sailors died. They were shot, blasted by artillery or mortar fire, incinerated by flamethrowers, or suffocated, most of them in the tunnels below the shell-scarred surface. Uncounted numbers of the enemy, trapped underground for weeks without enough water or food, took what for them was the honorable way out. They killed themselves.

Iwo Jima is such a flyspeck in the ocean that one marvels at its capacity to contain the more than 100,000 troops who fought there. Perhaps photographer Edward Steichen described it best: "Iwo Jima is an ugly island. Sulphurous mists ooze up here and there from its mud-colored surface. The beaches are black, and the black beaches with the ribbons of white surf run a mourning border around the island."

Ironically, many Marines were killed on the ugly island by mistake— by "friendly fire," a military term that did not come into widespread use until decades later when the armed forces were required to investigate and identify all such casualties. Friends who survived Iwo despise this term. They say that, whatever its source, no bullet or mortar round that kills a Marine should be labeled "friendly." Since time and wars began, battle commanders have suffered nightmares about killing their own men. Such casualties are anticipated by battle planners because it is human nature for mistakes to be made during the stress and terror of combat. No proof exists but very likely—because of the masses of Marines, the masses of artillery, and the island's small size—more of our own men were killed by American mistakes on Iwo Jima than in any other Pacific battle.

But what about mistakes after the war? Should an oversight by deskbound Washington military policymakers in 1945 go uncorrected for decades afterward?

There were other mistakes, including the fatal one made by Bill Genaust, the battle-weary Marine sergeant who turned on his flashlight in a dark cave. A little more than a week previously, he had made Marine Corps history with his movie camera as he stood beside Joe Rosenthal on the volcano rim and followed the rising Stars and Stripes with his lens.

Rosenthal went on to international acclaim for his photo, which became the most reproduced photo in history. He received the Pulitzer Prize and a long list of other honors. One art critic deemed the photo a masterpiece comparable to Leonardo da Vinci's *Last Supper.* Monetary offers poured in from everywhere. Rosenthal could have become a wealthy man if he had wished. But he remembered the men who died at Iwo Jima, including his friend Genaust, and had no desire to earn riches from their sacrifices. He turned over to charity most of the flag-raising money that came his way.

Strangely, for forty years, Genaust was officially neglected by the Marine Corps that he served so well. Although one of his Kodachrome color movie frames was a match for Rosenthal's black-and-white photo, he received no credit for his achievement. As the decades passed and his filmstrip was seen worldwide by millions in theaters and on television, the Corps maintained its policy of not identifying him.

How could the Marine Corps ignore an artist who was also every inch a genuine combat hero? During the battle for Saipan the previous year, Genaust and two other Marines, had been attacked by many Japanese. He had put down his movie camera, picked up his carbine, and although wounded in the leg, helped his companions to kill nine enemy snipers hidden under a house. For his bravery and coolness under fire, he was awarded the Bronze Star. For his wound, he received the first of two Purple Hearts. His widow Adelaide received the second one, awarded for his fatal wound on Iwo.

The way the Marine Corps overlooked his Iwo Jima masterpiece was perhaps, in a way, Genaust's own doing because he made the mistake of switching on his flashlight. If he had lived, the Corps very likely would have honored him as one of its most gifted movie cameramen. Because he was killed (and his family did not choose to pursue honors for his flag

film), however, no formal action was taken in Washington on his behalf. This was not unusual, nor was there any conspiracy against him. Apparently, no decision is sometimes the easiest decision in some matters.

Is it possible that some of the leadership in Washington, unfamiliar with the basics of camera techniques, believed that Rosenthal shot the flag-raising motion picture as well as the still photo?

Possible but unlikely.

Did any of Sergeant Genaust's Iwo Jima Marine friends ever step forward and urge the Corps to identify him as the moviemaker?

Only one did so, another sergeant. He began badgering Marine Corps headquarters in 1945 and continued for decades—but to no avail.

Why?

An Impeccable Record

Sgt. William Homer Genaust was an artist with a camera. Much of the movie footage that he shot for the Marine Corps during World War II was used in training films to teach survival in frontline combat. Under fire, he was brave and heroic. He had an impeccable service record.

The private lives of some war heroes are not admirable. Could Genaust have been a renegade, an alcoholic, or some kind of misfit whose bad habits in public were embarrassing to the Corps? Was that why Headquarters Marine Corps declined to mention his name?

Hardly.

Bill Genaust was my friend. More than fifty years later, I still feel his loss. He was one of the most decent and honorable men I have ever known. Also highly intelligent, he was a perfectionist who worked at a task until he got it right. In private life, as well, Bill had been a solid citizen. Before he enlisted in the Marine Corps, he worked at the Ford Motor Company factory in Saint Paul, Minnesota, as a photographer, stenographer, and typist, with the hope of earning enough money to resume his study of dentistry at the University of Minnesota.

As a Marine, Bill was mature, quiet, and modest. I never heard him

mention the medals that he had won at Saipan. Like most Marines of that era, he was a chain-smoker, especially when he was overseas and separated from his family. At age thirty-eight, Bill was six feet tall, fair-skinned, a trim 175 pounds, muscular, and fit. His short hair was light brown with blond strands. Much of the time, he wore a small blondish-brown mustache. He was a handsome man, and his friends said that he was a dead-ringer for Douglas Fairbanks, Jr. A Hollywood director of the 1940s might have cast him as the clear-eyed, stalwart hero in a war action movie.

Bill Genaust, however, was no Hollywood Marine. He didn't strut or preen. He had eyes only for his wife Adelaide, to whom he had been married for seventeen years. While training in boot camp at Parris Island, South Carolina, and, later, based on islands in the Pacific, he wrote to her quite often, but his letters were infrequent compared with hers—Adelaide wrote to him every day.

She prized his letters because each one was a minor masterpiece, carefully written and thought-provoking, often including long paragraphs about the latest book he was reading, usually history or philosophy. He wrote amusing observations about the peculiarities of life on a troopship. For example, after taking a cold shower with salt water, he felt "like a dill pickle covered with warts." He usually added a sentence or two of optimistic thoughts about the good life they would have together after the war.

Bill prized the letters that Adelaide wrote to him and kept them in neat bundles in his canvas seabag. When mail was delayed, sometimes for weeks, he opened the bundles and reread her letters, often late at night by flashlight in a ship's bunk or on his cot in a Marine tent. She wrote about unexpected crises at home, meat and sugar rationing, price controls, and shortages of Palmolive soap and her favorite shampoo, Johnson's.

Military and civilian analysts who studied aspects of the Iwo Jima operation after the war offered a number of reasons for what appeared to be contradictions in the Marine Corps policy regarding honors and credits for individuals. Some of these contradictions were related to the unprecedented attention that the Corps received from the Rosenthal flag photo. It was the single most effective recruiting device ever developed by any branch of the armed forces. Eager prospective Marines lined up at recruiting stations across the land.

The phenomenon began within hours after Rosenthal's photo appeared on page one in newspapers throughout the United States. Worldwide

attention continued to focus on the photograph and the Genaust movie strip in a variety of unexpected ways for the next half century. It is not unreasonable to predict that the phenomenon will continue into the twenty-first century and beyond.

The first military analyst to question the Corps' strange lack of recognition for Sergeant Genaust was Harrold Weinberger,[1] a much-decorated U.S. Marine moviemaker who won a National Headliner award for his color films of Iwo battle scenes. Weinberger, who worked closely with both Rosenthal and Genaust, was an extraordinary military man with a long service record dating back to 1917, when he had joined the Navy during World War I.

On Iwo Jima, Weinberger, then age forty-five, won the Bronze Star for Valor and a Purple Heart for his wounds. After his promotion to master sergeant, he was the top noncommissioned officer in the 4th Marine Division's G-2 photo section that assigned two-man camera teams to photograph battle scenes. Each team included a still photographer and a movie cameraman. Weinberger, who later became a major, described Sergeant Genaust as "one of my boys, a quiet Marine for whom I had the greatest respect." Because he was a civilian, Rosenthal operated independently, but he and Weinberger were good friends. "Joe was always a professional," Weinberger told me when I interviewed him. "I liked the way he worked. No mistakes, always on the ball and a nice fellow besides."

After the battle for Iwo ended, Weinberger was delighted by the honors that continued to roll in for Rosenthal and mystified by the Corps' silence about Genaust. As weeks became months and the brief Genaust movie of 198 frames became one of the most reproduced strips in the history of filmmaking, civilian or military, Weinberger began a campaign of direct action to get official credit for his friend.

Weinberger was the first to seek such credit for Genaust. He started his effort in mid-1945 and continued it for decades, while he was active in the Marine Corps Reserve and the U.S. Marine Corps Combat Correspondents Association. Most of the time, this was a one-man campaign. But, half a lifetime later, when Major Weinberger was in his eighties, the association's six hundred members gave him nationwide support and urged at least a commendation for Genaust and mention of his name whenever his movie was shown.

During the 1950s and 1960s, Weinberger's letters, telephone calls, and personal contacts with important figures in and out of the Marine Corps

produced promises of "We'll look into it," but no results. Even close friends who later became colonels and generals at Marine Corps headquarters in Washington were reluctant to take the kind of direct action that he sought.

"I understood why," Weinberger told me. "They didn't want to rock the boat. They didn't want to risk their careers by going up against decisions made at the very top."

The chief stickler that Weinberger encountered was what turned out to be a quirk in official credit policy. Early in the war, it had been decreed that Marine still photographers should get bylines for their work but the films of combat movie cameramen were to be circulated anonymously.

"Though I interviewed a lot of officers and noncoms," Weinberger said, "I was never able to pin down exactly when that decree was established, who established it—and most important—why a mere quirk became such a hardfast rule. Nor could I find anyone who made an effort to change it during the war when Marine moviemen shot huge amounts of film under dangerous combat conditions at Tarawa, Guadalcanal, Saipan, Okinawa, and so forth."

The biggest obstacle to Weinberger's campaign occurred about twenty years after the war when he received an official communique from Washington that stated, in effect: The Marine Corps has concluded reluctantly that it is prevented by law from honoring Sgt. William Homer Genaust. Military awards must be approved within five years of the date of the action.

Weinberger was disappointed but stubbornly refused to give up. "Because I served in the military in both world wars," he related, "I'd been around a long, long time and knew a lot about how military minds work. I'd seen the making and breaking of so-called unbreakable rules and decisions. I decided to be patient. If I was lucky, I might see new decision makers arrive in Washington who would be willing to toss out old policies."

On 12 July 1973, however, a disastrous fire broke out at the National Personnel Records Center near Saint Louis, Missouri. Along with 18 million other military service records, Genaust's Marine Corps records were destroyed. Unable to verify Genaust's service history, the Corps decided to postpone indefinitely any action on questions concerning him.

Eventually, Weinberger's series of investigations led him to two conclusions:

1. Someone high up on the commandant's staff decided that nothing should be allowed to dull the luster of Rosenthal's accomplishment, which had become more important to the Corps with each passing year. Weinberger said, "They decided Joe's picture was a gift from God to the Corps, the most perfect symbol ever seen of men in combat, fighting for their country and their flag. It was a singular accomplishment by one photographer, and there was no reason to detract from it by mentioning that another photographer, a movie man, shot the identical scene."

2. From 1945 on, Headquarters Marine Corps pursued a "hands-off" policy regarding media coverage of the Rosenthal photo and Genaust's film footage. This was partly a reaction to years of sniping from the other armed forces, who had accused the Corps of operating a shameless propaganda machine. "Although the Corps was smaller than the Army, Navy or Air Force," Weinberger said, "it was accused of having the biggest, most ambitious, most self-serving, and most overstaffed publicity department in the military."

The Corps counteracted those accusations by doing nothing to generate publicity for the Rosenthal photo and the Genaust footage; it did not have to. The pictures were self-generating in ways and numbers never seen before.

On request, the Associated Press supplied reporters and editors with countless Rosenthal prints. Also on request, the Corps quietly supplied vast quantities of extra Genaust movie prints, in color or black and white, to newsreel and television companies, motion picture studios, schools, and patriotic societies. The Genaust footage showed up repeatedly in theaters, school auditoriums, patriotic halls, amusement parks, and stadium shows. It was projected on giant screens at national political conventions and used as a dramatic after-midnight sign-off on television stations nationwide.

Weinberger's inquiries also revealed how the Corps, through its "hands-off" policy, was able to overcome many controversies surrounding the flag-raising photos, some of which were disruptive and put the Corps in a negative light. For example, Rosenthal himself suffered years of neglect involving the massive bronze statue of the flag raising, near Arlington National Cemetery in Arlington, Virginia, that stands as a memorial to all

Marines. Although an exact replica of Rosenthal's photo, the sculpture did not contain a credit line for Rosenthal when it was unveiled in 1954. Its plaque identified only the sculptor, Felix de Weldon.

Distressed by the snub, Rosenthal's many San Francisco friends, backed by Congressman John Burton, began a campaign to get his name placed on the magnificent hundred-ton sculpture. An act of Congress, signed by President Ronald Reagan in 1982, finally allowed Rosenthal to receive credit. The campaign required most of thirty years; at no time did the Marine Corps take any official steps to help it along.

Even when Rosenthal's name finally appeared, the snub was still in effect, in a different way. His credit line was placed on a pylon seventy-five feet from the sculpture. Again, Rosenthal's friends were forced to take action. Many more years would pass before Rosenthal's name was placed on the sculpture—on a plaque separate from de Weldon's.

Another controversy that the Marine Corps carefully steered around involved the fact that the flag raising photographed by Rosenthal and Genaust was not the first one to take place atop Mount Suribachi on 23 February 1945.[2] Headquarters Marine Corps in Washington did nothing to support the cause of a handful of heroic combat Marines who wanted the world to know that there were two flag raisings on Suribachi that day and that theirs was the first. These men could not understand why their achievement was snubbed by the same world media that gave unprecedented attention to the second flag raising photographed by Rosenthal and Genaust.

The first flag had been raised on the morning of 23 February at 1030 by elements of a forty-man patrol from the 28th Regiment of the 5th Marine Division shortly after it captured the summit. The patrol had to fight its way up the steep, treacherous slopes of the 556-foot extinct volcano, as it was attacked by Japanese firing on them from caves and throwing grenades. The Marines killed all the enemy they could find and suffered no casualties of their own.

(This patrol was not the first to climb Mount Suribachi. That distinction went to a small patrol that volunteered to go up the night before, 22 February. See Chapter 8, Note 7, for the previously unpublished account of Pfc Raul V. Paredes and four other intrepid men who climbed the steep, slippery slopes under the cover of darkness when Suribachi was entirely enemy territory. Joined eventually by other Marines, they fought a

furious battle, during which an estimated twenty Japanese defenders were killed.)

The flag was attached to a tall length of rusty pipe liberated from a nearby rainwater cistern and raised above the summit. Although it was small, only fifty-four by twenty-eight inches, the flag was seen immediately because a stiff breeze whipped it out fully from the pole. A great cheer went up from thousands of Marines down below, as well as from multitudes of sailors in the armada of warships offshore. The moment was tremendously emotional and inspiring for the frontline units of the 4th and 5th Marine Divisions, whose casualties during the first four days of fighting had been among the highest in Corps history.

Among those on the beach who saw the flag go up were Secretary of the Navy James V. Forrestal and Lt. Gen. Holland M. ("Howlin' Mad") Smith, commander of the 75,000-man Marine invasion force.[3] Gazing up at the flag, Forrestal said, "Holland, this means a Marine Corps for the next five hundred years." The white-haired general nodded, and his eyes filled with tears.[4]

The raising of the first flag was photographed by Marine Sgt. Lou Lowery, a twenty-five-year-old staff photographer for *Leatherneck* magazine. As he tripped the shutter of his big Speed Graphic, a Japanese soldier jumped from a cave and fired at him. The bullet missed, and the soldier was slain by another Marine. Grenades came flying from the cave and other caves nearby.

To escape one of the blasts, Lowery leaped backward and tumbled fifty feet down a rocky slope. He was shaken but unhurt. Although his camera was smashed, his film of the flag raising was not damaged.

Sergeant Lowery's picture of the Stars and Stripes being guarded by a Marine rifleman was an outstanding photo, especially because the photographer nearly lost his life while shooting it. If there had not been a second flag raising ninety minutes later, Lowery's photo likely would have been judged one of the finest photo achievements of the battle for Iwo Jima. Unfortunately for Lowery, Rosenthal came along around noon and took another picture.

The Mysteries
of Art and War

Great art is as irrational as great music. It is mad with its own loveliness.

—George Jean Nathan

Art hath an enemy called ignorance.

—Ben Jonson

If a nation's foremost critics can't decide what is art and what is not, no one should expect the men who raised two flags on Suribachi to know the difference. The Marines who raised the first flag atop the dead volcano, and who somehow were still alive after the terrible six-week battle, had every right to be mystified afterward about the difference in the two photos. They were not art critics or scholars, artists, or professional photographers.

Months, even years later, when they compared the flag photos, it was obvious to these men, because of their personal interest, that Lou Lowery's photo was the better one. It was the most significant and most truthful. Rosenthal's photo contained no hint of death or danger. The fighting was in hiatus when he snapped it, and most of the Japanese defenders of the hilltop were dead.

In Lowery's photo, the truth was there in the Marine guarding the rocky flag site with his carbine. Only minutes before, the patrol had fought Japanese soldiers and killed them. The photo showed Pfc James R.

Michels, with his finger on the trigger, ready to blast any Japanese who might dare to attack again.[1]

Even more significant was the reaction all over the island when the first flag went up. The sight electrified tens of thousands of battle-weary Marines. They shouted, cheered, and slapped one another on the back. The Stars and Stripes on top of Suribachi meant that they were a big step closer to victory.

When the second flag went up an hour and a half later, there were no cheers and shouts. The armada of warships offshore didn't sound their sirens, bells, and whistles. By then, the fighting had resumed and the Marines were grimly attending to business with their flamethrowers, mortars, and machine guns.

Today, half a century afterward, the inescapable truth about the two photos is this: The raising of the first flag electrified myriads of brave men on a tiny island. Joe Rosenthal's photo of the second flag raising electrified a nation and the world.

Art scholars summarize the effect in words similar to these: Had Rosenthal and Genaust not been on Iwo, the battle would to this day not hold such a grip on the nation's consciousness. Flags went up on every island the U.S. captured, and photographers were there when it happened, but none ever captured such a dramatic scene, largely because the Rosenthal/Genaust pictures were unplanned, rather than posed and ceremonial like most other flag raisings.

War is unfair, life is unfair, and art itself can be unfair toward those who are a part of it. The six men who raised the second flag were honored by name for generations to come as the heroes of Suribachi. They were Pfc Franklin R. Sousley, Pfc Ira H. Hayes, Navy Pharmacist's Mate Second Class John H. Bradley, Cpl. Harlon H. Block, Pfc Rene A. Gagnon, and Sgt. Michael Strank. Before the battle ended, three of the six—Strank, Sousley, and Block—were dead, never to learn of their fame.

The six men, pictured by Lowery, who raised the first flag were not just forgotten—some of them were never even mentioned. They were 1st Lt. Harold G. Schrier, Pvt. Louis C. Charlo, Cpl. Charles W. Lindberg, Sgt. Ernest Ivy ("Boots") Thomas, Sgt. Henry O. Hansen, and Pfc James R. Michels, the rifleman in the foreground who guarded the Stars and Stripes. Thomas, Hansen, and radioman Charlo were subsequently killed in action.

For his gallantry on Iwo, Schrier was awarded the Navy Cross. Lindberg, who lugged a seventy-pound flamethrower to the summit, won the Silver Star for heroism and the Purple Heart for an arm wound. Thomas was awarded the Navy Cross for heroism and the Purple Heart.

Of the forty men in the patrol that raised both flags, thirty-six were dead or wounded before the battle for Iwo ended.

The young officer who chose the patrol for that mission was Capt. Dave Severance, commander of Company E, 2nd Battalion, and a former Marine paratrooper. A career Marine, he was awarded the Silver Star for his direction of the company's assault against fierce resistance during the battle for Hill 362A in March. Later, during the Korean War, Severance would fly sixty-two missions as a fighter pilot and receive the Distinguished Flying Cross and four Air Medals.[2]

Among the men in the flag patrol who battled their way up the steep sides of Mount Suribachi, Lou Lowery was most frequently mentioned in magazine and newspaper articles after the war because of his photo essay that revealed, step by step, exactly how the patrol made it to the top. As he climbed the slippery slopes with the fighting men, Lowery shot photo after photo with a heavy, boxy Speed Graphic camera. His photos depict the Marines carrying the rolled-up Stars and Stripes, as well as loads of ammunition and flamethrowers; climbing past the blackened, burned body of a Japanese soldier; and crawling over craters blasted by artillery shells.

The series of quick grab shots, all in sharp focus, were widely praised for the way Lowery revealed the drama of men coolly going it alone, far beyond the front lines, as they battled upward every step of the way.

Following the first flag raising, Lt. Col. Chandler Johnson, from his 2d Battalion command post at the base of the mountain, ordered that a bigger banner be found and substituted. The first flag was too small and could be seen from a distance of little more than a mile. (The battalion commander was killed in action eight days later.) Second Lt. Ted Tuttle went down to the beach and boarded landing ship 779. He was given a new flag from the ship's stores—a beauty, ninety-six by fifty-six inches, big enough to be visible from almost anywhere on the tiny island. Tuttle rushed the flag to Colonel Johnson, who gave it to his message runner, Private First Class Gagnon, with orders to take it immediately to the top of Suribachi.

"And bring back the little one!" Johnson snapped. "Some son of a bitch is going to want that flag for a souvenir, but he's not going to get it!"[3]

While Gagnon hurried up the slopes, Joe Rosenthal was slowly climbing below him and following the tracks of a group of Marines who were checking caves for hidden Japanese. To make sure there were no sudden attacks, the Marines pitched grenades into some of the caves. Because he carried no weapon, the near-sighted Rosenthal was accompanied by two armed Marine photographers, Campbell and Genaust, who were there to give him protection as well as to take pictures. As the three went up, they met Lowery coming down.

"You guys are late," Lowery said. He explained that he had already photographed the flag raising. "But you might like to go up," he added, "It's a helluva good view from up there."[4]

Although disappointed, Rosenthal decided to keep climbing anyway, in the hope of finding something interesting to photograph. At that time, neither he nor Lowery knew of any plans to raise the bigger flag. Lowery continued downward to the base of the volcano, while Rosenthal, Genaust, and Campbell made their way to the top. It was a tough climb because Marine artillery and mammoth sixteen-inch shells from the Navy's battleships had shredded the steep slopes and hurled small and large rocks all over the place. When Rosenthal reached the rim of the volcano, he saw the small flag flying horizontally in the breeze and was surprised to find that Marines kneeling beside it were preparing to put up the second, larger banner. The tall, slim officer in charge was Lieutenant Schrier, who had led the patrol to the top.

For twenty-four-year-old Schrier (who later became a general), the day was busy, as well as dangerous. Expecting a fierce battle to capture the summit, he was relieved that the enemy had offered only token resistance, but he wondered why. He got the answer after he sent Sergeant Thomas and ten men to explore the cave from which the last attack had come. The cave led to a tunnel, longer than a football field, that the Japanese had dug into the mountain. In it, Thomas and his men found the bodies of 150 Japanese. Most had died by holding grenades to their abdomens. They were trapped when the naval barrages collapsed the connecting escape tunnels.

Later explorations of Suribachi revealed that the mountain's interior had been excavated to accommodate a seven-story structure with plastered

walls, concrete blast revetments, and a sewer system. Fresh air, electricity, water, and steam were piped in. At one time, Suribachi's rooms and tunnels held 1,300 Japanese soldiers and 640 naval troops assigned to defend it.

After the war, Rosenthal and Lowery became closer friends. When they met, usually at gatherings of Iwo survivors, they had good things to say about one another. One of Lowery's prized mementos was a photo of the second flag raising autographed by Rosenthal: "To Lou Lowery, who got there first—a helluva Marine and a great guy, all the best from lucky Joe Rosenthal."

In 1960, when Lowery was forty-two years old and Rosenthal forty-eight, Lowery spoke up strongly on Rosenthal's behalf after scurrilous remarks about Joe's flag photo appeared in a play on NBC-TV's "Sunday Showcase." The play, titled "The American" and starring Lee Marvin, was a poorly scripted, badly researched life story of Ira Hayes, one of the flag raisers in Rosenthal's photo, who died in 1955 of chronic alcoholism. The story had Hayes saying bitterly: "They'd taken about 10,000 pictures that day. . . . Everybody knew it was a phony. Everybody on the island was laughing about that phony flag-raising picture."[5]

The next day in an Associated Press (AP) interview, Lowery said the Rosenthal photo was "definitely not a phony . . . and certainly not a posed picture."[6] The AP, also defending Rosenthal, issued a statement that there "was not the slightest foundation in fact for any suggestion that the picture was a phony."[7]

When Lowery died in 1987 at age seventy, Rosenthal attended his funeral at Quantico National Cemetery, Virginia.

Rosenthal is soft spoken and genuinely modest. Whenever he discusses his photo with friends or strangers, he lets others mention that the experts consider it a work of art. He always emphasizes how lucky he had been that day and that he just happened to click his shutter at the exact split second.

If someone mentions that there were four other photographers shooting pictures atop Mount Suribachi that memorable day and none of them achieved what he did, Rosenthal always makes pretty much the same quiet comment: "Yes, they were all there, but I was the luckiest." He is never impolite but always sensitive about other people's feelings. Sometimes, if there is an appropriate way to work it into the conversation, he offers a

correction to the statement that of the five cameramen "Joe was the only one who got the great shot."

"I wasn't the only one," he told me. "Another cameraman got the same picture, a cameraman who was later killed on the island. We made the steep climb to the crater together, and he was standing right beside me when the flag went up. He was Bill Genaust, a Marine sergeant with a movie camera—a very good photographer—and he duplicated my shot exactly in color on 16-mm Kodachrome. His film proved to all the skeptics that my photo wasn't a phony, wasn't posed."[8]

Rosenthal thought so much of Genaust that, in 1983, he wrote a letter to President Ronald Reagan. He asked the president to honor the memory of the man who, after making his historic flag movie, gave his life for his country. Rosenthal explained that previous requests for official recognition of Sergeant Genaust had failed. He added: "I pray you may see some way of correcting this oversight."[9]

The White House sent Rosenthal a brief reply signed by a secretary. It thanked him for his letter and added a few courteous words that meant nothing.

4

Heartbreak

It is heartbreak like no other. Only the person who has been through it knows how deep the pain is and that it never ends. Mothers, fathers, wives, daughters, sons, brothers, and sisters—the official designation for them is cold and unfeeling: *next of kin*.

The heartbreak begins with a knock or a ring at the door and the arrival of a telegram—a telegram that no one wants to read. During World War II, these telegrams were always delivered in person. Some were delivered by a man in a khaki Western Union uniform, who rode a bicycle because gasoline was rationed and others by a woman in civilian clothes or a youth too young to be in military service.

The telegram addressed to Adelaide Genaust in Minneapolis, Minnesota, arrived late in the afternoon of 25 April 1945, nearly two months after Bill was killed, but she was not told that. The War Department delayed notifying her because Bill's fate was unknown.

When I interviewed Adelaide in Florida after the passage of many years, she still remembered, distinctly, the pain and confusion of those first moments with the telegram. "I was young," she said, "and emotional and I loved my husband very, very much. All I could think was Bill, Bill, Bill . . ."[1]

As soon as she saw the pale yellow envelope, she knew what it was. "My heart stopped," she said. "Afterward I couldn't remember what I said to the elderly man who delivered it. Maybe I didn't say anything because of the shock. I think I closed the door without giving him a tip. And I felt guilty about that."

She told me that during the first moments she didn't want to open the envelope. Then she thought perhaps it wasn't the news she dreaded. Perhaps the telegram wasn't from the government. Or if it was, maybe Bill was all right and this was about something else. Maybe it didn't involve Bill at all.

She opened it, and the torn envelope dropped from her fingers to the floor. The telegram contained the message that she dreaded:

MRS ADELAIDE C GENAUST
5700 TWELFTH AVE SOUTH MPLS [MINNEAPOLIS]

DEEPLY REGRET TO INFORM YOU THAT YOUR HUSBAND SERGEANT WILLIAM H GENAUST USMC IS MISSING IN ACTION IN THE PERFORMANCE OF HIS DUTY AND SERVICE OF HIS COUNTRY. I REALIZE YOUR GREAT ANXIETY BUT DETAILS NOT AVAILABLE AND DELAY IN RECEIPT THEREOF MUST BE EXPECTED. TO PREVENT POSSIBLE AID TO OUR ENEMIES DO NOT DIVULGE THE NAME OF HIS SHIP OR STATION. LETTER FOLLOWS

A A VANDEGRIFT GENERAL USMC COMMANDANT OF THE MARINE CORPS

"I guess I was numb," she said. "My eyes couldn't focus on the paper, but I managed to read it again and concentrate on some of the words."

Talking about it forty years later, Adelaide said that was the worst afternoon of her life because the telegram left out more facts than it presented. *Missing in action.* What did it mean? Was Bill alive somewhere but unaccounted for? Was he hurt and suffering with pain from some kind of wound? Has he lost a leg or an eye?

"I didn't cry," she recalled. "Not then. I remember that my eyes were blurry with tears but I was able to read the words again. And again. The telegram said nothing about Bill being wounded. And I thanked the Good Lord because it said nothing about him being dead. . . ." She hesitated, remembering and thinking. "Back then, I couldn't face that word. I absolutely could not face it or even think it."

She remembered turning the telegram over and over in her hands—looking for more information, looking for something that would tell her where Bill was. As the minutes passed, slowly, she realized there was no mention of any place in the Pacific where Bill was and no mention of his outfit, the 4th Marine Division.

"I took hope," she said, "in what *missing in action* could mean. A lot of men who were missing were found later and turned out to be just fine. So I thought that maybe this news wasn't so bad after all. Maybe Bill would be one of the lucky ones. What was the old saying? 'Where there's hope, there's a way.' Or was it 'Where there's hope there's life'?"

When Adelaide and I talked, the year was 1983. We sat in her expensively furnished new apartment in Winter Park, Florida, a suburb of Orlando. By then, she had been widowed twice and her second husband, R. E. Dobbins, a successful businessman, had left her well off. She was seventy-five years old, a nicely plump, immaculate matron wearing a simple but fashionable white frock and dangling earrings that were just right for her. She had short, wavy hair, grayish blonde, and clear fair skin inherited from her Norwegian ancestors. She had few wrinkles, but her vision was poor because a broken blood vessel had destroyed the sight in one eye.

"The day of the telegram," she said, "seemed to last forever. For the longest time, I felt rotten and weak, and then, finally, the hopeful feeling began to come back and I made up my mind that I should think only about being hopeful. I had this strong feeling here [she touched her breast] that Bill was all right and I would hear from him before long."

Bill's widowed mother, Jessie, who lived with Bill and Adelaide, had been away for part of that day. She returned home soon after the telegram arrived, and Adelaide told her the bad news. After reading the telegram, Jessie Genaust wailed and burst into tears. The two women wept together and tried to console each other.

"I finally stopped," Adelaide said, "but Jessie couldn't, for the longest time. But finally she made some fresh coffee and the two of us were able to talk. We tried to look at the bright side, that before long we'd get another telegram or a letter saying Bill was all right."

Because of wartime censorship about troop movements, families were told not to speculate about where their men in the service might be stationed. "Signs were on walls everywhere," Adelaide said, "saying things

like 'Loose lips sink ships' and so forth. But, of course, we did talk a lot about where Bill might be, but we were careful to keep such talk in the family."

They were pretty sure that Bill was still somewhere out in the Pacific with the 4th Marine Division. "Mostly we were guessing," Adelaide said, "but Jessie had a friend who worked for the Red Cross downtown and who quite often picked up the latest scuttlebutt. Only the day before, her friend had heard a tidbit that the 4th was one of the divisions at Iwo Jima."

When Adelaide heard that, she turned pale and didn't want to hear anything more. In February and March, the Minneapolis newspapers had been full of black headlines about the Marines' terrible bloodbath at Iwo Jima. But Jessie said they shouldn't worry about that because the battle for Iwo had ended over a month before and if Bill was there he must've gotten through okay.

"If I know my boy Bill," Jessie said, "and I do, very well, he's plenty smart and can take care of himself, no matter what's happening."

(Jessie was 99.9 percent right about her son. Under normal circumstances, Bill was not error-prone. But, on Iwo, he had made that terrible mistake with his flashlight.)

Adelaide was not satisfied with rumors and guesses. She mentioned something else to Jessie that troubled her. The battle for Okinawa had started on Easter Sunday, 1 April, more than three weeks previously. It was said to be a bigger and bloodier battle than Iwo Jima and involved both Marine and Army divisions.

"I read that the casualties are just awful," Adelaide told Jessie.

"Don't worry about it," said Jessie confidently. "My Red Cross friend has heard all the talk about Okinawa and is absolutely sure the 4th isn't there."

A few days later, Adelaide received the letter that was promised in General Vandegrift's telegram. Signed by Maj. D. Routh, USMC, Headquarters Marine Corps, Washington, D.C., it was written on 26 April 1945, the day after the telegram was sent:

Dear Mrs. Genaust,

It is with regret that I confirm the telegram sent you on 25 April 1945, regarding your husband, Sergeant William Homer Genaust, United States Marine Corps. The only available information shows that he has been missing in action since 3 March 1945[2] while serving at Iwo Jima, Volcano Islands.

The Commandant of the Marine Corps directs me to convey to you his sincere sympathy in your anxiety. Everything humanly possible is being done to learn the fate and whereabouts of your husband. Please be assured that when additional information is received concerning him it will be sent to you promptly.

Adelaide looked away from me and stared for a few moments at a large painting of the Florida Everglades on the wall.

"That was another terrible day," she said, her voice almost a whisper. "As bad as the day of the telegram. The two words that stung my eyes and made the tears come were Iwo Jima. The terrible, terrible tiny little island where the newspapers said so many thousands of Marines were killed. And the letter said that Bill had been missing for weeks, ever since the third of March."

During the days and weeks that followed, Adelaide waited every day for the mail. Most nights, sick with worry, she couldn't sleep. One day, she received an envelope from the Navy containing several letters that Bill had written months before, in early February. The letters were the same as always, no news about where he had been or where he would be going next.

The letters expressed no worry about the future and usually concluded with how much he missed her and loved her, and reminding her of all the wonderful things they would do together after the war. One letter was the exception. For the first time, Adelaide detected a note of depression. The letter wasn't positive about the future. Instead of saying, "When I get back," Bill wrote: "*If* I get back. . . ."

She received two more of Bill's letters written in late January and early February, several weeks before the invasion of Iwo Jima.

Late in May, another letter came from Washington, and it was signed by Commandant Vandegrift. It was the worst of all possible letters. It was the letter that Adelaide had dreaded above all others, the letter she knew might come some day, the letter she prayed and prayed would never come.

Throughout the interview, Adelaide had been in a good mood. She had answered my questions calmly, but now, as she remembered the crushing effect of the general's letter, her voice broke and the tears came. When she regained control, she asked if we could talk about something else.

"Something not so sad," she said. " I've saved all the official correspondence from Washington, dozens of letters, including the Number One general's, and I'll get it all out for you. But right now can't we talk about

something different, like the happy days when Bill and I were young?"

"Of course," I said. "Let's go way back to the early times, where you and Bill were born and how you first met. Okay?"

Her blue eyes and her mood immediately brightened. She told me that Bill was born in Pipestone, Minnesota, in 1907, and she was born in 1908 in Ringsted, western Iowa, and went to school in Bricelyn, Minnesota. Bill went to school in Pipestone and Chicago.

"Eventually," she said, "our families moved to Minneapolis and that's where we met. We were both living with roommates in what was called a fourplex—an apartment building. I was nineteen and a career girl working in an office. Bill was a year older, attending the University of Minnesota, and he was so tall and good-looking, so polite and so quiet that we took to one another right off. Those were the fun days of 1926 and 1927, carefree and exciting. I was sure, after we got married, that our whole life together would be like that. And it was. We lived in our own brick house, cozy in the cold winters, and our life together was absolutely wonderful. For seventeen wonderful years. Until the war—"

Adelaide felt so much better that she was willing to go to a closet and find the suitcase that contained all the letters she had carefully saved for forty years. Bill's were wartime V-mail (the V stood for victory) letters written on tissue-thin paper. Many of the letters from Headquarters Marine Corps in Washington were still in their official letter-sized brown envelopes.

Because she was a trained office worker, Adelaide had filed the letters by date, and she had no difficulty locating the one from the commandant, General Vandegrift, the letter that broke her heart. It was dated 23 May 1945, nearly three months after Bill was killed:

Dear Mrs. Genaust:

It is a source of profound regret to me and to his comrades in the Marine Corps that your husband, Sergeant William Homer Genaust, lost his life in action against the enemies of his country and I wish to express my deepest sympathy to you and members of your family in your great loss.

There is little I can say to lessen your grief but it is my earnest hope that the knowledge of your husband's splendid record in the service, and the thought that he nobly gave his life in the performance of his duty, may in some measure comfort you in this sad hour.

Adelaide told me that after she read the general's letter she could not stop crying. "I cried," she said, "until I was all cried out and my throat and ears hurt. I didn't talk to anybody that day. Not to Jessie, who stayed in her room. Nor did I talk to Bill's older brother, Frank, when he came over to visit his mother."

The pain was never-ending. The following month, in June 1945, another letter came, and it hurt Adelaide the most.

"It was from Bill," she said. "It had gone astray and was weeks late. It was one of the most cheerful letters he ever wrote. It was censored, with parts blacked out, but they let him say he was writing it on Iwo Jima during the fighting. He'd made up his mind that after the war he would go back to the university, but not to study dentistry. He wrote that he wanted to go into real medicine and become a family doctor. He wanted to spend the rest of his life doing all he could to help the sick and dying, to take away their pain and suffering."

At the end of the letter, Bill was optimistic. He wrote: "Honey, this has been a horrendous experience, but things are looking up and for the first time since I've been here I feel I'll be coming back."

On that day, Adelaide couldn't cry any more. Her heart was filled with bitterness.

"Everything was gone," she said. "Our lives together were gone. I couldn't stand it. I hated that letter. I hated it so much I tore it to shreds, and I put the shreds down the toilet."

It was an act of bitterness that Adelaide Genaust would regret for the rest of her life. The next day, she realized that it was one of Bill's finest, most beautifully written letters.

"I didn't know it that day or the next," she said, "but it was Bill's last letter. I never received another one from him."

5

He Never Knew

Sgt. Bill Genaust died without ever knowing that his flag-raising film would become a classic of movie making and be copied and analyzed by art critics and art scholars throughout the world. It's possible that Genaust thought that he had missed most of the flag-raising scene because he ran out of film before it was over. The movie strip was short, only 198 frames, but he had captured the entire scene before his camera quit. The strip ends with the iron pipe straight up and the Stars and Stripes flying triumphantly.

During the 1940s, the processing of Kodachrome color movie film was slow, far more slow than processing the work of still photographers. Consequently, Genaust's strip was not viewed until weeks after the Rosenthal photo was page-one news. By that time, the death toll on Iwo Jima[1] was so high that the Marine Corps was being lambasted in black-bordered editorials on the front pages of newspapers.

The Hearst papers, then the country's largest newspaper chain and the most vehement in their accusations, accused the Corps of killing too many men on Iwo. Hearst editorials demanded that Gen. Douglas MacArthur be given command of the Pacific war because, under his leadership, important islands had been captured by the Army with far less casualties.

Marine Corps headquarters was swamped with letters and telegrams from outraged families of Iwo victims that said many of them had died needlessly. The correspondence tended to echo the emotional Hearst cry that MacArthur's campaigns were better planned and less bloody.

Suddenly, the Corps discovered that even the favorable publicity from the Rosenthal photo had a backlash. When correspondents revealed that half of the flag raisers had been killed, more letters of condemnation came in. The Corps was attacked so bitterly that it dodged more bad publicity by keeping secret until May that a fourth man (Sergeant Genaust) involved in the flag raising had been killed. By that time, the battle for Iwo was over and the Marines were praised and honored for their victory. The low-key disclosure of Sergeant Genaust's death created no bad reaction from the press or Iwo victims' families.

Nor was there any reaction to the death of a fifth man, one who had been significantly involved in the flag raising. This was Colonel Johnson, commander of the 2d Battalion. If he had not ordered a second flag to be raised, there never would have been a Rosenthal photo or a Genaust movie and the Corps never would have acquired its best recruiting tools. By chance, the media missed entirely the angle that Johnson was the fifth man associated with the Rosenthal/Genaust flag pictures to die. The Corps was careful not to correct the oversight.

Another grim statistic was also overlooked. Not one of the seventy topflight journalists covering the campaign and sending off thousands of dispatches discovered the fact that eight of the seventeen men directly involved in the raising of the two flags were later killed in action. They were Sergeant Thomas, Sergeant Hansen, and Private Charlo, who raised the first flag; Sergeant Strank, Corporal Block, and Private First Class Sousley, who raised the second flag; Colonel Johnson; and Sergeant Genaust.

Only the *Washington* (D.C.) *Daily News* did a big spread on the death of Genaust. On 22 May 1945, it published four action photos taken from his movie of the second flag raising, along with a large picture of Genaust snapped on Iwo by his friend, Bob Campbell. The photo showed an exhausted, unshaven Genaust resting on a slope and smoking a cigarette. His face was dirty and deeply lined; the expression in his eyes was that of a man who had been through hell. A few days after the picture was taken, Genaust was dead.

Reporters on Iwo had repeatedly filed eyewitness accounts of Marines being slaughtered day after day, week after week. The nation's reaction was so negative that Marine Corps headquarters withheld all additional news of heavy losses and emphasized instead the courage and heroism of individual Marines.

Twenty-two Marines and five Navy personnel were awarded the Medal of Honor, the nation's highest decoration, for a total of twenty-seven Medals of Honor awarded for heroism on Iwo Jima. This was a remarkably high proportion of all those who received the award. During the nearly four years of U.S. participation in World War II, with millions of Americans fighting in Europe, Africa, the Pacific, and elsewhere, a total of only 353 men were awarded the Medal of Honor.

After the Iwo battle ended, the Corps delayed announcing the toll of dead and wounded. By the time it released what it called the "final figures" (later revised sharply upward), the war in Europe was over, and the battle for the island of Okinawa was dominating the news. Iwo Jima follow-up stories were pushed to the back pages.

In 1950, the official final figure of Iwo casualties totaled 20,979. The total was increased to 24,891 in 1954. The official total was increased again in 1980 to 28,686 and has remained unchanged (see chapter 7).

The war on Okinawa, which lasted three months, was the bloodiest of all the battles in the Pacific. The combined U.S. Army and Marine Corps casualties were 47,000—12,000 killed and 35,000 wounded. Approximately 100,000 Japanese were killed. The island of Okinawa, only 325 miles from the Japanese homeland, is seventy miles long and about seven miles wide, fifteen times larger than Iwo Jima.

After peace was declared in Europe in May 1945, the nation concentrated on news about the transfer of thousands of troops from Europe to the war in the Pacific. Military analysts predicted that the invasion of Japan would produce the worst casualties of World War II. The projected tolls were so shockingly high that the Iwo Jima death toll began to look small, and somehow even reasonable.

Sunday, 4 March 1945, was chilly. The sun hid behind the clouds shrouding Iwo Jima that morning. From time to time, a cold winter rain fell. Visibility was so poor that flight commanders canceled air strikes and Marine officers scratched artillery schedules. Battleships and

cruisers, invisible offshore in heavy mists, postponed their gunfire because of the danger of hitting Marines at the front lines.[2]

This was the day when a disabled B-29 first landed on the island's largest airstrip after a bomb run over the Japanese homeland. During the ferocious battle for Iwo Jima, the airstrip's hard-packed volcanic earth had been blasted into rubble and craters, but energetic Seabees had now restored and smoothed it.

The huge bomber, with the appropriate name of Dinah Might, came through the dark overcast and landed safely. This was the first of 2,251 emergency landings made by damaged or malfunctioning B-29s on Iwo Jima during the next five months that resulted in saving the lives of an estimated 24,751 airmen.[3]

If the morning had been clear and sunny, Bill Genaust would have spent the day shooting movies of combat scenes. Because of the rain and mist, however, photography was impossible with his slow color film, ASA 8, so he ventured into an enemy cave.[4]

Genaust was a religious man but seldom attended Sunday church services conducted by the Navy chaplains. During the intermittent rain, he joined the men of the 28th Regiment at the front line in the vicinity of Nishi Ridge and Hill 362A. He had spent a lot of time with the men of the 2d Battalion and knew many of them by name. The battalion was now commanded by Maj. Thomas Pearce, who had taken over the day before after Johnson was killed.

For most of the morning, Genaust functioned as a rifleman and grenade-thrower. He had his Bell & Howell camera in his heavy rucksack, along with grenades, a two-cell flashlight, rifle ammo, extra cans of film, and cans of C-rations. Although Nishi Ridge and Hill 362A were now U.S. Marine territory, there was a lot of mopping up to do and Bill joined in. He was armed with his 30-caliber carbine, and his .45 pistol was holstered on his hip.

The troops passed many cave entrances that had been earlier attacked or bypassed. Some had been sealed over with rocks by bulldozers. The Marines threw grenades into the caves that were still open. If an entrance was small and dark, the men had to get down on their knees to make accurate throws. At large entrances, they threw in half a dozen grenades to make sure that any Japanese in the caves were wiped out.

Around noon, the misty drizzle turned into a heavy downpour. Bill and another Marine spotted an open cave and decided to get in out of the wet.

Before they went in, they checked with several nearby Marines to find out if the cave had been secured.

Exactly what happened after that was never clear. Men who were questioned later told slightly different stories. One man said that Bill and his companion threw three or four grenades into the cave before entering. Another said that they threw no grenades but were assured that the cave had been attacked and cleared earlier that morning by squads from the 2d Battalion. According to a third account, some of the Marines were not sure that the cave was secure. One asked if anybody had a flashlight. Bill said yes and volunteered to go in and look around. He and another Marine went in first.

As soon as Bill switched on his flashlight, hidden Japanese opened fire. Both men turned to run and were shot. Marines looking in from the cave entrance said both were shot in the back, riddled by perhaps a dozen enemy rifles, and died instantly. Neither body was recovered. Five minutes later, a Marine with a flamethrower incinerated the entrance.

An armored bulldozer finished the job, its steel blade shoving and heaping tons of rocks and earth until the entrance was closed tight. After that, the sealed cave looked like dozens of others. Its exact location was not recorded. Men who were interviewed weeks later, including Joe Rosenthal, said the cave was on the north bluffs of Hill 362A.

Very likely, the men who secured the cave earlier in the day did not go far enough in to determine whether the cave connected at the rear with tunnels that allowed enemy soldiers to move in and out at will. On its steep north sides, many of Hill 362A's systems of tunnels had been burrowed upward to chambers and then continued farther up to the flat tablelike top where big guns were located.

Among the many Marines who admired Bill Genaust was his friend and former commanding officer, Lt. Col. Donald L. Dickson. In June, three months after Bill died, Dickson devoted hours to composing a five-page letter to Bill's widow. It was one of many letters that Adelaide received from men who knew and liked Bill, but she thought it the best. The letter from Dickson was the only one that contained the details of how her husband died. It was written in firm, easy-to-read longhand.

Dear Mrs. Genaust:

Your letter of 7 May has been forwarded to me here at my new station. Please let me begin by telling you a little of how I feel about your

husband. Sgt. Bill Genaust was one of the finest men it has ever been my privilege to serve with. He was quiet, industrious and very courageous. I know how devoted he was to you because he told me about you several times. Bill was the kind of man who represents the very best in the Marine Corps. When I first heard he had become a casualty, it hit me harder personally than any of the other fine men I had lost. I had great confidence in Bill and I think he felt that. He never once let me down or did anything to lessen my feeling of his competence.

When we first hit Saipan in the Marianas in 1944, Bill was on the beach early. It was rough because the Japs were throwing shells on that beach from every mortar within range. Several of these mortar shells landed near Bill and the concussion shocked him. We told him to remain at the rest center in Saipan's town of Charan Kanoa until I could arrange transportation for him back to Pearl Harbor.

However, in a day or two Bill announced that he was completely recovered, took his camera and rejoined his outfit. My opinion of him went up even higher.

I imagine he has told you about how he was wounded on Saipan. Let me give you the story as I have pieced it together from witnesses.

Bill and a Marine photographer named Howard McClue, plus a scout from the Fourth Division, were returning from Marpi Point on Saipan, a day or so before the island was announced "secure." They had completed their mission and were returning to deliver their negatives and receive fresh film.

While still in the forward area, and very late in the afternoon, they were attacked by about twenty Japs. Bill told me that at first he thought it was our own men who were charging them thinking Bill's party was Japs. They called out to stop shooting, that they were Marines, but then they discovered the attackers were Japs.

The three Marines took up positions behind a sugar cane railway embankment and opened fire on the charging Japs. By the time the Japs had come within a hundred yards of the three Marines, the attack was broken up and the remaining Japs took cover behind rocks, where they began a sniping duel.

Unknown to Bill or McClue, the scout withdrew to get help from a nearby Marine unit. McClue also withdrew, gathered about twenty Marines and returned to the scene about an hour later. In the meantime, Bill remained and continued the fight. We counted nine Jap bodies later. When I asked Bill why he remained there fighting, and if escape were possible for him, he answered in true Marine spirit. "Yes, I could have retreated through the canefield behind me, but when I yelled to the oth-

er two I got no answer. I thought they might have been hurt so I stayed to make sure the Japs didn't get them."

When McClue returned after an hour, it was pretty dark and he brought his Marines out of the canefield too far down. Bill jumped up and yelled to them. At that moment, a Jap rifleman put a bullet through the fleshy part of Bill's thigh. A hospital corpsman came up through the canefield, gave Bill first aid and helped him back to the aid station. Some time that night, probably near morning, McClue was shot through the heart while he was apparently searching for Bill.

Bill's wound was neither complicated or serious and a few days later he reported back from the field hospital to me. He limped a bit because he said his leg was stiff, but otherwise he felt fine and told me he was ready to return to duty.

We had the Tinian invasion operation coming up in about a week and I badly needed photographers, but I told Bill to take it easy, I was sending him back to Pearl Harbor. He left by air a few days later.

I immediately wrote up a recommendation for a Navy Cross for Bill and McClue, the Navy's second highest decoration, and asked the division to which they were attached to forward it through official channels. When I returned to Pearl Harbor after the Tinian show, I again submitted these recommendations. To date I have heard no results.

I won't bore you with the details, but my responsibility to the photographers of my unit was rather unusual. I could order my public relation personnel here and there, but with photo personnel it was different and required a bit of red tape.

I had made up my mind that I would send Bill back to the States for a rest and had started the ball rolling for his transfer when I, myself, was ordered back on completion of my second tour of duty. I personally asked my relief to carry out Bill's transfer, but something unexpected must have turned up after I left, because Bill was assigned to the Iwo Jima operation.

Mrs. Genaust, I know you only from what Bill has told me. However, if you are like Bill I think you want all the facts I can give you concerning him. These things are very difficult for me to write but I will try to tell you what I know happened to Bill.

From two photographers who were at Iwo, I received this information. I believe it myself and I give it to you as I heard it.

Bill is not a prisoner. He has given his most valued possession to his country—his life. He went to his God like the real man and Marine he was. If it must happen to me, I would want to go the same way.

As I understand it, a group of Marines were clearing caves of diehard Japs. Grenades were thrown in one cave and it was believed all the enemy were killed. The Marines wanted to doublecheck and asked Bill if they could borrow his flashlight. Bill said he would go in with them. They crawled in and Bill flashed his light around. There were many Japs still alive and they immediately opened fire. Bill dropped without a sound. As the bearer of the light, he had been the target for a number of bullets. I feel sure he never knew what hit him

The Marines forced the Japs deeper into the cave, but could not get them out. More men would have been killed in carrying out of the narrow cave Bill's lifeless body.

TNT charges were quickly planted at the cave mouth and exploded. The whole cave mouth was blocked with earth from the explosion and Bill's body was completely buried by it. [This part of the colonel's letter is contradicted by Marines at the scene who said the entrance was bull-dozed shut.]

That is why Bill has been carried as "missing in action." There is an iron-bound rule that the body must be recovered and identified before a man is reported "killed in action." So until the cave is excavated and Bill's body recovered, he will be carried as "missing in action."

General Denig informs me that a *movie* of the flag-raising on Mount Suribachi was taken by Bill. You may have seen it in the newsreels. Bill must have been standing beside Joe Rosenthal when Joe made his famous still picture of the flag-raising which is so widely used as a poster for the Seventh War Loan Drive. Bill got movies of the same event, and when I look at the picture I will always think of Sergeant Bill Genaust and be proud that he was one of my boys.

Inadequate as it is during times like these, I offer my deepest sympathy to you and the rest of Bill's family. The world and the Marine Corps has lost a fine, courageous man. I have lost a friend.

Please feel free to call upon me for anything in which I can help you. I shall, of course, send on to you any further information concerning Bill that I receive.

May Bill's courage and character be a source of strength to you at this time.

Sincerely,
Donald L. Dickson
Lt. Col. USMC[5]

6

The Most
Difficult Letter

About six weeks before he was killed, Bill Genaust had written a letter of sympathy to the widow of his closest Marine friend, Howard McClue. Ironically, the words he put down so carefully were much like the feelings in the letter that Colonel Dickson would write a few months later to Bill's widow.

That these two letters were written so close together was not strange. During the war, multitudes of such letters, always difficult to compose, were written by commanding officers. More multitudes were written by soldiers, sailors, Marines, and airmen from all of the nations embroiled in the war to the families of their dear and loyal friends lost in battle.

Even greater multitudes of such letters were never written. Men tried, or thought about trying, to write them, but they could never find the words. Many felt guilty about their failure ever after. That is one of the subtle aspects of war never recorded by the historians. In its own way, it is as cruel to the emotions as are all the barbaric acts of war.

Bill Genaust thought about his letter for eight months before he felt ready to write it. He was a perfectionist. He was also a serious reader. After he left the University of Minnesota, he continued to read for hours every night, usually American and European history, English literature,

and Greek philosophy. His letter to Mrs. McClue reflected some of those interests. It also told a lot about Bill himself, about his deepest feelings and his strong character. Although a man of few words in casual conversation, he loved the written word. With it, he could express feelings that otherwise remained locked inside.

Of all the men with whom Bill served throughout the war, Howard Mc-Clue was his best and most trusted friend. They had trained together as photographers in U.S. Marine photo schools and were assigned to the same photo unit in the 4th Division. On Saipan during the summer of 1944, they had shared danger together, day and night. One of the Marine Corps' worst island battles, the war on Saipan had cost the lives of three thousand Marines and soldiers, and another ten thousand had been wounded.

In his letter, Bill gave Mrs. McClue many details about Howard's death that were not contained in the official Marine Corps correspondence to her. Bill did not mention that he had received the Bronze Star for Valor on Saipan, nor did he place any importance on his wound received during the battle that cost his friend's life.

Bill's letter, with part of one sentence cut out by a Marine Corps censor, was written "somewhere in the Central Pacific." It was dated 25 January 1945, less than a month before he went ashore on Iwo Jima with the invasion forces.

Dear Mrs. McClue:

I have tried a number of times to write to you before now, but seeing how inadequately my words expressed my thoughts I have given up and put it off until later. I [censored]—so I'll send this no matter how it sounds.

You probably know that Howard shipped out with me and that we were in very close contact from the time we left Quantico until his death on Saipan. We worked, ate and slept together through the whole miserable campaign and his passing has taken something from me which can never be regained.

I read your letter to Bob Swain in which you expressed regret at the fact that Howard received none of your last letters. You will be glad to know that some mail was delivered to him on Saipan and that he did hear from you around the first of July. He also wrote you about the same time; I hope that his letter got through to you.

Sunday morning, July 9, 1944, was warm and bright. I awoke first and built a small fire and made coffee. After Howard got up and had

morning chow, he attended divine service while I checked over my gear. We left the command post early and, with Bob McNally, made our way up to the line in time to join the advance which was to wipe out all organized resistance on the island.

Noon found us on Marpi airstrip, where our regiment ran up our colors. We advanced around the end of the island to join the forces which were driving up the other side to meet us. We three were out in front and made the first contact with the other division, a tank which had advanced in front of their infantry. The tank driver asked for some riflemen to go back with him to clean out about a dozen Japs from some buildings he had just passed. We had slung our cameras and were using our rifles, so we took the job.

As the tank turned around to start back, it ran over a land mine and was put out of action, so we went on alone. We found and killed ten or twelve Jap soldiers who were hiding in the houses. Soon the other infantry came up and the action seemed over.

We started back to our our C.P. around 1600 (4 P.M.), to turn in our film and get a little rest. It was on our way back that we were attacked by a group of about fifteen Jap soldiers who fired on us from a distance of about two hundred yards and then charged us in one of their Banzai rushes.

We hit the deck and sought what cover we could—Howard on my right and McNally on my left. We knocked down several of them on their way down the slope and the rest of them sought shelter and firing positions behind some rocks about fifty or seventy-five yards in front of us. I was so busy for a while that I didn't notice the withdrawal of either Howard or McNally. McNally had run out of ammunition and Howard had gone to get help for us.

In about thirty or forty-five minutes, I saw Howard coming in on the right, leading a group of Marines he had picked up further back. When I saw help arriving, I stood up and moved forward, directing the group toward the Jap position. Howard called over and asked if I was all right. When I answered okay, he gave me the "on the beam" signal and we both moved forward. I had taken but a few steps when I was hit with a rifle bullet, fired from another Jap position on the cliff that overlooked the area. Howard again called over when he saw me go down, asking if I was hit bad. When I answered no, he went on.

We were getting heavy fire from the cliffs and I had to seek cover again. When I was situated and looked out again, everyone had hit the deck and started to withdraw. We were in the open and there were no visible targets so a withdrawal was the only possible action.

I did not see Howard again. He had been hit during the time I was taking cover. I was evacuated from the area at dusk by a Navy corpsman and a Marine who had worked their way up through a canefield from the rear. It was two days later that news of Howard's death reached me.

Painful as it is to mention, I wish you to know that he died quickly and cleanly—one bullet through the heart. He was found the next morning by a search party organized to look for us. A truck was commandeered by Sergeant Harrold Weinberger, our chief of section, and Howard was taken down to the Fourth Division Cemetery where he was laid to rest with full military honors in the presence of his sorrowing friends and buddies.

His grave is near the shore where we first set foot almost a month before. It is a beautiful spot and time will soon erase the scars of war as I hope it will ease the pain in your heart.

Please feel free to write me, and if there is anything more I can tell you, I shall be very happy to answer your questions.

In closing, I wish to quote a few words written by Shakespeare and which were contained in Winston Churchill's letter to Harry Hopkins on the death of Hopkins's son in the Marine Corps:

> Your son, my lord, has paid a soldier's debt:
> He only lived but till he was a man;
> The which no sooner had his prowess confirmed
> In the shrinking station where he fought,
> But like a man he died.

> Sincerely,
> [Signed] Bill Genaust
> Sergeant William H. Genaust,
> U.S.M.C.[1]

No matter how bad things got on Iwo Jima and Saipan, no Marine ever saw Bill Genaust cry. In battle, he was the strong silent type who kept his emotions in check. Only his wife Adelaide ever saw him cry—and it happened only once. During the Depression in the mid-1930s, good jobs were hard to get. Bill was in his late twenties when he finally landed a pretty good job at the Ford Motor Company factory in Saint Paul. His first day was rough because his boss put him on the car assembly line where there was too much pressure. Bill had never done such work before and couldn't keep up.

Immortal Images

During our conversations years later, Adelaide told me how Bill looked when he came home from the factory that first night.[2] "He was still shook," she said, "and he broke down and cried. He just wasn't the type to be on the line. So I told him, 'Honey, please don't cry. There'll be other jobs.'"

Adelaide was right. When Bill went back the next day, the supervisors lined up all the new employees and told those with university training to form a separate line.

"Bill got into that line awful fast," Adelaide said, "He'd taken training in stenography in high school and he always liked to type, so they put him in an office and made him a stenographer. It turned out just fine because he was a whiz at that kind of work."

Bill and Adelaide were married in 1928 when he was twenty-one years old and she was twenty. "From the very beginning of our marriage," she said, "he had photography in the back of his mind. He subscribed to everything, and we saved money for his equipment. He had a real flair for taking pictures and even built a tiny darkroom in our apartment."

He made extra money by taking photos of friends' weddings and babies. When he showed some of his pictures to the executives at the Ford plant, they made him their official cameraman. They gave him a new title, stenographer-photographer, and a pay raise. Bill took group photos of employees, as well as thousands of individual identification photos for the factory's personnel files.

Adelaide had a good job with the Internal Revenue Service in Minneapolis. With their two salaries, they saved enough money to build a red brick house that they designed. It was on a corner lot and had five rooms, including a big darkroom with running water.

They talked about having children, but Adelaide was reluctant to give up her job. She and Bill agreed to postpone their family. When war broke out in Europe in 1939 and Bill registered for the draft, he was thirty-two years old.

"After Pearl Harbor," Adelaide said, "it looked like Bill would be drafted into the Army. He hated the idea and kept saying 'No Army, no way! That old biddy isn't going to get me!'—meaning the woman who ran the draft board. He was real upset with her."

When I asked if Bill volunteered for the Marine Corps, Adelaide said proudly: "He certainly did—and I'm the one who did it for him. He was sound asleep one night, but I was still up and had the radio on. The an-

nouncer said the Marine Corps was looking for combat photographers. So I woke Bill up and we both got so excited! The next morning, he was up at dawn, went down to the Marine recruit office, and signed up."

For a few moments, Adelaide was silent and thoughtful. She sighed. "Yes, I'm the one who did it. Even though it all turned out the way it did, so sad in the end, I'm glad I did it—because joining the Marines and being a photographer made Bill so happy!"

7

The Strangest Battle
of the Century

Hill 362A was a terrifying example of what the U.S. Marines were up against after they captured Mount Suribachi and slowly moved northeast across the island. Genaust accompanied the troops and filmed them as they were forced to fight, inch by inch and foot by foot, through an incredible jungle of stone. The terrain had been exploded into heaps of broken rock, sheer high cliffs, and chopped-up rocky gorges. Included in the roaring barrages were monstrous one-ton shells from battleships offshore, five-hundred–pound bombs from the sky, and ground-based Marine 75-, 105-, and 155-mm artillery.

Tens of thousands of tons of high explosives merely made the enemy's ears ring. Hidden underground, the Japanese regiments suffered negligible casualties. But, if an observer happened to poke his head up at the wrong moment, it was blown off.

Because the island was so tiny and because of the way the enemy stayed below the surface in caves and networks of tunnels, the battle of Iwo Jima was a strange battle. It differed from all other battles of World War II, as well as the battles of World War I, the Korean War, and the Vietnam War. It was fought by more than 75,000 Marines aboveground and an estimated 23,000 Japanese soldiers and sailors underground.

The Japanese learned to stay underground. Whenever they dared to fight in the open on the surface, sometimes in company or battalion strength, the Marines wiped them out with their superior firepower and leadership.

Although the Japanese were largely invisible, they could be heard at times when the sounds of battle diminished, usually at night. Marines in their foxholes heard the Japanese chattering and singing in the tunnels just below them. Sometimes, they heard the clangs and thuds of shovels and picks striking rocks. One Marine swore that he heard the hiss of a teakettle as the enemy brewed tea.

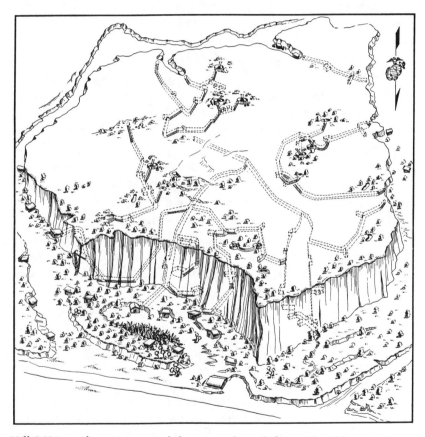

Hill 362A, with a view toward the top and north face. Dotted lines indicate underground Japanese construction and tunnels. (Sketch by 31st Construction Battalion, U.S. Navy)

Resembling a misshapen avocado, with Suribachi at the stem, Iwo Jima was the tiniest island ever to sustain such large fighting forces. Because of its size, Iwo was easier than other islands to fortify. Work on the underground fortifications had been started years before World War II, and it was greatly accelerated after Lt. Gen. Tadamichi Kuribayashi became island commander in June 1944. When the Marines invaded, Iwo was nearly the equivalent of a huge, thick-walled concrete blockhouse. A cellar consisting of networks of tunnels, three to five stories deep in places, extended throughout the island in all directions.

The Japanese defenses bristled with hundreds of cannon, some of which could be drawn back into caves or tunnels on rails during American barrages of artillery shells, falling bombs, or naval gunfire. The Japanese weaponry ranged from long-barreled 8-inch shore guns that sank or damaged eighteen U.S. warships to field artillery, anti-aircraft guns, heavy and light machine guns, 90-mm mortars (versus the Marines' 81-mm), rockets, and monstrous 320-mm spigot mortars that sounded like steam engines flying overhead.

Iwo Jima was the only battle in U.S Marine history in which an amphibious landing force suffered more casualties than the enemy.[1] The Japanese had planned it that way. The defenses were designed by General Kuribayashi himself. He exhorted his troops to inflict ten Marine casualties for each Japanese casualty, but they did not come close to that goal. Total American casualties of 28,686[2] were estimated to be 6,000 to 7,000 more than Japanese casualties, although the latter were impossible to measure accurately. The majority of the Japanese perished underground in tunnels and caves. An estimated total of 21,000 to 22,000 Japanese were slain or committed suicide. Many were destroyed by flamethrowers or demolition charges or sealed alive in the tunnels by Marine bulldozers and tanks. Because Kuribayashi demanded that his men follow the samurai code and fight to the death, only about 1,100 surrendered or were captured. Many who surrendered were Korean labor troops who had been conscripted by the Japanese.

Back in Washington, ailing President Franklin D. Roosevelt, who would suffer a fatal brain hemorrhage two months later, shuddered when an aide handed him a sheet listing U.S. casualties for the first three days of fighting: 4,574 men killed and wounded, a figure far higher than had been predicted.

The 4th Marine Division lost 2,517 men killed or wounded during the brutal D-day landings and in the push to take the largest airstrip, Motoyama No. 2. The 5th Division lost 2,057 men killed or wounded on the beaches and in the fight to capture Mount Suribachi.[3]

The president shuddered again when the Joint Chiefs of Staff told him that capturing the rest of the flyspeck island would result in an even higher and bloodier toll. When Roosevelt reminded them that they had predicted the battle would be short, they refused to admit that any mistakes had been made. The Joint Chiefs insisted that they had followed the book. They explained that the island had been bombarded for months before the invasion by hordes of bombers and a fleet of warships. They told Roosevelt, with regrets, that because the planes and ships were desperately needed elsewhere in the Pacific, it had been necessary to reduce the preinvasion bombardment from ten days to three.[4]

Howlin' Mad Smith, the elderly, cigar-chewing commander of the Marine forces, had pleaded until the final moments for the promised ten days of bombardment. General Smith cursed and wept when his pleas were rebuffed by Adm. Raymond A. Spruance, Nimitz's righthand man, because he knew the reduction would cost the lives of many Marines.

The old man's predictions came true when men died by the hundreds on D-day because the defenders and their weapons were largely intact. But, there was another factor. Months later, when studies by military analysts were summarized, Howlin' Mad was amazed, as were his superiors, by how few casualties were inflicted on the Japanese during the months of bombardment. Reluctantly, he admitted that even ten days of bombardment just prior to the invasion would not have helped.[5]

Iwo was also a strange battleground. None of the invaders, whether of high or low rank, was immune to death. Because of the island's size, Japanese mortar rounds could rain down on any part. Even when they were taking pictures two or three miles behind the front lines, Genaust and other photographers were in danger from sudden mortar rounds.

During the days of fighting for Hill 362A, Genaust told his fellow photographer, Bob Campbell, that one morning he had seen a mortar round kill two advancing Marines only a dozen feet away. "No warning," Genaust said. "A sudden bang, their helmets flew up in the air—and they were gone."[6]

Campbell, who shot many classic photos of Marines in action and who survived everything that Iwo threw at him for the entire battle, had simi-

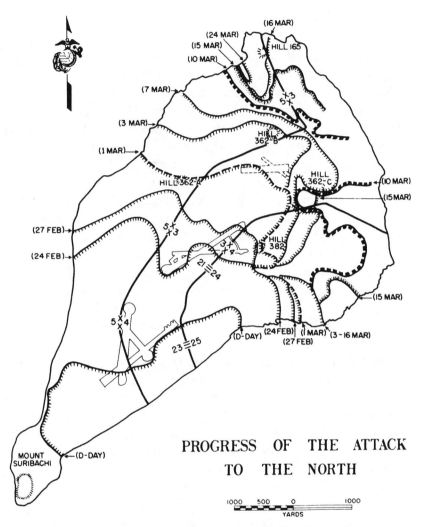

Progress of attacks to the north on Iwo Jima, February–March 1945. (U.S. Marine Corps map)

lar stories to tell. One day, he showed Genaust a hole burned into his brown-and-beige cloth helmet cover by a hot mortar fragment. The next day, Campbell showed him a second hole ripped into the cover by another chunk of metal.

"You know, Bill," Campbell said wryly, "I think a fellow can get more than a scratch around here."

A Marine down in a foxhole was generally safer from rifle or machine-gun fire, but a mortar shell could fall on him and blow him to bits. As they walked along, or sometimes ran in a crouch for cover, Genaust and Campbell developed the habit of not looking down into empty foxholes unless they knew burial details had been there and cleaned up the remains.

After the war, when Campbell and I both returned to our jobs on the *San Francisco Chronicle,* we rarely talked about the horrors that we had seen on the island. One day, however, when we were on assignment with an arrogant, talkative young reporter from another newspaper, whom we disliked, Campbell suddenly made a disgusting remark.

"Wish you could've been with me on Iwo," Campbell said to him. "I would've loved kicking your ass down into a foxhole onto half of what was left of a Jap."

It worked. The young reporter kept his mouth shut during the rest of our assignment.

Campbell's news photos won many national awards. His photos of Iwo Jima battle action were so graphic and well composed that editors selected many to illustrate major Iwo books. Campbell deserved, but never received, a commendation for his bravery in combat and the quality of his camera work. In 1968, he died at age fifty-seven. He left his wife, five daughters, and a son.

Some of the most striking Iwo Jima photos were taken by an unidentified aerial photographer from a slow-flying, olive-green Marine Corps observation plane on the eleventh day of the fighting. The photos reveal perhaps ten thousand to twelve thousand Marines spread out across a flat, broken-up staging area a mile or two northeast of Suribachi. The men and their equipment resemble a giant campout. Some of the Marines are in shallow trenches, foxholes, and shell craters. Others are aboveground in or around trucks, Jeeps, camouflaged pup tents, and field hospitals. Many wounded men can be seen lying on ponchos laid across the rough ground. Everywhere near the men and far off into the distance are thousands of craters from shell and mortar blasts, a scene as bizarre as the craters on the moon.

What the photos do not show is the vulnerability of every man to explosives falling from the sky. Japanese artillery and mortar spotters occupying the high ground on Hill 362A and Hill 382 could see the troops almost as distinctly as the photographer overhead.

Iwo Jima was so small that there was no safe place to put those troops. The masses of exposed men almost equaled the population of a city as large as modern-day Farmington, New York, or Canon City, Colorado. No matter where a Japanese mortarman aimed his shell, he was bound to hit someone.

No Time
for Cameras

When Sergeant Genaust's reels of Kodachrome color film were processed in Hawaii, some showed the tired frontline Marines of the 5th Division several miles northeast of Mount Suribachi as they fought their way toward Hill 362A. Their progress was excruciatingly slow because the enemy battled for every lousy rock scattered across the terrain. If a man stepped in the wrong place, he could explode a buried land mine and lose one or both legs.

Genaust's film pictured men performing dangerous tasks. Crouching Marines, hurling grenades over ledges of stone or into gorges where Japanese snipers were hidden, had to duck fast when the Japanese threw their own grenades. Riflemen lying prone or hunched over behind slowly rolling Sherman tanks fired round after round from their M1s, carbines, and rapid-fire BARs (Browning automatic rifles). Marine flamethrower specialists, selected for their courage and brawn, stood tall despite heavy tanks of jellied fuel on their backs and sent thirty- to forty-foot tongues of sizzling flames into rocky openings.

What the film did not show were the times when Genaust stowed his camera in his large canvas rucksack and became a rifleman, replacing dead or wounded Marines whose loss depleted thirteen-man squads to

dangerously low levels. When the men made brief, sporadic advances, Genaust was with them—firing his carbine, dodging from rock to rock, dropping prone, and rising again.

As an expert marksman and experienced combat Marine, Genaust did not waste ammunition. He fired only when other Marines pointed out targets. At times, his rucksack was heavy with grenades. He had a strong arm and got good distance on his throws. Like the others, he saw no live Japanese, only an occasional corpse or part of a corpse, skin and dungarees burned black.

Genaust's film revealed the hill that the Marines, supported by the tanks, intended to capture. Looming like the rock of Gibraltar hundreds of yards ahead, it was 362 feet high, hence its designation on maps as Hill 362A. On its flat top, acres wide, the Japanese had set up half a dozen anti-aircraft guns, their barrels deflected to fire down on the advancing Marines. Their armament also included heavy mortars, rapid-fire antitank guns, and heavy artillery.

The hill's rocky steep slopes and sheer eighty-foot cliffs concealed more than sixty cave entrances connecting with tunnels heading north, south, east, and west. The 1,500 elite Japanese soldiers in the tunnels could travel underground in any direction to defend the hill wherever it was under attack. In gullies around the hill's broad base were bunkers and small concrete blockhouses, camouflaged and armed with heavy weapons.

On Thursday, 1 March, the 28th Regiment, led by Col. Harry ("the Horse") Liversedge, six-foot, four-inch former Olympic hammer thrower, got heavy support from the battleship *Nevada* and the cruisers *Pensacola* and *Indianapolis*. The ships hurled hundreds of rounds onto the flat top and the sides of Hill 362A. When the forty-minute barrage ended, 3,000 Marines jumped off for the assault.

The Navy shellfire raised clouds of brown dust and black smoke high into the air and chased the Japanese away from the openings where their guns were located. In three hours, Marines made it triumphantly to the top of the hill and suffered only light casualties. Other Marines surrounded the base of 362A.

Then came disappointment. Dead Japanese littered the landscape, but the bulk of the defenders were gone, having escaped through the tunnels to openings at the base of the high cliffs on the hill's north side. They fled 300 yards to Nishi Ridge, where they took up new defensive positions.

The ridge, more than 360 feet high, was fortified with heavy guns and well-designed defenses. Manned by well over 1,000 highly trained troops, it was likely Iwo's best fortification.

In the grinding battles that followed, half of the men who had raised the two flags on Mount Suribachi were killed or wounded, one by one. Platoon Sergeant Thomas, who had helped to hoist the first flag, was shot through the head as he was phoning his command post to say that his platoon's advance was temporarily stalled.

Sergeant Hansen, also part of the first flag raising, was killed while trying to advance against a heavily defended rocky position. Ironically, Hansen's life had been saved on 21 February, when Pfc Donald Ruhl threw himself on a grenade and died in the blast. For his sacrifice, Ruhl was awarded the Medal of Honor.

Big, brawny Sergeant Strank, who had participated in the second flag raising, was killed during the slow advance in the same area. Private First Class Sousley, also with the second group of flag raisers, survived in the thick of battle for six weeks before his luck ran out. Yard by slow yard, he fought over Iwo's roughest ravines and rocky hills for $4\frac{1}{2}$ miles from Suribachi to northernmost Kitano Point. Sousley was killed just two days before Company E, by now badly shot up, was pulled back from the fighting.

Sergeant Genaust roamed the areas around Hill 362A and Nishi Ridge. Climbing ridges with the troops, he was always looking for the best camera angle. During the struggles for the hill and the ridge, a first lieutenant shook his head grimly and said: "The trouble with this place is there are too damned many ridges. You take one ridge and then you got to take another. There's always another ridge."[1]

In detailing the fight for Hill 362A, a Marine correspondent gives the following account of a radio exchange between a battalion command post and a company headquarters:

> Battalion: What are you people doing down there, sleeping? Why don't you move out?
> Company: Move out, hell! Every time we twitch an eyebrow we get it shot off!
> Battalion: Never mind that. We gotta take that hill today.
> Company: We always gotta take a hill. We took a hill yesterday and the day before that. When do we run out of hills? Say, it's plenty hot down here. Getting lots of small arms fire. Keeps us pinned down.

Battalion: You gotta take that hill—today!

Company: Well, if the outfit on our left would move up and protect our flank, maybe we could move.

Battalion: That company says they're fifty yards ahead of you already!

Company: The hell they are! Anyway, George Company on our right wants to throw some mortars right in here where we are. Where the hell do we go?

Battalion: They're not going to throw any mortars in there, if you mean between you and the tanks. Quit worrying.[2]

The steep slopes of Nishi Ridge extended almost to the western beaches of Iwo, where the foamy white surf was a clean contrast to the dirt and broken rocks of the slopes and gulches above. Nishi's sides were pocked by eighty or ninety cave entrances, some camouflaged, all armed with 90-mm mortars, heavy machines guns, and light but deadly Nambu machine guns.

All of the cave entrances were linked by the usual intricate systems of tunnels, including one that was five hundred feet long and another more than a thousand feet long. The tunnels, chiseled in some places through soft sandstone, had overhead electric lighting, electric hot plates for cooking, and fans that sent dank air to the top through ventilation tunnels. Two-wheeled carts were used to move ammunition rapidly to gunners manning the cave openings.

When the Nishi attack bogged down, U.S. Navy and Marine artillery laid down new barrages onto the ridges and also on the sides of Hill 362A, where pockets of the enemy were still a problem. After the barrages lifted, thousands of troops again moved forward, supported by rumbling Sherman tanks. The units included three badly depleted battalions from the 26th Regiment and two from the 28th.

This time, the barrages were not so helpful. The enemy hesitated at first, but, as soon as masses of Marines were visible, the Japanese opened up with all their guns. Men fell to the left and right. The gains were only six feet here and a yard there. Green replacements for the dead and wounded men were soon killed or wounded themselves. A captain from Colonel Johnson's 2d Battalion described the action as like capturing Suribachi a second time.

In the nearby 27th Regiment's sector, the Marines encountered a strange situation, described by Sgt. Henry Giniger, a combat correspon-

dent from Brooklyn, New York. On a high ridge several hundred yards ahead, ten Japanese soldiers squatted at regular intervals in a circle. An eleventh man, apparently their leader, sat off by himself. All carried weapons but didn't fire them. Giniger continues:

> They seemed to be holding some sort of conference. They talked for several minutes and then broke off as if they'd decided something. Since they were squatting, they didn't make good targets, so all we did was lie there and watch. A moment later, the leader rose to his feet and stood looking down toward the Marine lines. He was a perfect target and bullets from a dozen rifles riddled him.
>
> Then a second soldier stood up, as casually as if he was going for a walk. He was shot down. Around the circle it went, one soldier standing up as soon as the preceding one had been shot down. In about two minutes, all eleven were dead.[3]

Back in the 28th's section, the advance was slower and tougher, with the troops receiving deadly fire from the caves behind them on the slopes of Hill 362A, as well as from high positions on Nishi Ridge just ahead. Sergeant Genaust, staying close to the assault companies, filmed in Kodachrome color the long, leaping flames from Sherman tanks that poured into cave and tunnel openings. He mentioned to other cameramen that most of his motion picture footage was now repetitive, consisting of Marines making slow progress against a mostly unseen enemy that seemed to have an inexhaustible supply of cave openings from which to launch grenades and mortar shells.

The casualties in this sector included twenty-four-year–old Capt. Aaron C. Wilkins of Company A, the last of the 1st Battalion's three original company commanders. He and three other men were killed by a mortar blast. Capt. Robert A. Wilson and what was left of his Company B tried to advance but were clobbered by fire from the high ground. Wilson was severely wounded by mortar fragments. 1st Lt. Charles A. Weaver was now the company's commanding officer for the second time. On D-day, as the battalion had crossed the island to isolate Suribachi, Weaver replaced heroic Capt. Dwayne E. ("Bobo") Mears when the former gridiron star, armed only with a pistol, was killed while leading a frontal attack on a blockhouse.

By the time the battle for Iwo was finally over, Company B, which had started with about 250 men, suffered well over 100 percent casual-

ties; many of its replacement troops were also dead or wounded.

Among those killed on 1 March was husky Cpl. Tony Stein, who was known to be "as tough as iron." His loss was an emotional blow to all of the entire 5th Division because he had been an inspiring, devil-may-care fighter during the D-day holocaust and afterward. A veteran of the Guadalcanal, Bougainville, and Vella Lavella campaigns, Stein wielded a special weapon that he called his stinger, a machine gun found in the wreckage of a navy plane. Assaulting pillboxes and bunkers with the stinger, Stein had killed more than twenty Japanese on D-day. Although he was wounded in the shoulder by chunks of flying metal, Stein refused to leave the battle. He was the first Marine on Iwo to be awarded the Medal of Honor, but he would never know this.

During the battle for Nishi Ridge, Stein's luck ran out. Armed with his stinger, he volunteered to take a patrol of eighteen men onto the ridge to assault the enemy soldiers whose deadly fire had stalled the advance. The patrol dodged helter-skelter up a ravine as mortar rounds and bullets rained down. Only nine men made it back. Stein was killed by a sniper.

While Lt. Col. Jackson Butterfield's 1st Battalion caught hell from the ridge, Sherman tanks were unable to help because of tank traps and gulches. When a tank stopped, Japanese soldiers popped up from seemingly nowhere and threw demolition charges at it, but the blasts did no harm. They were deflected by three-inch hardwood planks fastened to the sides of each tank.

Twice that day, Colonel Johnson's troops were frightened nearly out of their wits when they thought they were under deadly gas attacks. Enemy mortar rounds fell among them and spread thick billowing clouds of green smoke. Because there was no wind, the pungent mists clung to the ground. Men coughed, became nauseous, and vomited all along the front line. Their eyes burned and flooded with tears. The troops and their officers, lacking gas masks, wondered if the fighting was in a new phase, with possibly more and bigger gas attacks to come. Fortunately, the green fumes quickly dissipated, with no permanent harm done. A second gas attack later that morning dissipated just as swiftly.

Analysts at 5th Division headquarters decided that the strange gas was probably picric acid. Although toxic, it is not in the deadly class of mustard and chlorine gases. The Japanese sometimes combined picric acid with explosive charges.

Not until after the war was it revealed that, prior to the Iwo Jima invasion, experts in the highest U.S. military and political circles in Washington debated whether to use gas warfare on the island. Those in favor argued that, because of the way the Japanese were dug in underground, they would be extremely vulnerable to gas.

The gas debate was conducted in secret during the summer of 1944.[4] Generals and admirals argued that Iwo was the most perfect gas target of all the Pacific islands and that, by killing thousands of the enemy, gas shells would save untold numbers of U.S. Marines. At that time, no one knew how deadly the battle for Iwo would be. Even if the Joint Chiefs of Staff had projected such losses, however, it is doubtful that they would have approved the use of gas. When it had been employed during World War I, worldwide storms of protest erupted.

Before the Joint Chiefs' final decision, studies and recommendations for gas warfare had moved ahead rapidly. Stanley P. Lovell, director of research and development for the Office of Strategic Services, flew to Pearl Harbor in June 1944 and explained the gas scenario to Fleet Admiral Nimitz. To prevent Japanese from revealing that they were being gassed, the plan called for destruction of all enemy radio transmitters on Iwo Jima. Lovell recommended that the color banding on the gas shells be removed so that U.S. artillery gunners would not know what they were shooting.

At the conclusion of Lovell's meetings with Admiral Nimitz, he reported: "Nimitz was for it, I thought." When Lovell returned to Washington, he was told that the gas plan had been approved at all high levels except the White House. The plan was shelved for the duration of the war because the White House sent it back stamped: "All prior endorsements denied—Franklin D. Roosevelt, Commander-in-Chief."

The battle for Nishi Ridge seemed to last forever and a day. Yard by yard, Colonel Johnson's 2d Battalion captured one enemy position after another. The worst exchange of grenades, mortars, and gunfire occurred on 3 March, just before 1400, when an estimated 160 Japanese soldiers launched a surprise counterattack. This was not a wild, sake-induced banzai run but a charge by some of the emperor's best men, skilled in killing Marines. They were thrown back by Johnson's men, who destroyed most of them. The Marines suffered only light casualties.

Throughout the battle, as he had done day after day, the colonel stayed with the frontline troops and inspired them with his fearlessness under fire. His men loved him and bragged to other outfits that he was the best man on the island, "a guy who laughed at death."

A number of the men in his battalion had so much respect for the thirty-seven-year–old colonel that they insisted on returning to duty after being treated for wounds. Some suffered a second wound a day or so later and some even a third wound, yet they still came back to fight.

Johnson was overweight and heavy-bellied, but he could move around quickly and deftly when he had to. Although he insisted that every man in his outfit wear a steel helmet at all times, the colonel himself would not wear one. He wore a ragged, faded green fatigue cap with the bill turned up. His weapon was a heavy 45-caliber pistol poking out of a hip pocket. He was stern and cursed like an alley fighter, but he could be softhearted and sensitive when one of his men came to him with a personal problem.

After the attackers were beaten off, the 2d Battalion took a twenty-minute breather. Johnson wandered around in the midst of the nearly exhausted men. He offered small talk and wisecracks as they sat on the ground and smoked or ate C rations. One of the men, Pfc Lowell B. Holly, rode around on an enemy bicycle that he had found in a nearby cave with the bodies of several Japanese. As he rang its bell, ding-ding-ding, one of the laughing Marines remarked, "Here comes the ice cream man."

Ross describes what happened next:

> Several of the men watched a grunting crew pulling and pushing a 37-mm antitank weapon into firing position. One grimy, bleary-eyed corporal, his green dungarees tattered and stained with sweat and volcanic ash, chuckled loudly as he saw the jaunty, rambunctious colonel approach a shell hole. He was sure Johnson expected to find Marines relaxing down there. Instead, Japanese dead were sprawled in the crater.
>
> In that instant, a shell exploded at Chandler Johnson's feet and he was blown to bits. One second he was striding along in all his vigor, the next he was in pieces scattered all over the place. The bizarre scene was made all the more bizarre and tragic by the fact that Johnson was probably killed by accidental fire from an American gun.[5]

Wheeler's research also indicates that the colonel likely was killed by a shell from a Marine gun.[6]

Pfc Rolla A. Perry told his comrades that "the biggest piece we could find was the colonel's rib cage." He also mentioned that something the colonel said "made me laugh just as the shell exploded and because my mouth was open I gagged on a piece of flesh."

Pvt. Arthur J. Stanton found the colonel's shirt collar, without a drop of blood on it, cut off at the neck as if with a sharp pair of scissors. Yards away were a hand and wrist, with a ticking, unscratched watch.

The men shed tears without shame. If they talked, it was with heavy lumps in dry throats. "Son of a bitch! He's gone! I can't believe it—the colonel's gone!"

The shell that killed Johnson also killed and wounded others. Sitting on a bluff, Private Stanton had leaned over to hand another man a cracker from his K-ration. Stanton said, "Just as he took the cracker, the shell fragment cut the top of his head right off just above the eyes, all the way to the back of his neck."

News of Johnson's death spread rapidly among the men of the 1st, 2d, and 3d battalions. Decades later, when gray-haired survivors of Johnson's battalion met at reunions, they inevitably got around to telling stories about the bravery and camaraderie of their beloved colonel. Sometimes, they were exaggerated claims about his weight, such as "Yeah, he must've weighed two fifty, but he was light on his feet like a boxer" or "Sure he was fat, but he had a big heart, too."

Also, at the reunions, Genaust's film of the flag raising was run off on a projector and copies of the Rosenthal photo were passed around and autographed as souvenirs. Invariably, someone would remark that if it had not been for Colonel Johnson, there never would have been such photos to remind the world of what took place at Iwo Jima. The veterans also reminded each other to tell the folks back home that not one but two flags went up that day and "our colonel was the man who ordered them both."[7]

In addition to Colonel Johnson, another 508 5th Division troops fell that Saturday, 3 March.[8] No one ever knew what the Japanese losses were, but sixty-eight caves were sealed by tanks and bulldozers. When darkness came, hundreds of enemy bodies were sprawled among the rocks and in the ravines.

Although Hill 362A behind them was quiet and no longer as dangerous, the Marines knew that the battle for Nishi Ridge was not over. The night after Johnson was killed, fifty Japanese soldiers tried to infiltrate the

lines near Hill 362A and some of them made it. At a company command post, Sgt. William G. Harrell awoke in his foxhole to find a sudden attack swirling around him in the darkness. He opened fire with his carbine and killed two of the enemy, but an exploding grenade tore off his left hand and fractured his thigh. Although crippled, he continued to wage a fierce lone battle with the attackers. A saber-wielding captain rushed his foxhole and slashed Harrell deeply. Harrell shot him with his 45-caliber pistol.

After ordering another Marine to safety, the exhausted, blood-soaked Harrell was attacked by two more enemy soldiers, who dropped a grenade near his hand. Harrell killed one with his pistol. Then he grabbed the sizzling grenade with his good hand and shoved it toward the other Japanese attacker, who was crouching nearby and aiming a death blow. The grenade exploded, killing the enemy but also severing Harrell's remaining hand.

At dawn, Harrell was evacuated from a position surrounded by twelve dead Japanese, at least five of whom he had killed. He was awarded the Medal of Honor. Fitted with mechanical hands after the war, he went to Texas and helped to run a cattle ranch.[9]

On that bloody Saturday, Harrell was only one of five men of the 5th Division who won the Medal of Honor, a day's record unmatched in modern warfare.[10] Cpl. Charles J. Berry and Pfc William R. Caddy leapt onto live grenades and gave their lives to save their comrades. Pharmacist's Mate Second Class George Wahlen, moving forward six hundred yards with the 26th Regiment, treated casualties all the way. Wounded for the third time in six days, this time critically, he refused to quit and was still crawling forward when he collapsed. He survived. The fifth medal went to Jack Williams, another Navy corpsman. Although wounded by three bullets, he continued to treat other wounded until he was killed. (For the full account of Williams's rare heroism, see chapter 12.)

Before the day ended, the 28th Regiment managed to power its way up and over Nishi Ridge, 360 feet high, and it also fought through the wreckage of Nishi Village on the north side. All that remained of the village were a few tumbledown huts and small buildings that once had rain cisterns on their roofs. The regiment did not stop until it had advanced another two hundred yards over shell-shattered terrain.

When the horrors of that day finally ceased, 135 men, including 8 officers, of the 5th Division had died. Total casualties, dead and wounded,

were 518, the worst since the fighting around Suribachi on 21 February, and the worst that any division would have until the battle for Iwo ended.

Despite their losses, the Marines took pride in the fact that they had inflicted mighty damage on the enemy. Most of the Japanese artillery and tanks in that sector had been destroyed. The Japanese survivors underground were in bad shape and were suffering from disease and drastic shortages of water, food, and medical supplies. When General Kuribayashi radioed Tokyo, he reported that 65 percent of his officers had been killed. He estimated that fewer than 3,500 effective Japanese troops remained.[11]

To achieve that destruction, and more in the weeks that followed, the Marines had paid a ghastly price. The fate of Colonel Johnson's 2d Battalion was an example. The battalion had gone into battle on D-day strongly reinforced to 1,400 men and had received 288 replacements. Day after day, this magnificent battalion was destroyed. By 26 March, it was reduced to a grim, hollow-eyed—but still indomitable––band of 177 men, half of whom had returned to combat after being wounded.

No Interviews!

Now in his eighties, Joe Rosenthal is a grouch—a special kind of self-described grouch. He becomes sour and uncooperative only when asked for an interview by the media. The rest of the time he is sweet-tempered and sociable.

Except for a few infirmities of age, Rosenthal is not much different than he was fifty years ago when he was catapulted from the ranks of ordinary newsphotographers into instant fame and lost his privacy forever. He is still a man of integrity, quiet and sensitive to the feelings of others. Regarding his photographic achievement, he has always maintained a unique modesty.

Rosenthal is portly and bald, with a fringe of snow-white hair and a bristly, snow-white mustache. He walks with a cane, wears a dark European-style beret, and is never without his trademark, thick-lensed glasses. Because of glaucoma and tunnel vision, his eyesight is poorer than ever. He reads painstakingly with a magnifying glass.

Joe has a long, long memory. He has never forgotten how, in 1945, he was betrayed by fellow journalists who caused irreparable harm to his reputation. He swore off being interviewed then and is now tougher than ever with would-be interviewers. During the forties and fifties, Joe was polite

when he turned down an interviewer. Now that he is a wise and experienced elder, he chooses the privilege of being rude and gruff when he refuses an interview.

He discussed his bias toward interviewers when I chatted with him in the fall of 1993. Technically, our telephone conversation was an interview, but Joe was amiable and cooperative.[1] Our friendship goes back half a century to when we worked together for several years as a photographer/reporter team on the *San Francisco Chronicle*. Joe does not forget his friends.

Although the fiftieth-anniversary observances of the battle for Iwo Jima were still almost a year and a half away, Joe already was being pressured for interviews by journalists and reporters en masse. When we talked on the phone, he had just returned from a two-week visit to the south of France, where he had attended an international photography conference. He was bitter about two things: (1) American Airlines had lost his luggage and (2), even worse, he had been pressured at the conference for an interview by a journalist who had promised that it would take no longer than thirty minutes. The interview had dragged on for more than three exhausting hours, and the journalist had badgered him with the same antique questions about his integrity that Joe has been answering in clear detail since 1945. He has explained "a million and one times" to the media that his flag photo was not, repeat *not,* posed.

When Joe arrived home from his trip, twenty-five messages, many from would-be interviewers, awaited him on his answering machine. "That did it," he said. "I decided to become a grouch. A terrible grouch. The grouchiest of grouches. All in self-defense."

Joe was born in Washington, D.C., on 9 October 1911.[2] He was one of five sons of Russian immigrants David and Lena Rosenthal. His father was in the clothing business. While growing up, Joe became a Boy Scout and experimented with an Eastman Kodak Brownie camera that he obtained by mailing in coupons. Because he was so small, the coaches at Washington's McKinley Technical High School refused to let him try out for the football team. Instead, he joined the track team and surprised everyone, including himself, by becoming a champion pole vaulter. He won his letter and several medals. In 1928, at seventeen, he could vault eleven feet, an excellent height; the Olympics championship height that year was thirteen feet and nine inches.

After graduating from high school in 1929, he left Washington to join his brothers in San Francisco and work his way through the University of California. He registered for classes but never attended any. His new job as office boy for the Newspaper Enterprise Association (NEA), a Scripps-Howard news service, was too interesting, and it occupied all his time. He later attended the University of San Francisco for a year.

At NEA, his work included on-the-job training in news photography, which Joe found fascinating. As he acquired more expertise, the idea of having his name at the beginning of news stories appealed to him, so two years later he became a combination reporter-photographer for the *San Francisco News*. His news beats were hospitals, police headquarters, and civil courts.

A decade before he shot his Iwo Jima flag picture, Rosenthal was already so versatile with his lens that he had twice won nationwide recognition for his photo enterprise and artistry. In 1934, when he was twenty-three years old, he made newspaper headlines across the nation. Despite receiving injuries that sent him to the hospital for eight days, he managed to obtain an unusual photograph of the strikers in a lengthy and violent San Francisco waterfront labor dispute. Two years later, his photo of former world heavyweight boxing champion Max Baer taking a shower won first place in the sport division of *Editor and Publisher* magazine's annual national competition. The judges also designated it the best news photograph of 1936.

Joe became chief photographer for the San Francisco bureau of Acme News Service in 1935. The following year, he switched to Wide World Photos as bureau manager, a job he described as "janitor and vice president in charge of licking stamps." In August 1941, when Associated Press bought Wide World Photos, Joe became an Associated Press cameraman.

After the attack on Pearl Harbor, Joe did his best to get into the armed forces, but the Army, Navy, and Marine Corps, one after the other, rejected him because of his vision, then about one twentieth of normal. One of Joe's San Francisco friends persuaded the U.S. Maritime Service to waive its eye test for Joe, and he took a leave of absence from the AP to become a maritime photographer, with the rank of warrant officer. Assigned to a convoy bound for England in July 1943, he took pictures of war zone shipping actions in the Atlantic Ocean, England, and North Africa.

Returning to the United States seven months later, he obtained a new job with the AP because it promised more battle action. He became an accredited war photographer in the Pacific zone and was assigned to the Wartime Still Pictures Pool, which supplied photos to news services, newspapers, and magazines. His assignments took him to Guadalcanal and the invasions of New Guinea, Hollandia (now Jayapura, Indonesia), Guam, and Peleliu and Angaur in the Palau Islands. On the latter islands, he made three landings within three days.

During the invasion of Peleliu, Joe went on a reconnaissance patrol into enemy territory with Marine Sgt. Jeremiah O'Leary, who later became a columnist for the *Washington* (D.C.) *Times*. In one of his columns, O'Leary recalls that he and Joe met on a miserable day in September 1944, when the jungle temperature hit 110 blazing, humid degrees.[3]

O'Leary was attached to the Intelligence Section of the 7th Marine Regiment. He was not at all impressed with the size, age, and appearance of the stranger approaching the foxhole where he was resting and trying to avoid the heat:

> I was flaked out, when here comes this rumpled little guy dressed in a melange of raggedy uniform parts, wearing an Army helmet and laden down with camera equipment. He was thirty-two years old—an ancient age for consorting with Marines on the front line—and I was twenty-four, lean and mean and battlewise from two previous amphibious battles against the Japanese.
>
> He carried no weapon, and I was wondering who he was when he told me, "I'm Joe Rosenthal of the AP, and I was told you would take me on patrol." I welcomed this encounter with as much pleasure as I would get from receiving a notice from the Internal Revenue Service for an audit. But the little guy was so earnest that I couldn't say no. I told him there was one rule on Marine patrols: *Stragglers get left behind!*

Taking over as Rosenthal's bodyguard and guide, O'Leary grabbed his rifle, and the two clambered across outcroppings of coral to the patrol's assembly point. Soon, the group took off on a foray into a canyonlike area where advancing Marines had bypassed many Japanese soldiers hiding in caves. It quickly became obvious to the sergeant that the little photographer could not keep up because of the patrol's fast pace and the exhausting heat.

"Joe's thick eyeglasses were fogged over with sweat and dirt," O'Leary recalls, "and he kept stumbling as the patrol got farther and farther ahead of us. I had a decision to make: Abandon Joe to his fate or stay behind with him as he puffed and heaved for breath."

O'Leary stuck with Joe who—without a bodyguard or rifle—would have been "dead meat" (O'Leary's term) had enemy soldiers discovered him. As the patrol disappeared into the distance, Joe suggested that they explore one of the caves where there might be some photo opportunities.

"That foolhardy sidetrack was abandoned," O'Leary writes, "when both of us bumped into the body of a Japanese officer who had hanged himself in the Stygian darkness of the cave."

O'Leary aborted their mission, escorted Rosenthal to the regimental command post, and forgot about him until five months later. While home on leave, the sergeant opened up a newspaper and got his first glimpse of the flag-raising photo that was to become the most famous picture of the war. Much to his amazement, he learned that the photographer was the grungy little misfit he had met on Peleliu.

Joe kept busy during the fall of 1944 by photographing carrier-launched planes going on bombing missions over Formosa, Okinawa in the Ryukyu Islands, and the Philippines. With a grin, he told friends later that very likely he was the only cameraman who spent a month at General MacArthur's headquarter without taking a picture of the general.[4]

Within weeks after he photographed the flag raising on Iwo Jima in February 1945, the AP rushed Rosenthal back to San Francisco and then New York and Washington to face mind-boggling acclaim. Like the three surviving Marines in his photo, who were also rushed home, Rosenthal found it impossible to adjust to the outpouring of nationwide publicity and personal praise. He was not a war hero. He had not led any Marines to victory on Mount Suribachi. He had not shot at any Japanese. Yet, wherever he went, he received the same welcoming accolades given to returning Marines, soldiers, sailors, and airmen who had won medals for their heroics in battle.

This was difficult for Joe, a genuinely modest man, to accept. He felt that the continual praise was out of proportion and exaggerated. Again and again, he told anyone who would listen that the Marines who had fought and died on Iwo Jima were the heroes, not Joe Rosenthal. He told

reporters, correspondents, radio interviewers, and banquet audiences that he was not a war hero and could never be one.

Eventually, he stopped arguing and quietly and resolutely put up with everything, ridiculous or sublime, that came his way. The AP arranged for him to appear on "We the People," one of the foremost network radio shows of that era, and sent him on a nonstop round of banquets, interviews, and meetings with government officials. He dined with AP's president, Kent Cooper, and sat down with editors of *U.S. Camera* magazine to select a group of his war photos for a spread in its pages. Wistfully, he told an interviewer for *The New Yorker* magazine that he would like to see the Statue of Liberty but did not expect to have the time because he had to leave for Washington to meet President Harry Truman.

The photograph won Rosenthal an unprecedented list of honors and awards that would continue to arrive for years. In May 1945, he won the Pulitzer Prize, then $500, for news photography. He received a plaque from the New York Photographers Association.

In April, he had received another plaque from the recently organized Catholic Institution of the Press at its first public function, a Communion breakfast at the Waldorf Astoria Hotel. (Rosenthal has been a Catholic since 1939.) The plaque bears a scroll, below a reproduction of the flag raising, with the inscription: "Faith in God was his armor, his weapons valor and skill. He served in the best traditions of the American press photographer." Rosenthal gave the plaque to the AP.

In addition to a generous raise in salary, Rosenthal received the largest bonus that the AP had ever given a photographer. At a banquet in his honor, given by *U.S. Camera* in June 1945, he received a medallion and a $1,000 war bond, which he later turned over to charity. A statement prepared by the editors of *U.S. Camera* was read at the banquet:

> The Editors of *U.S. Camera* were guided in making their selection by the conviction that the Iwo picture fully accomplished the ultimate purpose of photography, which is to make the viewer relive the events recorded. The Iwo picture caught the event so effectively that one who looks at it can virtually feel and hear the breeze which whips the flag. In a sense, in that moment, Rosenthal's camera recorded the soul of a nation.

When his photograph, in the form of a color oil painting by C. C. Beall, became the official poster of the Seventh War Loan Drive, Rosenthal was

sent on a war bond tour across the nation. Rene Gagnon, John Bradley, and Ira Hayes, the three surviving flag raisers, were also sent on tours apart from Rosenthal's. Each tour was an exhausting round of banquets, interviews, strange hotel rooms, and interminable speeches by leather-lunged orators. The men hated every dragged-out minute of being paraded in public before large and small audiences. At times, Hayes and Gagnon could not smother their feelings in public, but Rosenthal clenched his teeth and concealed his irritation.

It has been estimated that, for the Seventh War Loan Drive, Rosenthal's flag photo appeared on 3,500,000 color posters, 15,000 large outdoor billboards, and 175,000 cards in streetcars and buses (see Introduction). In simplified form, the photograph was published in millions of copies of newspaper and magazine advertisements.

The photo was portrayed in Marine-green ink on a commemorative three-cent (first-class) postage stamp honoring the Marine Corps. When it was issued on 11 July 1945, the stamp broke all records for first-day cover cancellations. A total of 400,279 covers or envelopes were canceled and sold to people who had stood patiently in post office lines stretching for city blocks. The previous record of 391,650 canceled covers had been set 27 June 1945, when a three-cent stamp was issued in memory of President Franklin D. Roosevelt, who had died that April.

Ten years before the massive de Weldon sculpture was erected in Arlington National Cemetery, committees in cities throughout the United States worked hard at proposals for similar sculptures based on the Rosenthal photo. None of their proposals was on the scale of the hundred-ton de Weldon sculpture. One of the largest was a fifty-foot statue erected in mid-1945 in New York's Times Square. Private funds for it were raised by a war activities committee of the movie industry. Six Marines from the South Pacific war zones, who posed for the statue, duplicated the action in Rosenthal's photo. The lifelike figures were approximately twelve feet high. When the statue was unveiled, Bradley, Hayes, and Gagnon hoisted the original Iwo Jima banner to the top of the statue's flagstaff. The statue stood in Times Square throughout the summer months. On 26 October 1945, it was presented to the U.S. Naval Hospital at St. Albans, Queens, New York.

Before he became disenchanted with the tactics of media interviewers, Rosenthal was known to the press as an amiable but shy man. Journalist

Malcom Johnson met Rosenthal on Guam in March 1945 not long after he had shot the flag picture. Johnson summarized Rosenthal's personality: "He's the kind of fellow who will return from a hard day's work to find his room overflowing with acquaintances, even strangers, engaged in an endless session of shooting the breeze. More often than not, they have appropriated Joe's liquor as well as his room. Instead of mentioning that he's tired and wants to go to bed, Joe will retire modestly to a corner, usually sitting on the floor. He will smoke a cigarette in his long holder, grin good-naturedly and then nod and doze while the session continues far into the night."[5]

On 5 October 1947, when he was thirty-six years old, Joe married Lee Walch of Minneapolis in San Francisco's Saint Brigid's Catholic Church. Fellow *Chronicle* photographer Bob Campbell was one of the ushers. Joe and Lee were divorced many years ago. Joe has a son, Joe Jr.; a daughter, Anne; two grandchildren; and four great-grandchildren. He doesn't see the little ones as often as he would like because they live in other cities. One great-granddaughter delights him with her solution to the distance problem. She sends her funniest drawings to him by fax.

Joe continues to guard his privacy as much as possible and refuses to discuss his private life with the media. For a long time, he has lived alone on the same street near San Francisco's Golden Gate Park and has had the same unlisted telephone number during that time. His friends estimate that, since 1945, Joe has made nearly ten thousand prints of his photo for friends, acquaintances, and others—all at his own expense.

When Joe is with friends, he's more modest than he ever was and prefers not to talk about his photo achievements or all that comes with being an international celebrity. If someone puts too much emphasis on his Iwo Jima accomplishments (the flag photo overshadows his other great combat pictures), he tends to clam up. He would rather talk about the fighting men on Iwo whose bravery and sacrifices made it possible for him to shoot his photos.

He never mentions that 4-F Joe Rosenthal, whose attempts to enlist were rejected by the U.S. Army, Marines, and Navy, was part of six particularly dangerous World War II invasions. He made four landings under fire in the Pacific and two in Europe—far more than most participants in World War II.

Efforts to Honor Rosenthal and Genaust

The San Francisco media, whether print or electronic, have rarely caused Joe Rosenthal any trouble or embarrassment. Reporters and editors do not try to twist his words around. They treat him with the kind of respect deserved by one of the city's most renowned citizens.

For thirty-five years, from 1946 to 1981, Joe quietly went about his business of recording the city's history with his *Chronicle* news camera. He had no wish to become an editor or an executive. All he wanted to do was take pictures. Despite his celebrity status, he was always on time and accepted all assignments in good spirits, no matter how menial. He photographed everything from conflagrations and earthquakes to plane crashes and murder scenes, from visiting U.S. presidents and major political conventions to celebrity weddings and fire department rescues of kittens from treetops.

When it came time for him to retire from the *Chronicle* in 1981 at age seventy, Rosenthal suspected that the staff was planning a surprise retirement party for him but he never guessed what a major event it would be. It was the whopper of all *Chronicle* office parties.

"A couple of my pals on the paper got it started," Joe recalled. "They

were ex-Marines and they got permission from the Navy to hold the party on Treasure Island. They began selling tickets at six bucks a head to pay for the booze. I didn't get wind of it until one of these guys asked, casually, 'Joe, where will you be in March?' So I told him, just as casually, that I'd be around."[1]

On the evening of the party, Joe was astounded by the size of the turnout. The 1st Division Marine band came from Camp Pendleton, a five hundred mile trip, just to salute him! More than eight hundred well-dressed people showed up, including many of the big names of San Francisco society. They toasted Joe with $5,000 worth of excellent wines, beer, Scotch, and bourbon. Joe signed what seemed to be a thousand and one autographs and shook hands until his fingers were sore. Most of the speeches were short and some were amusing. Joe, a man embarrassed by compliments, received so many of them, accompanied by repeated applause, that his round cheeks were in danger of turning perpetually pink.

Congratulatory telegrams arrived from President Ronald Reagan, former President Richard Nixon, and Senator S. I. Hayakawa, all of whom had appeared in Rosenthal news photos from time to time. One of the biggest surprises of the evening came from Congressman John Burton of San Francisco. He presented Joe with a framed copy of a resolution, which he intended to submit to the House Interior Committee, urging that Joe's name be placed on the flag-raising sculpture in Arlington National Cemetery. Many of the party guests were not aware that Joe's name was not included on the sculpture. They reacted with disbelief when Burton told them that only de Weldon's name was on the plaque at the base of the monument. When Burton explained how he intended to correct the omission of Joe's name, both he and Joe received ovations from the crowd.

"I was totally unprepared for it," Joe told me two years later. "It was awkward for me. All I could do was smile and thank him for doing such a nice thing."[2]

Congressman Burton was the first person to take direct action to rectify the snub, and because of his position, he had the power to make things happen. In 1954, the National Press Photographers' Association had taken umbrage at the neglect of Rosenthal and urged redress but quickly ran into complications. Because the sculpture is government property on government land, anyone trying to make changes encountered an enormous amount of red tape.

To add Rosenthal's name required action by the House Interior Committee, followed by a bill enacted by Congress. After this was accomplished, Joe's credit line was still omitted from the sculpture itself. His name appeared on a bronze plaque, mounted on a four-foot-high granite pylon, in an obscure location seventy-five feet to the side of the sculpture. It was dedicated in a brief, informal ceremony in March 1957 by Defense Secretary Charles Wilson and Gen. Randolph Pate, Marine Corps commandant, with Rosenthal standing between them. The plaque reads:

> Created by Felix de Weldon, and inspired by the immortal photograph taken by Joseph J. Rosenthal on February 23, 1945, atop Mt. Surabachi, Iwo Jima, Volcano Islands.

No one present commented that the word Suribachi was misspelled.

When they heard about the pylon and its distance from the monument, members of the National Press Photographers' Association and multitudes of Joe's friends became furious and regarded it as a continuation of the snub. The photographers said they would start a new campaign to eliminate the pylon and place the plaque on the monument itself.

Joe's reaction to the controversy revealed his character and the depth of his modesty. He politely distanced himself from it and declined to comment when questioned by the media. Even in private conversations with his closest friends, he did not express all of his feelings, but his friends knew that, deep inside, he was disappointed.

Years passed. Congressman Burton went to bat for Joe again and sponsored more legislation, this time directing the Interior Department to put Rosenthal's name *on* the monument. The law was signed by President Reagan on 14 October 1982.

And so, nearly thirty years after the great monument was erected, Rosenthal's name was inscribed on a small bronze plaque mounted on the right side of the monument's base of gleaming black Swedish granite. The plaque says simply: "Photographer Joseph Rosenthal." The letters are much smaller than those in de Weldon's credit line on the much larger bronze plaque located on the left side of the base. The sculptor's plaque also bears the legend, "Copyright Felix de Weldon."

When I interviewed Joe in the fall of 1983, he was reluctant to discuss

de Weldon and the monument. He much preferred to talk about his friend, Sergeant Genaust, and the Marine Corps' strange reluctance to honor Genaust for his flag-raising movie.

"Giving him credit," Joe said, "should be a natural part of history. The Corps must be moved on the matter of Genaust, but I have somewhat of a jaundiced eye on the subject. My suspicion is that the Corps will never make waves outside the Corps and the rightness or wrongness of it gets eventually lost."[3]

He mentioned that once, on the spur of the moment, he sent a news clipping related to the Corps' lack of honors for Genaust to Brig. Gen. Edwin H. Simmons at Marine Corps headquarters. He enclosed a letter suggesting that the general, director of the History and Museums Division, look into why the Corps had ignored, for so many decades, the film achievement of its cameraman who had been killed on Iwo Jima.

"I told him," Joe said, "that the first step should be a Marine credit line on Genaust's film. The general sent me a reply that said, 'Your letter is a good addition for our files.' And that was it."[4]

Rosenthal kept trying. In the fall of 1983, he decided to try an authority higher than the Marine Corps by writing to the commander-in-chief, President Reagan. Through the years, especially when Reagan was governor of California, Joe had found him unusually amiable and kind whenever they met during photo sessions. Also, he remembered that it was Reagan who had signed the legislation giving him the credit line on the de Weldon monument.

Joe spent hours writing and rewriting his letter to the president. He kept it short but put in all the facts:

November 4, 1983

President Ronald Reagan
The White House
Washington, D.C.

Dear Mr. President,

This is about a Marine named Bill Genaust.

February 23, 1945, high atop a hill called Suribachi on Iwo Jima, I stood at arm's length from Sgt. Genaust as he made a fantastic movie of the raising of the American flag there. I made a still photo at the same time.

The pictures had a widespread good effect on the morale of our fighting men; more, they made an impact at home that seemed to lift the spirits of worried parents, lovers, friends and citizens.

Genaust's powerful movie clip was used on all TV newscasts, movie houses, documentaries and station sign-offs, not only during the remainder of World War II, but for decades into the present date.

But Genaust never saw his film; his raw exposed undeveloped battleside film was shipped back to Headquarter while he continued his coverage of the Battle for Iwo Jima with the cine camera and gun.

He was killed there nine days later.

At Headquarters his flag-raising scene, along with much of his other action cinema film (along with that of other photographers) was assembled and distributed as a documentary of the Battle of Iwo Jima. Credit lines abound for some at Headquarters, but no credit line for Sgt. William H. Genaust, who gave more than his life on Iwo Jima—an unforgettably dramatic scene of courage, devotion and patriotism.

Sir, previous requests for official recognition of Sgt. Genaust, by an order for screen credit, or other appropriate means, seem to have run into technical snags of time or regulations.

But surely, such recognition, even at this late date, would be a boon to his widow and family.

I pray you may see some way of correcting this oversight.

> Respectfully,
> [Signed] Joe Rosenthal
> (Former Associated Press
> photographer at Iwo Jima)[5]

Very likely, Joe's letter was not seen by President Reagan, who, only two years earlier, had called Joe a "living legend" in a telegram sent to his retirement party. Joe received a noncommittal reply signed by a White House secretary. His disappointment in this reply was eased four months later, however, when the Marine Corps quietly issued a Certificate of Appreciation honoring Genaust for his flag movie. Signed by Gen. P. X. Kelley, then the commandant, the certificate was issued in February 1984 on the eve of the thirty-ninth anniversary of the flag raising atop Mount Suribachi. This is the only time that the Corps has honored Genaust.

Like Maj. Harrold Weinberger, USMCR (Ret.), who had worked tirelessly for the recognition of Genaust (see chapter 2), Joe was troubled by

the fact that it was only in the form of a Certificate of Appreciation instead of a commendation or a medal, but he was delighted by General Kelley's beautiful language. In praising Genaust, the commandant captured the full significance of the event and its historic effect on the American people:

CERTIFICATE OF APPRECIATION

from

COMMANDANT OF THE MARINE CORPS

to

SERGEANT WILLIAM H. GENAUST

On 23 February 1945, an event occurred atop a mountain on a Pacific island little known at that time by the American public. The flag of the United States was raised on Mount Suribachi, amidst the fierce and costly battle for Iwo Jima in the closing days of World War II. This fairly obscure ceremony was to be immortalized on film by no less than three men—a civilian Associated Press photographer, a *Leatherneck* magazine photographer, and Sergeant William H. GENAUST, a Marine Corps motion picture cameraman. The patriotic fervor of Americans would, for many years to come, be stirred by the image of those Marines and a Navy Corpsman performing an act during a battle where "uncommon valor was a common virtue." Sergeant GENAUST could not possibly have known the effect his work would have on Americans for generations to come, and the pride which would be engendered each time his film was shown.

Sergeant GENAUST died only nine days after shooting that historic scene, but the images he captured have reappeared countless times during the thirty-eight years that have now passed since 'Old Glory' was raised on Mount Suribachi. His significant contributions to the proud heritage of our Corps are ones which will never be forgotten so long as there lingers the memory of the sacrifices and determination which United States Marines have displayed throughout their 208 years. As long as there is a Marine Corps, Sergeant GENAUST'S film achievement will serve as an example of our esprit, professionalism and burning desire to place our nation's flag where it can proudly wave for the whole world to see.

For his untiring devotion to duty and exemplary photographic skill, Sergeant GENAUST is hereby posthumuously commended. His dedi-

cated service to Corps and country will be remembered by all Marines, past, present and future.

[Signed] P. X. Kelley
General, U.S. Marine Corps[6]

The certificate was the climax of Major Weinberger's four-decade campaign on behalf of his friend Bill Genaust. The commandant's action was the direct result of a 1,200-word letter that Weinberger had written to him in 1983. It accompanied a resolution adopted on 24 September 1983 by the 600-member U.S. Marine Corps Combat Correspondents Association at its national conference in New Orleans, Louisiana.

The resolution, drafted by Weinberger, urged the commandant to honor Genaust and gave many reasons why he should do so. With the power of 600 ex-Marines behind it, the resolution was the key to motivating General Kelley into issuing the certificate, but two unusual paragraphs in Weinberger's letter very likely had a major influence on the general:

In June 1983, at the annual conference and banquet of the Fourth Marine Division Association, Major Weinberger displayed a print of the Rosenthal picture. He asked the audience if they knew the name of the photographer. There was a great voluminous reply of "Joe Rosenthal!" This was before an audience of approximately 1,000, most of whom were Fourth Division veterans. The major then asked if they knew the name of the movie photographer. Aside from the few persons involved in the recognition campaign, there was absolute silence. And this was a Marine audience.

It is our belief that the Marine Corps, by its silence, has contributed to this mass ignorance. Marine and civilian publications have published scores of stories about the flag-raising. Many made mention of Sergeant Lowery. All credited Joe Rosenthal. Except for a few recent news stories generated by this campaign, none of the stories brought to our attention has ever mentioned Sergeant Genaust.

At an informal ceremony on 26 April 1984 at the U.S. Marine recruiting station in Orlando, Florida, the Marine Corps presented the Certificate of Appreciation to Genaust's widow, seventy-eight-year-old Adelaide Genaust Dobbins. Standing proudly beside her was eighty-four-year-old Harrold Weinberger.

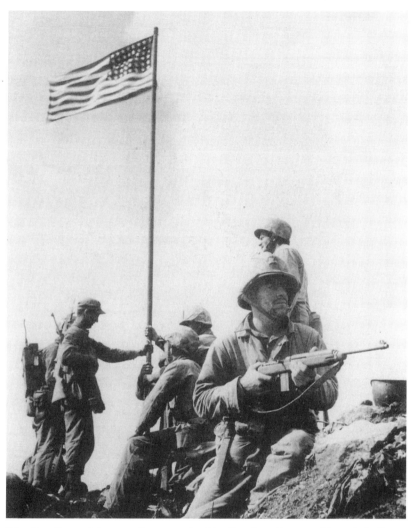

The first flag raising, as photographed by Sgt. Lou Lowery. From left, Pvt. Louis C. Charlo (with radio equipment on his back), Sgt. Henry O. Hansen, Platoon Sgt. Ernest L. Thomas (seated by pole), 1st Lt. Harold G. Schrier (behind Thomas's shoulder), Pfc. James R. Michels (with carbine), and Cpl. Charles W. Lindberg (behind Michels). (U.S. Marine Corps photo, courtesy of Charles W. Lindberg)

A

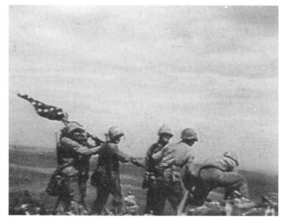

B

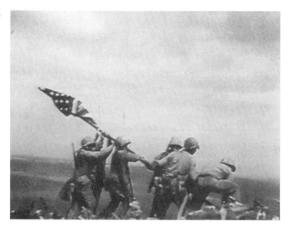

C

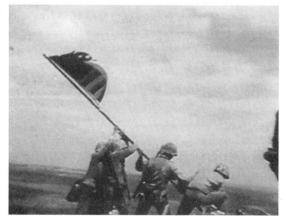

Series of photographs (in order, A through F) reproduced from Sgt. William H. Genaust's motion picture of the second flag raising on Iwo Jima. Photo D is a match for Rosenthal's famous photograph.

D

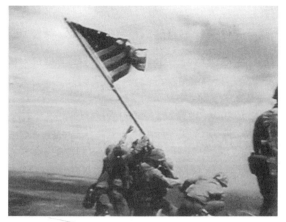

E

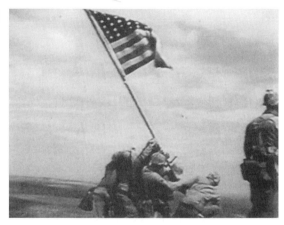

F

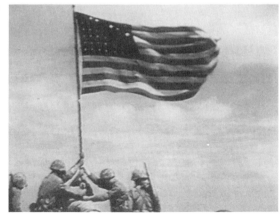

(U.S. Marine Corps photos)

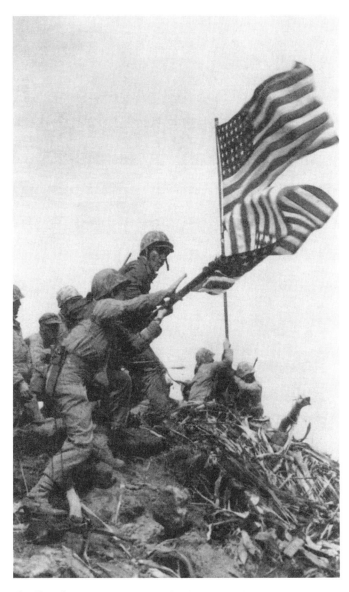

The first flag atop Mount Suribachi comes down as the second flag goes up. (U.S. Marine Corps photo, by Pvt. Bob Campbell)

Joe Rosenthal, with Speed
Graphic camera, in combat
gear on Iwo Jima.
(U.S. Marine Corps photo,
by Sgt. William H. Genaust)

Joe Rosenthal, with 35-mm
camera, in a postwar photo.
(Courtesy of *San Francisco
Chronicle*)

Sgt. William H. Genaust holds the motion picture camera that he used to shoot the flag-raising film. (U.S. Marine Corps photo, by Sgt. Lou Lowery; courtesy of Susan Genaust Naber)

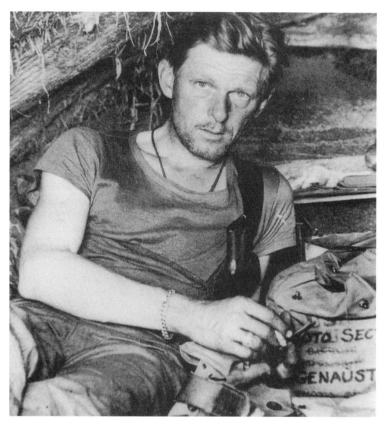
An exhausted Genaust is pictured a few days before he was killed in a cave on Iwo Jima. (U.S. Marine Corps photo, by Pvt. Bob Campbell)

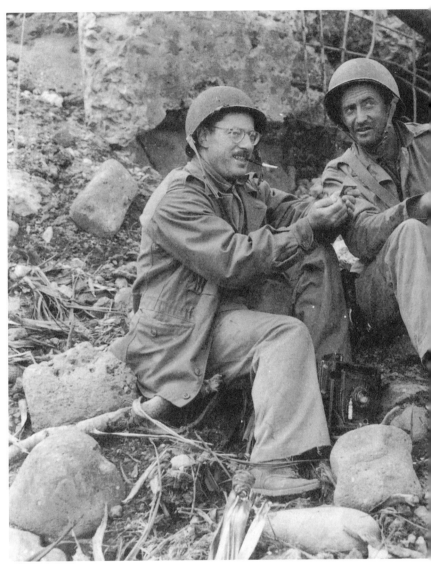

Joe Rosenthal (left) relaxes with Pvt. Bob Campbell at the base of Mount Suribachi shortly after they shot the raising of the second flag.
(U.S. Marine Corps photo, by Sgt. William H. Genaust)

Sgt. Lou Lowery, who photographed the first flag raising. (U.S. Marine Corps photo, courtesy of Doris Lowery)

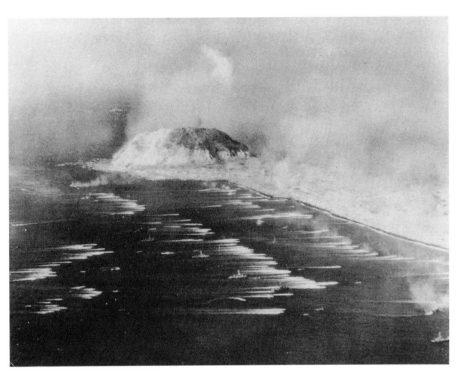

Masses of landing craft are viewed from the air on D-day. Smoke and dust rise from Mount Suribachi (in the background).
(Department of Defense photo)

OPPOSITE PAGE
On D-day, U.S. Marines break from a landing craft and scramble up a steep black sand terrace on Iwo Jima. (U.S. Marine Corps photo)

The soft volcanic sand of this Iwo Jima beach offers frontline Marines scant natural cover on D-day. (U.S. Marine Corps photo)

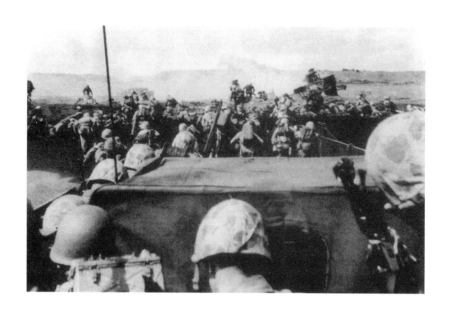

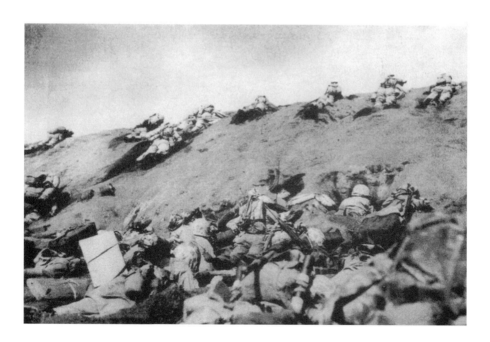

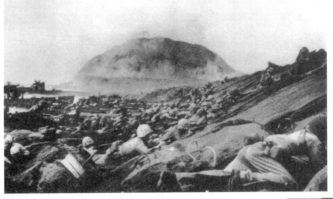

Mount Suribachi, in the background, is hit by U.S. bombs and naval gunfire as assault Marines hug the beach shortly after landing on Iwo Jima. (U.S. Marine Corps photo)

The surf rises as U.S. Marines move supplies up the soft black sand on an Iwo Jima terrace. (U.S. Coast Guard photo)

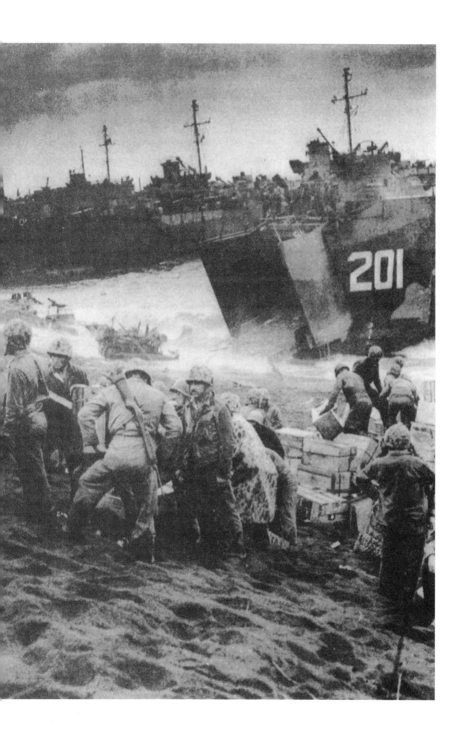

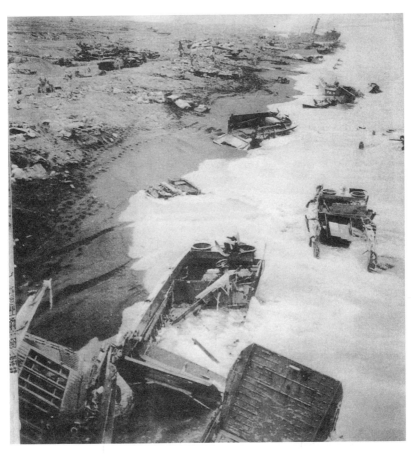

Japanese fire takes a heavy toll on landing craft bringing U.S. Marines ashore on Iwo Jima. (U.S. Marine Corps photo)

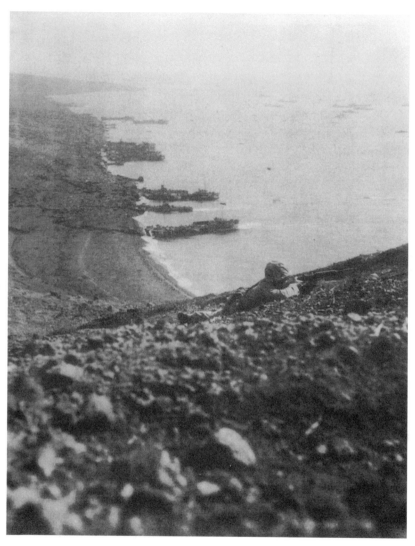

A Marine inches his way up a steep slope of Mount Suribachi that over-looks the invasion beach. (U.S. Marine Corps photo)

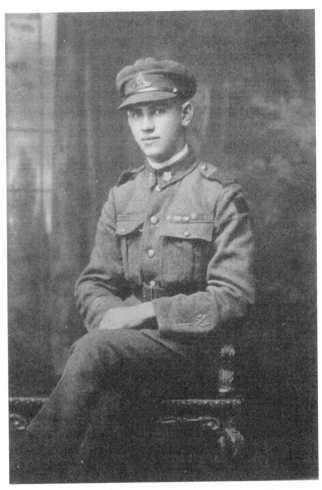

A rare photo of teenaged Harrold Weinberger, as he poses in his Canadian Army uniform during World War I.

M. Sgt. Harrold Weinberger,
wearing his Purple Heart
after the presentation cere-
mony on Iwo Jima, 1945.
(U.S. Marine Corps photo)

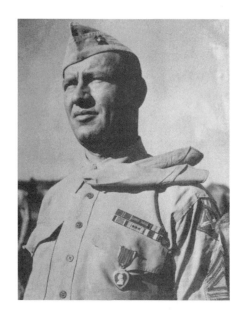

Harrold Weinberger,
at age ninety-three, is
pictured with the
memorial plaque
honoring Sgt. William
H. Genaust.

Joe Rosenthal signs his autograph at a Marine Corps meeting in
Los Angeles, 1983. At right is Federico Claveria, former U.S. Marine
combat motion picture cameraman.

Marine Capt. Mark Roberts stands near the Genaust memorial plaque (left) erected in February 1995 beside the 5th Marine Division monument, the site of the second flag raising atop Mount Suribachi. (U.S. Marine Corps photo)

One of four Japanese granite monuments atop Mount Suribachi, 1995. (U.S. Marine Corps photo)

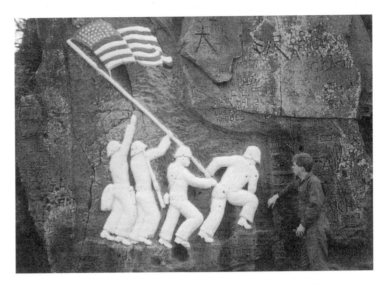

This sandstone replica of Joe Rosenthal's photo still stands on Iwo Jima. It was carved by Waldon T. Rich, 31st Construction Battalion, U.S. Navy, in 1945.

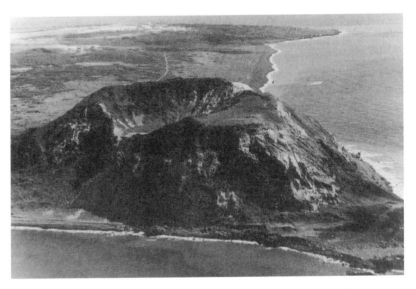

Aerial photo of Mount Suribachi, as it appears today. (Courtesy of Maritime Self Defense Forces of Japan.)

Of Wars, Movies, and Genealogy

Harrold Weinberger has had a remarkable life:

— At age seventeen, he fought in World War I with the Canadian army and was gassed by the Germans in France, but he recovered.
— At age twenty-two, he fought an exhibition boxing match with Argentine heavyweight champion Luis Angel Firpo.
— At age twenty-six, he was a professional newsreel cameraman filming the 1925 World Series between the Washington Senators and Pittsburgh Pirates with a hand-cranked camera.
— At age thirty-nine, he was a Hollywood moviemaker and assistant director on the movie *Strange Cargo,* starring Clark Gable and Joan Crawford.
— At age forty-three in World War II, he was one of the oldest privates in the Marine Corps, but he soon became a staff sergeant and was awarded the Bronze Star and Purple Heart for actions at Iwo Jima.

To those statistics can be added another: At age ninety-five, despite imperfect health, Weinberger continued to seek honors for his friend, Bill Genaust. His efforts included urging the U.S. Navy to name a frigate for

Genaust and prevailing upon the Marine Corps to place a plaque on Iwo Jima to honor Genaust for his motion picture achievement.

In early 1995, he achieved the second of these goals. The Corps installed a small bronze plaque dedicated to Sergeant Genaust in a permanent location on the historic flag site atop Mount Suribachi.[1] Measuring seven by fourteen inches, the plaque is adjacent to a large concrete monument erected half a century ago in honor of the flag-raising 2d Battalion of the 28th Regiment, 5th Marine Division. On the monument is a bas-relief sculpture of Joe Rosenthal's photograph of the flag raising.

Harrold still lives in Los Angeles with Marge, his second wife, in a pink stucco house that he bought in 1938. During a series of separate interviews with Gunnery Sgt. David Vergun, a Marine Corps writer, and myself, Harrold recalled with joy the details of a life crammed with enough careers for half a dozen energetic men.[2]

Harrold was born in Yonkers, New York, on 4 December 1899, the son of a cigar maker. His first name was spelled with two *r*'s because the doctor who delivered him was Scandinavian and used the Scandinavian spelling. Although a bright student, he dropped out of high school to join the U.S. Navy in March 1917, shortly before the United States entered World War I. Because he was only seventeen and the minimum enlistment age then was eighteen, he was forced to lie and add a year to his age. He was six feet, one inch tall and brawnier than most men, so the Navy was glad to get him. His first tour was on board the USS *Granite State,* a historic wooden vessel dating back to the Civil War.

For seven months, Harrold enjoyed an exciting naval career, and then the bottom dropped out. "My mother squealed on me," he told me. "She wrote a letter to the Navy saying I was under age." Two months after receiving an honorable discharge from the Navy, he was more eager than ever for war action and hurried to Toronto to enlist in the Canadian Army. He was issued a uniform that doubled as a field and dress uniform, the only type worn by Canadian soldiers during the war. In training maneuvers and later in battle in France, he wore out three uniforms. He was issued a Krag rifle that had seen action in the Boer War in South Africa from 1899 to 1902. Qualified as a marksman, he used it in combat against German soldiers.

During an interview with Sergeant Vergun, Harrold recalled, "We landed in Boulogne, France, in July of 1918. From there we marched for many

hours to a place north of Arras, near the French-Belgian border, where we fought alongside British colonial troops. I was a gunner with the Eighth Army Brigade of the Canadian field artillery. My battery consisted of four eighteen-pounders. An eighteen-pounder is a light artillery piece that lobs an eighteen-pound projectile up to four miles. Six horses were required to move a gun. We normally fired at the enemy at a distance of less than a mile."

Harrold was hit by German artillery shrapnel and suffered a flesh wound on the left leg. After being treated, he returned promptly to duty. In another attack, he was gassed. "It was a foggy morning," he told Sergeant Vergun. "perfect weather for a gas attack because there was no wind to disperse it away from us. When the gas alarm sounded, I hurried to put on my mask, but before I got it completely on the phosgene engulfed me and I was inhaling fumes. It was a suffocating gas. I managed to get the mask on, but for the longest time I struggled for air and thought I would die."

Treatment was rudimentary and consisted only of moving the patient to a place where there was plenty of fresh air. "Then you wait," Harrold said, "and hopefully the body will clear itself. I was back at the front lines the following day, but years later I could still feel the effects."

Harrold was in the thick of battle for months. He lost weight, lost sleep, and wondered if he would lose his sanity. Because of unsanitary conditions at the front lines—no bathing or changes of clothing—he was infected with lice and suffered continual itching.

Then came the historic day of 11 November 1918. "At five o'clock in the morning," he said, "we were ordered to cease fire, because the Germans had just withdrawn beyond the range of our eighteen-pounders. At nine A.M., our commanding officer announced that an armistice would take effect at 1100. No one cheered. We were all too tired."

Still hankering for adventure after the war, Harrold shipped out in the U.S Merchant Marine and served for four years. "Because of the lingering effect of the gas in my lungs," he told me, "I needed a job with plenty of fresh air."

On board ship, he kept in shape by boxing. With quick hands and brawny shoulders, he became the ship's best heavyweight. "On one trip in 1923," he said, "we stopped in Argentina to pick up passengers bound for New York. One of them was Luis Firpo, the Argentine heavyweight

champion, who was on his way to fight Jack Dempsey. Firpo and I fought an exhibition match. He weighed 215 and I weighed 180. I did okay, trading punches with him. Of course, if he'd wanted he could've killed me."

Harrold soon became a landlubber again. He obtained employment with the shipping department of a company affiliated with Hearst International Newsreels at $17.50 a week. His duties included working as a helper for newsreel cameramen on news assignments and toting their extra equipment and film supplies. Because he was observant and quick to learn, the cameramen taught him the tricks of their trade, everything from camera angles to correct lighting and exposures.

Within a year, Harrold was promoted to newsreel cameraman and began his professional film career that lasted for more than half a century. Eleven years later, in 1936, he joined MGM Studios in Hollywood as an executive with dual responsibilities. On big-budget movies, he worked either as assistant director or as production manager. He performed both jobs simultaneously on films with small budgets.

One of his first major movie jobs was as assistant director on *Three Comrades,* starring Robert Taylor, Robert Young, and Franchot Tone, released in 1938. He worked on two major 1940 releases, *Northwest Passage,* starring Spencer Tracy, and *Strange Cargo,* with Clark Gable and Joan Crawford, in which he had a small acting role. For *Northwest Passage,* Harrold spent two months in Idaho, Washington, Oregon, Montana, and Wyoming to recruit Native Americans for the movie. He visited eleven reservations and signed up 480 Native Americans, who were paid $10 a day and given room and board while they worked as movie extras.

His long list of motion picture credits included *The Big City,* with Spencer Tracy and Luise Rainer; *Hell to Eternity,* with David Janssen; *The Last Voyage,* with Robert Stack and Dorothy Malone; and *Tora! Tora! Tora!* with Jason Robards and Joseph Cotton. As assistant director on *The Wizard of Oz,* his tasks included finding the mischievous sixteen-year-old Judy Garland in one of her many hiding places and bringing her back to the set. Among his television series credits are "Gomer Pyle," "Death Valley Days," "The Green Hornet," and "Twelve O'Clock High."

When Hitler invaded Poland in 1939, Harrold anticipated that the United States would be drawn into World War II, and he joined the California National Guard as a lieutenant. After Pearl Harbor, he resigned to enlist as a private in the Marine Corps. "I did that for two reasons," he told

me. "The Marine Corps sent out a call for cinematographers, and I knew I'd see a lot more action than in the Guard. Although I was forty-three and far above the enlistment age limit, the Corps made room for me."

He was right about seeing more action. Promoted to staff sergeant and then master sergeant, Harrold joined the 4th Marine Division for the invasions of Roi-Namur off Kwajalein Island, Saipan and Tinian in the Marshall Islands, and Iwo Jima in the Volcano Islands. On his beribboned uniform, he was entitled to nine battle stars, far more than most Marine veterans. He wore four for World War II actions and five for World War I actions with the Canadian Army, including four for battles in France and one for action in Belgium.

During the invasions, Harrold was a cinematographer as well as the top noncom in the division's G-2 photo section. He directed the assignment of twenty photographers. "We operated in teams of two," he said, "a still cameraman with a motion picture photographer. While one man worked a camera, the other covered him with a rifle." His personal camera was a Bell & Howell Automaster, a compact three-turret camera with 16-mm Kodachrome film. "We Marines," he told Sergeant Vergun "were the first combat photographers to carry color film in our motion picture cameras. While the European war was seen by viewers in black and white, we brought the Pacific war to you in living color."

Before the Iwo Jima operation, the Marine Corps and the Navy arranged for Harrold to film a human interest story featuring a seventeen-year-old Marine private and a twenty-one-year-old Navy coxswain on one of the small invasion landing boats. "They were both good-looking boys," Harrold told me. "I began shooting movie film of them in training back in Hawaii, and the idea was for me to do the story of how they worked together in training and combat. I photographed them aboard ship crossing the Pacific and got more footage as they went ashore on Iwo on D-day."

The project quickly became a disaster. "The Marine was killed on D-day," Harrold continued, "and the Navy boy was killed on the first or second day of the battle. The story had to be abandoned."

On D-day at Iwo, Harrold hit the beach with the third wave of the 4th Division assault companies and came under heavy fire from Japanese mortars, artillery, and machine guns concealed in caves on the high ground. "On the first night," he told Sergeant Vergun, "I slept in a deep shell hole with Mark Kaufman, who later became a *Life* magazine photographer.

Throughout the night, weapons fire clattered and we couldn't sleep. And then—ka-boom!—a division ammunition dump, about a hundred feet from our shell hole, blew up with a gigantic explosion that rattled our teeth and shook the ground like an earthquake. In the morning, Mark said sarcastically: 'I'll never sleep with you again, you s.o.b. How could I get any rest with your loud snoring?'"

Harrold stayed in the thick of the action until most of the fighting on Iwo ended many weeks later. One of his assignments was to create a special motion picture titled *Objective Prisoners*. Accompanying the troops as they captured and interrogated the few Japanese who surrendered, he shot 80 percent of the picture's footage. In Kodachrome color, he showed U.S Marine linguists, who spoke Japanese, coaxing soldiers to come out of their caves and caught the action as the Japanese emerged fearfully with arms upraised. He also showed the prisoners, some of whom looked half-starved, sitting on the ground in barbed-wire enclosures and wolfing down Marine chow.

Weinberger's film was flown back to Washington, where Marine intelligence units studied it as they devised strategies to encourage more Japanese to surrender in future operations, including the invasion of Japan. Some of the film was seen later in newsreels released nationwide. Other portions were used in Marine training films to teach officers and enlisted men how to handle prisoners in the field.

Harrold's prisoner movie included footage of the first crippled B-29 bomber to land on Iwo after making a bombing run over mainland Japan. He told Sergeant Vergun that it was an emotional moment: "A young officer got out of that plane, came over to me and said: 'God bless you Marines. Without your help, we'd have gone down at sea.'"

The bomber, nicknamed Dinah Might, had a crew of eleven. A few weeks later, ten of those men were dead. Some were killed in a B-29 shot down over Japan and others in a B-29 that crashed while taking off from its base on Tinian Island.

After the war, Harrold resumed his career as assistant director/production manager at major Hollywood motion picture studios. Promoted to major in the Marine Corps Reserve, he also found time to produce training films for the Marine Corps and public service announcements for its Toys for Tots program. In 1970, he retired from movie studio work. Never idle, even in retirement, he went back to school to study Judaism. The

course required four years. In 1976, at the age of seventy-seven, he graduated from the University of Judaism in Los Angeles. That same year, he had a very belated bar mitzvah, a Jewish coming-of-age ceremony usually held for thirteen-year-old boys who have successfully completed their studies of Judaism. As coauthor of a comprehensive 1980 genealogy, *Nine Klein Generations,* he devoted years to documenting 185 of his relatives killed by the Nazis during the war. Copies of the book are now in the libraries of major U.S. universities; the genealogy archives of the Church of Latter-Day Saints, Salt Lake City, Utah; and every university in Israel.

When Harrold was in his nineties, the Academy of Motion Picture Arts and Sciences awarded him an honor that he prizes as much as he would an Oscar. The academy published his life story titled *Oral History of Harrold Weinberger.* It was produced by academy writers, who had interviewed and taped Harrold for many days. The book is kept in the reference section of the academy's library in Los Angeles.

Long before his friends Bill Genaust and Joe Rosenthal shot their flag pictures, Harrold had a unique way of demonstrating his love for the United States and the Stars and Stripes. When he was a teenager serving in the Canadian Army, he had a small, neatly folded forty-eight-star American flag in his wallet. He carried the same flag during all of World War II and for a long time afterward. "I seldom showed it to anyone," he told me, "I seldom talked about it. Just knowing it was there gave me a good feeling."

Heroes among
the Hills

In an act of heroism in late February, Floyd L. Garrett deliberately slit a Marine's throat.[1] The twenty-three-year-old Navy corpsman from Gadsen, Alabama, was in the 3d Marine Division's sector near Motoyama village. In the dim light of dawn, Garrett saw the Marine collapse in a ravine. Blood was spurting from a bullet hole in his neck.

Garrett knew that the man's jugular vein had been severed and that he would quickly die. The corpsman knelt, slit the Marine's throat with his knife, and exposed the severed vein. He put a metal clamp on it and stuffed the wound with gauze. His swift action save the Marine's life.

The corpsman's commander, Navy Lt. Cloyd L. Arford, a battalion surgeon, called Garrett's action "the most amazing presence of mind I ever saw under fire." The surgery was relatively simple, Doctor Arford said, "but Garrett had no assistant, poor light and was under fire from enemy mortars. Besides, it takes a lot of guts for a non-professional man to start cutting on a man, even to save his life."[2]

During the same action, the long, terrible battle for Hill 382, Pfc Douglas T. Jacobson was also a hero. Jacobson, from Rochester, New York, was only nineteen but already a combat-hardened Marine. When a bazooka man was knocked over by machine-gun slugs, Jacobson snatched

up the weapon and a heavy canvas bag of high explosives and went into action.[3]

His heroism came at a vital moment. His unit, the 3d Battalion of the 23d Regiment, 4th Division, was being clobbered by enemy fire. Seventeen Marines lay dead, and twenty-six were wounded. Clouds from smoke grenades shrouded stretcher teams as they carried casualties to the rear. The rest of the men went bravely forward despite heavy fire from pillboxes and made it to the base of Hill 382, where their attack stalled.

During the next half hour, Jacobson was a one-man battalion. Bent over by the weight of his weapons, he ran a zigzag pattern to avoid enemy fire and then began shooting bazooka shells and hurling demolition charges. He destroyed a machine-gun pillbox and a blockhouse, from which the Japanese had been killing Marines with heavier 20-mm rounds. Ignoring the screams of burning Japanese, he leaped over a boulder, knelt, aimed, and fired another bazooka rocket into still another concrete emplacement.

Ducking and weaving, Jacobson kept going forward into the enemy positions. He blasted one concrete gun emplacement after another—and still another—until all his ammo was gone. Marines who witnessed his assaults were amazed because normally a bazooka requires two men to fire it accurately.

Later, it was determined that young Jacobson had killed seventy-six Japanese soldiers and blown up sixteen enemy positions. For his achievement, he was awarded the Medal of Honor. Perhaps even more amazing was the fact that Jacobson, despite terrific enemy fire, survived the battle with only minor wounds.

These acts of valor occurred while the 3d, 4th, and 5th Marine Divisions were operating side by side in a major effort to capture the remainder of the island. During the grinding northward advance, the 4th was on the right flank, the 3d in the center, and the 5th on the left. The 5th Division had mounted a tremendous effort to capture Hill 362A (see chapters 6 and 7), and the 3d and 4th divisions were fighting equally hard to take the hills and other high ground in their sectors.

Most military analysts agree that, at this time, the 4th Division had the toughest challenge. Its men were ground up day after day in what was called the Meat Grinder, consisting of a group of objectives named Hill 382, the Amphitheater, Turkey Knob, and Minami. Each resulted in the slaughter of huge numbers of young Marines as they went forward over

incredibly complicated terrain resembling the surrealistic rocky gorges and ragged hills of the moon.

The bravery of those men cannot be described. As each day dawned, they were ordered to advance. They knew they would die, but they went. And they were killed.[4]

One of the heroes of the 3d Division was Private Wilson D. Watson of Earle, Arkansas, who fought with the 2d Battalion, 9th Marine Regiment. Just before the assault on Hill Oboe, dozens of howitzers laid down a ten-minute barrage of high explosives, and the infantry then ran up the hill. When he got to the top, twenty-three-year-old Watson was surprised to discover that he was the first man there. In the action that followed, he— like Private First Class Jacobson in the 4th Division sector—became a one-man battalion who captured a pillbox and killed Japanese at a furious rate, at times firing his heavy BAR from the hip.[5]

Watson's citation for the Medal of Honor noted that he killed sixty Japanese before his ammunition ran out and that "his valiant spirit against devastating odds were responsible for the advance of his platoon." The miracle of that battle was that Watson, like Jacobson, survived to fight other battles.

Among the ironies of Iwo Jima was the fact that the heroes who died by the thousands to capture the largest portions of the island received less credit back home than they deserved. On D-day, the invasion of Iwo Jima was covered by seventy top journalists. For a week, they remained on the scene and sent hundreds of thousands of words back to their newspapers, magazines, and radio networks. The newspaper stories started on page one beneath large headlines and continued on inside pages for dozens of column inches.

During the weeks that followed, as the three divisions, often advancing only a few yards at a time, slowly, methodically, and painfully captured the rest of the island, the story of Iwo lacked dramatic punch. Journalists by the dozens departed to cover the fighting in other theaters of war. Although men were still dying in huge numbers, the war on Iwo was shunted to inside pages, with short articles under small headlines.

The U.S. Navy corpsmen were among the bravest of the brave, but they never received sufficient credit. They wore Marine combat gear, treated multitudes of battle wounds, and often fought side by side with Marines to throw back enemy assaults. The corpsmen suffered horrendous casu-

alties. Half a year after the Iwo battle ended, their toll was listed as 195 dead and 529 wounded, but, in 1960, historian Samuel Eliot Morison updated those numbers to 205 dead and 622 wounded.

One of the most unlikely corpsman heroes was Pharmacist's Mate Third Class Jack Williams, a nineteen-year-old Arkansan who described himself as a hillbilly. He talked in a slow, sometimes comic drawl, and his vocabulary was sprinkled with such words as *doggery* and *donk*. A *doggery* was a saloon, and *donk* was the Ozark word for alcohol. A favorite saying in the hills was "Them tourists puts donk in their sody-pop constant."

Although slightly built, Jack was a man of steel beneath his hillbilly exterior. On D-day and for twelve days afterward, he treated more 28th Regiment Marines than he could count. Repeatedly, he returned to aid stations to refill his medical bag with bandages, morphine, plasma, and sulfa powder. From the amount of supplies that he used, the doctors estimated that he cared for hundreds of Marines and saved many lives.

Jack's worst day was 3 March. Suddenly, intense small-arms fire and grenades knocked down nineteen Marines directly in front of him. Five of them no longer needed his care. He went quickly from man to man to treat the other fourteen. As he knelt in a shell crater and shielded a Marine with his body while he bandaged him, a sniper shot Jack three times in the groin and belly.

Without saying a word or grunting in pain, Jack finished treating the man, bound up his own wounds as best he could, and gave first aid to still another man. Then he started back to the Marine lines, but he didn't make it. The sniper fired again, and Jack fell dead. For his determination and fortitude, he was awarded the Medal of Honor.

Three other youthful corpsmen received the Medal of Honor for saving the lives of wounded Marines and for extraordinary bravery under fire: Pharmacist's Mate First Class Francis Junior Pierce, age twenty, of Earlville, Iowa; Pharmacist's Mate Second Class George Wahlen, age twenty-one, of Ogden, Utah; and Pharmacist's Mate First Class John Harlan Willis, age twenty-three, of Columbia, Tennessee.[6]

Pierce and Wahlen survived grievous wounds, but Willis did not. During the 5th Division's long battle for Hill 362A, Willis was trapped halfway up the hill under heavy fire. Despite constant danger as he scrambled around on hands and knees, he bandaged bleeding Marines and comforted them by saying, "Hang on, fella. You're gonna make it."

Ripped by shrapnel, Willis was ordered back to a first-aid station for treatment. Half an hour later, he ran back to the hill and began treating more wounds. A Japanese grenade rolled down the hill. Willis snatched it up and hurled it toward the enemy. It was the first of nine grenades that came flying or rolling down the hill into Willis's position. One by one, Willis threw eight of the grenades back while keeping his other hand on a wounded Marine's plasma bottle. The ninth grenade exploded in Willis's hand and killed him instantly.

When they brought down his shattered body to the first-aid station, the battalion surgeon, Navy Lt. Charles J. Hely, lowered his head and wept. "Bravest young man I ever saw," he said. "Would've made one hell of a doctor because he had such good hands."

Corpsman Pierce's ordeal began when he was caught in heavy enemy rifle and machine-gun fire that wounded another corpsman and two of eight stretcher-bearers who were carrying two wounded Marines to a forward aid station. Quickly taking charge of the party, Pierce carried the wounded men to a sheltered position and gave them first aid. He then stood in the open to draw enemy fire and, blazing away with his weapon, held off the Japanese until all of the stretcher-bearers could reach safety.

While Pierce was attempting to stop the spurting blood of one casualty, a Japanese soldier fired from a nearby cave and wounded his patient again. Risking his own life, Pierce rose up, drew the attacker from the cave, and killed him with the last of his ammunition. He lifted his patient to his back and ran and walked across two hundred feet of open terrain. After Pierce put the man where he would be safe, he ran back, picked up another wounded man, and, drawing heavy fire, carried him to safety across the same open ground.

The next morning, Pierce led a combat patrol back to where the enemy snipers were holed up. The Japanese opened fire and wounded a Marine. While giving him first aid, Pierce was seriously wounded but did not quit. He kept firing at the enemy, while other members of the patrol treated his patient. Then, they all withdrew to safety and Pierce received treatment for his wound.

Corpsman Wahlen insisted on treating wounded Marines after he himself was wounded. He was attached to the 2d Battalion of the 28th Marine Regiment, which was harassed by hundreds of hidden Japanese during its assault on Hill 362B. The enemy soldiers were masters at popping up mo-

mentarily from foxholes and tunnel openings in the rugged rocky gorges, hurling mortar shells and grenades, and then disappearing. Wahlen was wounded twice by flying hot metal. Because his wounds were serious, he was evacuated to the rear each time. After he was treated the first time, he convinced the doctors that he must return to duty. "The guys need me up there," he said. "They're dropping like bricks!"

His bandages leaking red, he went back to the fighting. Dodging a terrific concentration of bullets, he carried a wounded Marine to safety and returned to treat fourteen more casualties. Wahlen was finally hospitalized for four days for treatment of his wounds, but he insisted on returning to action and was wounded a second time. Bleeding heavily, he crawled around treating Marines until his supply of bandages, plasma, and sulfa was used up. Then, exhausted, he collapsed. This time, he lost so much blood that he was near death, but his fighting spirit refused to quit. To the amazement of his doctors, he survived.

In the final weeks of the Iwo Jima operation, thousands of Japanese soldiers and sailors were killed or committed suicide. Day after day, they retreated to their last defenses on the northwest tip of the island at Kitano Point. The Japanese who attempted to escape by doubling back in their tunnel networks to the south did not succeed. Marines blew up their escape routes and blocked the tunnels and caves with fallen rock.

The Japanese were not the only men to perish in the tunnels. An unknown number of Americans presumably died underground with them. An official Marine Corps history reported that, at the end of the battle for Iwo Jima, three Marine officers and forty-three enlisted men were listed as missing in action.[7] Officially, their fate was a mystery. When interrogated by intelligence officers, several Marine enlisted men offered an unofficial scenario: Japanese who infiltrated the Marine lines at night kidnapped some Marines and took them down into the tunnels where they were tortured and killed. Others might have ventured on their own into the tunnels and been killed.

Nearly five decades after the battle, the mystery of the missing Marines was no closer to being solved; new data that emerged merely deepened the mystery. Associated Press, in a dispatch from Iwo Jima on 28 March 1992, reported that the island's tunnels and caves "continue to give up the dead. . . . The remains of 197 U.S. soldiers were recovered earlier this year in a government (Japanese) search. The bones of 7,816 Japanese have been

recovered in similar searches." Although the reference to 197 U.S. "soldiers" (instead of Marines) appears to be an error, the rest of the sixteen-paragraph article is an accurate report on the Japanese search for remains.

No official U.S. agency has confirmed the Japanese reference to the recovery of such a large number of American bodies. In its final casualty figures, the U.S. Army listed only one soldier as "missing and presumed dead."[8] Decades after the battle ended, Japanese exploring the tunnels occasionally turned up Marine dog tags.

Another disturbing aspect of Iwo Jima's battle statistics was the large number of cases of combat fatigue, sometimes described as "shell shock." Bartley's summary included 46 officers and 2,602 enlisted men in this category.[9] On D-day and directly afterward, a large number of cases were the result of concussion from continual mortar and artillery bombardments. Many of these men soon returned to frontline duty.

This was not the case during the later battles for Hills 362A and 382 and the slow advances to the northern tip of the island in mid-March. These men were subjected to weeks, not days, of bombardment. Dazed, glassy-eyed, and in mental chaos, some required months of hospitalization. Many did not recover, not even after years of treatment.

Surrounded by the daily death and horror that was Iwo Jima, some men lost their ability to smile and laugh while others found humor on the flip side of horror and laughed to keep from going crazy.

After Mount Suribachi was captured, the sight of the Stars and Stripes flying high on the peak gave a badly needed lift to the men's morale. Marines scaled the hill the following day and erected a crudely painted sign:

SURIBACHI HEIGHTS REALTY CO.
OCEAN VIEW, COOL BREEZES
FREE FIREWORKS NIGHTLY

Marines who stormed one of the beaches on D-day blinked with surprise when they encountered a wooden sign that read: WELCOME TO IWO JIMA. It had been placed on the beach by Navy and Marine frogmen when they swam ashore two days earlier to check the beaches for barbed wire and other blockades. The frogmen had expected to find miles of barbed

wire, but there was none. This was a big break for the invading Marines. Navy intelligence discovered later that the Japanese had made the mistake of putting all the barbed wire intended for Iwo Jima on board a single freighter that had been sunk by a U.S. submarine.

Navy Lt. Louis H. Valbracht, a Lutheran chaplain with the 27th Regiment, was astonished by the good humor in men about to face death on D-day. On the way to Beach Red with one of the first waves, a private peered over the side of the landing craft as he watched the geysers from exploding shells.

"Boy, what a place to go fishin'!" he said. "Look at those babies jump!"

Another teenager, pretending to be shocked, moaned, "Someone lied to me. The natives on this island ain't friendly!"[10]

Three thousand men of the regiment went ashore that day. When the battle for Iwo ended the next month, the 27th no longer existed. Only five hundred men were left, and they were put into what was called a composite battalion.

Maj. Ray Dollins of the 5th Division was an unusual entertainer on the morning of D-day. As an artillery observer on a plane flying over the island, he radioed target information to the gunners on Navy warships offshore. Between target transmissions, he told jokes on the radio and sang songs, using his own words, from the Broadway musical *Oklahoma*. His favorite song, by which he ignored the ugly scenes below, was "Oh What a Beautiful Morning."

As he finished the chorus, there was suddenly static on the radio, then silence. Dollins's plane had been hit. It dropped from the sky and crashed into the sea among dozens of small landing craft heading for shore. One of the boats picked up the broken bodies of Major Dollins and his pilot.[11]

When large bags of delayed mail arrived on the island in March, Navy Corpsman George Holzner received a letter from his girlfriend in Chicago. She wrote: "The Marines are doing a good job on Iwo Jima. As long as you're not there, I'm happy." Holzner read the letter to his comrades and they all laughed their heads off. They laughed again when Holzner added, "By god, I'm happy, too. I'm the friggin' little man who isn't here!"[12] His eyes were bloodshot, his cheeks were caved in, and he was exhausted. He had been in the hell of Iwo for ten days and sleepless nights, as he attended the wounded of the 21st Regiment. It had suffered heavy losses in the capture of Montoya No. 2, the biggest Japanese airstrip.

A corporal heated the last of his precious coffee by holding an aluminum cup over one of the island's volcanic hot spot, a crevice in the rocks. From it rose a foul-smelling but warm, sulfurous mist. The process took a few minutes, and the Marine, tired and bored, failed to notice that droplets of the mist fell into his cup.

When the coffee was warm enough, he took a big swig and instantly spit it all out. He cried, "Some SOB Jap pissed in my cup!"

In a foul-smelling area near the site of what had been a sulfur mine before the war, the ground was so hot from low-grade volcanic activity that Marines buried cans of C-rations. Within fifteen or twenty minutes, the contents were steaming hot.

While stationed for many days in an area of hot ground, an 81-mm mortar platoon of the 27th Regiment had suffered several casualties. Their green replacements were unfamiliar with the sector's unique characteristics. As soon as he arrived, one scared and nervous young private, who was at least six feet, six inches tall, began furiously digging a foxhole. "Because he was so tall," recalled Cpl. Jesse Darrell Bradley, "he thought he had to dig very, very deep. We told him he'd be sorry, but he was stubborn, throwing dirt around like a dervish."

After retiring in their holes for the night, the Marines stuck their heads up and watched the tall guy. "Pretty soon," Bradley said, "he jumped out and ran around, yelling 'My pants are on fire!' He was okay, but he gave us a good laugh that helped settle us down. We were always a little nervous, too."[13]

As they moved inland from the beach, a squad of Marines came across a large Japanese "No Trespassing" signboard that had been knocked flat. The Japanese words had been blown into splinters, but the English translation was intact:

TRESPASSING, SURVEYING, PHOTOGRAPHING, MODELLING, ETC., UPON THESE PREMISES WITHOUT PREVIOUS OFFICIAL PERMISSION ARE PROHIBITED BY THE MILITARY SECRETS PROTECTIVE LAW. ANY OFFENDER IN THIS REGARD WILL BE PUNISHED BY TERMS OF THE LAW.

MINISTRY OF THE NAVY, 1937

Below those words, a passing Marine had scribbled in heavy pencil strokes: "Jap boy, you gotta be kidding. [Signed] Tresspasser [sic] Jimmy Packard, PFC, 1945."

As dusk fell on 21 February, three kamikaze planes, using the bad light as a shield, smashed themselves against the U.S. aircraft carrier *Saratoga* about thirty-five miles northwest of Iwo Jima. They set the big ship ablaze and blew a huge hole in the flight deck. A confused fighter pilot from a smaller escort carrier managed to land safely on the *Saratoga's* deck. As he climbed from the cockpit, he said with relief, "Gee, I'm glad I'm not on that old Sara! All hell's broken out over there!"

A deckhand replied, "Take a look around, brother. This *is* hell!"[14]

Some of the stories that the Marines thought were funny had deadly undertones. Pfc John MacElroy returned to his home in Williamsport, Pennsylvania, and told the yarn of the Japanese soldier who had to be killed twice. One night, MacElroy helped to destroy a pillbox with explosives. Then, he and another Marine dug a hole and went to sleep. Early in the morning, MacElroy's companion got up from the hole and started to clean his rifle. From the wrecked pillbox came a single bullet that killed him. "What a lousy night," said MacElroy. "We thought we killed that Jap, but we only wounded him. So I had to kill him all over again, this time with a flamethrower."[15]

In another sector, a Japanese soldier suddenly darted from a pillbox with a Marine chasing him and jabbing at his butt with a bayonet. Nearby Marines burst into laughter. They laughed again when a second Marine cut the enemy down with a blast from his BAR before the first Marine's bayonet could touch him. They laughed still again when that Marine complained, "Aw, hell, you spoiled my fun. I was gonna goose him good!"

In the 3d Marine Division sector in the center of the island, a bizarre incident occurred. When a Marine jumped into a hole, he did not know that it was occupied by a Japanese soldier who held a grenade. Before the soldier could pull the pin, the brawny Marine grabbed him in a bear hug so tight that the smaller enemy soldier couldn't move a muscle. The Marine shouted for help. Two other Marines responded and carefully shot the enemy through the head without harming the hugger.

After the major part of the fighting was over, U.S. Army units came ashore to help secure the island. The troops included a detachment of the 147th Infantry Division and a platoon of the 604th Graves Registration Company. The soldiers mopped up die-hard Japanese who refused to surrender and buried enemy bodies by-passed by the advancing Marines.

An Army surrender team, composed of an officer and ten armed men, made numerous patrols up and down rock-blasted ravines. It had the mission of coaxing Japanese soldiers to come out of their tunnels and caves. The team was remarkably successful because all eleven of its members were nisei (second-generation Japanese Americans) who spoke the Japanese language. Using loudspeakers, they broadcast invitations that promised safety, plenty of good food and drink, and warm beds.

The Japanese who surrendered were a pathetic lot, half-starved, cheeks gaunt, uniforms in tatters. In April and May, 1,600 more Japanese were killed, but the nisei team talked 867 into surrendering, the most impressive total of the whole campaign.

The nisei were accompanied by Japanese prisoners on their patrols. One of the most effective at getting the surrender message across was a prisoner whom the Americans nicknamed "Tojo." (Hideki Tojo was the militant premier of Japan who had ordered the attack on Pearl Harbor.)

Tojo the prisoner was neither militant nor very bright. He was a jolly, talkative peasant-type Japanese, who became a great pet of the nisei soldiers. When he asked to be instructed in a few English words of politeness, the soldiers taught him the most revolting obscenities they could think of.

It became routine for any Army work party passing Tojo's group to yell out, "Hey, Tojo, how are you today?"

The happy little guy would come to attention, bow politely, and shout back an awesome obscenity that he had been led to believe meant, "Thank you very much."[16]

Because they had violated the samurai code of "fight to the death," a number of those who surrendered were to lead troubled lives when they returned to Japan. Haunted for years by their disgrace, some finally committed suicide. Others, unable to accept the taunts of neighbors, left Japan and never returned.

Newcomb relates a strange story of a surrender that occurred in April when U.S. Army soldiers discovered the Japanese 2d Mixed Brigade field hospital nearly a hundred feet underground in the eastern part of the island. Speaking in Japanese, a nisei officer appealed to the Japanese to come out.

"After a long discussion," Newcomb writes, "the senior Japanese medical officer, Major Masaru Inaoka, called for a vote. The ballot turned out

sixty-nine for surrender, three opposed. Of the three nays, Corporal Kyu-taro Kojima immediately committed suicide. The others came out, including two more medical officers, Captain Iwao Noguchi and Lieutenant Hideo Ota. Captain Noguchi, beset by remorse that he had lived while so many had died, later emigrated to Brazil, unable to accept life in Japan."[17]

One of the most bizarre incidents of Japanese surrender turned out to be a fake. Near Hill 362A, a Japanese soldier suddenly came out of the mouth of a big cave and calmly sat down in full view of about a dozen Marines. 1st Lt. John K. McLean, who spoke Japanese, was summoned to talk the soldier into surrendering. For thirty minutes, McLean coaxed and promised him food, water, and medical aid.

"This is your last chance," McLean said. "If you don't give up, we will have to shoot you."

The soldier didn't answer. His expression was blank. He scooped up a handful of sand and let it sift through his fingers. One of the Marines moved in closer and saw wires leading from the sitting soldier back into the cave.

"He's bait!" yelled the Marine. "He's wired with explosives!"

Another Marine riddled the soldier with bullets and killed him. McLean then made the same mistake that Sgt. Bill Genaust had made earlier in another cave in the same area. Accompanied by five other Marines, he went into the cave. Hidden Japanese soldiers immediately began throwing grenades and firing a machine gun. When the skirmish ended, three Marines were dead and two were wounded. McLean had squeezed into a niche in the cave wall, out of the line of fire, and survived. The Marines killed the remaining Japanese and incinerated the cave with a flamethrower.[18]

Although the Marines hated every inch of the hellish island, U.S. Air Corps ground crews and Navy Seabees, who arrived in July and August long after the battle had ended, wrote home that Iwo was a fine place to serve. Army officers of the 147th Infantry garrison section said that they would not trade Iwo for any South Pacific island.

The weather was coolish and pleasant. Best of all, there were no mosquitoes.

13

Adelaide and the
Flag-Raising Movie

In June 1945, grieving Adelaide Genaust was invited
by women friends in Minneapolis to go to a movie. They picked a double
feature of slapstick comedies in the hope of cheering up Adelaide with a
few laughs. She no longer laughed much, but she was glad to get out of
the house for a while.

Unfortunately, the Fox Movietone News newsreel that night showed
Marines fighting on the island of Okinawa. Adelaide wept because the bat-
tle uniforms and sounds of gunfire were reminders of Bill. At the end of
the newsreel, there was a brief film of the Marines raising the Stars and
Stripes on Iwo Jima. The audience broke into loud applause at the sight
of the flag going up, but Adelaide wept harder. Any mention of Iwo Jima
on the radio or in the newspapers was hard to bear.

During an interview with Adelaide many years later,[1] she gave me a sad
little smile. "You know," she said, "it was so strange. I saw that flag thing
other times in newsreels, weeks before, the flag going up, audiences ap-
plauding and everything—and each time I didn't even know it was Bill's
movie. Can you believe that?"

Not until much later was Adelaide told that the Iwo Jima flag movie
was the work of her husband. She first got the news in a brief letter of con-

dolence from one of Bill's Marine friends, a letter that was long delayed in the massive clog of wartime mail from overseas.

"At the end of the letter," she said, "there was a P.S. and a question, something like, 'Did you know Bill did the flag movie?' I was so dumb that at first I didn't get it. And then it hit me that he meant what was in the newsreels."

"Were you glad to find out?" I asked.

Her answer took me by surprise. "No. I hated that flag movie. I didn't want to see it. I stayed away from the movie theaters because I might see it."

Again, she gave me the little sad smile. It conveyed that her pain was gone, after the passage of so many years, but not the memories.

For a while, we didn't talk. Then Adelaide told me that it wasn't just the flag film that troubled her so much in June, July, and subsequent months of 1945. It was everything she saw and heard that reminded her of the war and that she would never see Bill again.

"Especially the uniforms," she said. "On the streets downtown, I would see Marines in Bill's green uniform and I wanted to cry. But I didn't cry until I got home. Sometimes at the IRS office where I worked, a Marine in uniform would come in and I couldn't take it. Especially if he was about Bill's age, in his late thirties. I'd run to the bathroom and not come out until I settled down."

"How long did you feel like that?"

"Months. All the rest of '45 and on in to '46. It was even worse when the war ended and all the boys started coming back. Months and months of boys and men. All coming home. And then more and more of them. It was over and everybody was happy."

Adelaide retreated to her kitchen and brewed some coffee. She stayed there quite a while. The coffee she brought was steaming hot and strong. As we sipped, she began to talk at length and I was careful not to interrupt her. Her subject was the plight of war widows, and she said that only a war widow can understand the feelings of another war widow.

"The deep-down feelings," she said. "The loss that doesn't go away. People always say you'll get over it. They like to say it may take months. But they don't know. They don't know at all. There is only one way to know. You have to be a war widow to know, really know."

She went over to the open suitcase on the dining room table and took

out some of the official letters from the Marine Corps that dealt with Bill's death.

"It's these letters," she said. "I remember that they kept coming forever and ever from Washington. That's the worst part." Remembering, she pinched her plump cheek with two fingers and moved her head slowly from side to side. "They keep coming for years and every time one comes you get that down feeling again. I guess this is something every war widow must go through."

She handed me some of the letters that were still, after forty years, in their large ten-by-twelve-inch official Marine Corps envelopes. "Don't read them now," she said. "Take them with you. Return them when you have time."

We talked some more. I asked, "Do you still feel the same way about Bill's movie?"

With quick emphasis, she shook her head. "Of course not. I'm proud. But it's not the way you think. I still don't like that movie. But I'm proud of Bill because he did it—and I know he would be very pleased and proud that it turned out so well."

Later, when I studied the official letters and other items in the correspondence, I had a better understanding of what Adelaide went through. In all the wars and overseas "police actions" since then—Korea, Vietnam, Grenada, Panama, Somalia—the widows at home received similar official correspondence, and each letter that arrived renewed the loss and the pain.

Tucked in Adelaide's file of letters was the small "In Remembrance" program for the memorial service held for Bill at the Mt. Zion Lutheran Church in Minneapolis, where she worshiped for many years (without Bill, who, although religious, never attended). The service was on 3 June 1945. There was no casket, of course, and never would be.

The program mentioned that, in memory of Bill, a set of chimes had been presented to the church by his wife, relatives, and friends. The memorial service was held a dozen days after Adelaide received the letter of 23 May from General Vandegrift that confirmed Bill's death. It had been only a day or two after the service, when Adelaide was so depressed, that her friends took her to see the double-feature comedies that did little to lift her spirits.

The following are portions of only a few of the numerous letters from Adelaide's file, which she kept in careful chronological order. "I never

looked at them more than once," she said. "Too dreary." They cover the period from April 1945 to July 1948.

26 April 1945: Delayed letter of condolence from Sgt. Robert Gamble confirming his friend Bill's death, written nearly a month before Adelaide received the official confirmation letter from General Vandegrift. Gamble enclosed two photos of Bill, one taken on Saipan and the other on Iwo Jima.

7 May 1945: Delayed letter from Lt. Col. George A. Roll, USMC, written "somewhere in the Pacific." In part, it said, "I am writing as your husband's Commanding Officer to express my sympathies to you in his loss in the action on Iwo Jima. . . . I was in a position to observe his work closely and the photographs he took on Iwo Jima were outstanding in quality. . . . His motion picture of the flag raising on Mount Suribachi has already been nationally acclaimed."

30 May 1945: Letter of condolence from Bill's friend, A. G. (Archie) Beaubien, comparing Genaust's flag movie to the "famous Spirit of '76 painting of the two drummers and fife player marching with the flag in the Revolutionary War."

22 June 1945: Letter from Maj. P. H. Uhlinger, USMC, "I am directed by the Commandant of the Marine Corps to inform you that you are entitled to the Purple Heart and the inclosed Purple Heart Certificate posthumously awarded your husband in the name of the President of the United States and the Secretary of the Navy. The Purple Heart is being engraved and will be forwarded to you within the next two months."

6 July 1945: Letter from M. G. Craig, Headquarters Marine Corps, "All personal effects belonging to your husband which have been located up to the present time have been sent to you. No information has been received at this Headquarters concerning any additional items. . . ."

20 July 1945: Letter from Maj. Gen. D. Peck, Acting Commandant, Marine Corps, "I wish to assure you of my deep appreciation of the heroic achievement of your husband, the late Sergeant William H. Genaust . . . in action against the enemy on the island of Saipan, Marianas Group on 9 July 1944, for which he was awarded the Bronze Star with citation by the President of the United States. The permanent citation, which will bear the signature of the Secretary of the Navy, will

be forwarded to you when available. . . . The Marine Corps shares your pride in the gallant action of your husband."

1 August 1945: Letter from W. F. Cuthriell, Chaplain, U.S. Navy, 5th Marine Division, "Since the body of your husband was not recovered, his remains were not interred in a cemetery. A memorial service for all personnel of the Protestant faith of this command who died on Iwo Jima was held at the Fifth Marine Division Cemetery on 21 March 1945. You are correct in your assumption that the personal effects which you have received were those which your husband brought with him when he came to this Division for duty." The letter indicated that additional personal effects might be forwarded, "but there may be some delay."

4 September 1945: Letter from Capt. Kenneth C. Greenough, USMC Recruiting Station, Minneapolis, Minnesota, "As you may already have been informed, your husband has been awarded the Bronze Star Medal for heroism against the enemy at Saipan, 9 July 1944. . . . It is my duty and privilege to present this award. The presentation can be made at your home or another place you designate; or if you prefer, the presentation can be made at my office with my staff and any other guests that you desire in attendance." (The presentation was made at Adelaide's Minneapolis home with Bill's mother, Jessie Genaust, in attendance.)

18 October 1945: Letter from Col. A. E. O'Neil, Headquarters Marine Corps, "I am directed by the Commandant to forward to you the inclosed Citation Certificate awarded your husband, the late Sergeant William H. Genaust, by the National Headliners Club for photographic coverage of the Iwo-Jima Campaign, February–March 1945. The Commandant has noted with gratification the services of Sergeant Genaust, and a copy of the inclosure has been made a part of his permanent record in this Headquarters."

21 February 1946: Letter from Capt. Kenneth C. Greenough, USMC Recruiting Station, Minneapolis: "As you may already have been informed, your husband, the late Sergeant William H. Genaust, has been awarded the U.S. Navy Photographic Institute Citation." Mailed to Adelaide's home, the supersized citation bore the headline, "For Exceptionally Meritorious Photography." The institute was first to recognize the national importance of Genaust's flag film.

The citation stated: "For his ability and deep devotion to duty as a

U.S. Marine Corps combat motion picture photographer under enemy fire at Saipan and Iwo Jima. His color motion picture sequence of Marines raising the flag on Mount Suribachi stands as a symbol of Marine Corps courage and achievement in the Pacific. As a climax to the battle film *To the Shores of Iwo Jima,* it rallied the American public as no other sequence in war photography and reflected the highest credit upon Genaust and the Marine Corps Photographic Service."

The citation was signed by Secretary of the Navy James Forrestal and Navy Capt. Edward J. Steichen, director of the institute.

(No one in the U.S. Navy or Marine Corps informed Adelaide that Steichen was one of America's greatest photographers, a pioneer whose technique and visual imagination helped to make photography a fine art. Steichen's brother-in-law was poet Carl Sandburg, who coauthored *Steichen the Photographer,* published in 1961. Also an author, Steichen had composed the words on Genaust's citation.)

22 July 1948: Letter from Col. L. S. Hamel, Headquarters Marine Corps, "I am directed by the Commandant to forward to you the following posthumous awards to which you are entitled as the next of kin of the late Sergeant William H. Genaust: Asiatic-Pacific Campaign Medal and Copy of Navy Unit Commendation with ribbon bar awarded the Support Troops, Fifth Amphibious Corps, Reinforced, Service on Iwo Jima, Volcano Islands."

Ironically, although Marine Corps headquarters in Washington sent Adelaide many letters, five medals, and the prestigious U.S. Navy citation from Captain Steichen, the Corps itself, from 1945 to 1983, failed to honor Sergeant Genaust for his flag-raising photography.

My interviews with Adelaide in June 1983 took place almost a year before the Corps, at the behest of Harrold Weinberger and Joe Rosenthal, issued its first official recognition of Bill's flag achievement, the very belated (and perhaps inadequate) Certificate of Appreciation. At the conclusion of the interviews, I asked Adelaide if, during the past forty years, she was ever curious about the disregard of her husband's film by the Corps he served so honorably.

"Not at first," she said. "In 1945 and the years right after, I didn't care. I was sick of hearing from the Marine Corps. But after my second marriage, to Mr. Dobbins, we both noticed that Mr. Rosenthal's photo was still

being honored a lot and they even put up that big sculpture in Arlington. We saw Bill's movie a lot, but there was never any mention of Bill."

I asked if she and Mr. Dobbins ever considered formally asking the Marine Corps to honor Bill's film.

"Oh no," she said. "That would've been pushy. I was brought up never to be pushy because, well, it's impolite."

"Did you know that, although Joe Rosenthal received dozens of honors from other organizations, the Marine Corps never gave him a medal or citation for his photo?"

"Are you sure?"

"Absolutely."

Adelaide looked away. Frowning, she glanced around her apartment and then her gaze returned to me. She was puzzled.

"Do you know why?

I said no. Many more years were to pass before I would be able to assemble all the pieces of the puzzle.

14

Putting the Blame on General Vandegrift

Not until 1995 were the final pieces of the puzzle fitted together. They proved that Harrold Weinberger's hunch half a century ago was right on target. From the 1940s on, Harrold had strong feelings, but no evidence, that someone high in the commandant's office was responsible for the way the Marine Corps failed to honor Bill Genaust for his motion picture or even to credit him by name.

The person responsible turned out to be the commandant himself, Gen. Alexander Archer Vandegrift, hero of the bloody 1942 Guadalcanal campaign and one of the Corps' most revered icons.

When I informed Weinberger of Vandegrift's role in suppressing certain Iwo Jima photography, the ninety-five-year-old retired Marine was neither shocked nor surprised: "I should have guessed. Everything pointed to the commandant himself, but there was never any evidence that I could find."

The Vandegrift revelations surfaced in a book about Iwo Jima published in the spring of 1995. Albee and Freeman present evidence that, over a period of $2\frac{1}{2}$ years, from early 1945 to September 1947, General Vandegrift laid down a policy that suppressed issuance or recognition of any of the Marine Corps' Iwo Jima photography that might have diminished the uniqueness of the Rosenthal classic.[1]

The man most affected by the policy was Sgt. Lou Lowery, the *Leatherneck* magazine photographer who shot the photo of the first flag raising. Genaust was also affected because the commandant's office used the policy to reject all efforts to honor the sergeant posthumously for his motion picture achievement.

Albee and Freeman researched a series of media errors and misrepresentations made in 1945 that gave the appearance to the general public of only one flag raising on Iwo Jima—the one photographed by Rosenthal. Those errors led to a major misjudgment by General Vandegrift. The authors offered the following explanation for what became a series of misjudgments and errors by the commandant:

> It was in mid-March 1945 that the first deliberate attempt was made to shore up the heroic myth connecting Rosenthal's photograph with the first flag raising. Prior to this, all cases of mistaken identity had been the result of happenstance. But now the line was crossed into that ethical mine field, managed news. It was apparently Vandegrift who first crossed it.
>
> The press and public had formed a misimpression that Vandegrift found useful to leave uncorrected. Rosenthal had laid at his feet a picture worth much more than a thousand words. Vandegrift made a policy decision to suppress any photograph that might detract from Rosenthal's. He rightly grasped the fact that Rosenthal's picture impressed on the American mind an image of the Marine Corps' heroic sacrifice then under way on Iwo Jima. . . . The sacrifice was real. Withholding a few photographs must have seemed a minor matter compared with the high stakes game in which the Marine Corps was involved.[2]

Vandegrift decreed that *Leatherneck* could not publish any of the Suribachi photographs that Lowery shot on 23 February 1945, including the first flag raising. The decree remained in effect until late 1947, when the magazine came under increasing pressure—much of it from an angry Lowery himself—to publish his photos.

Albee and Freeman obtained some of their data on 28 December 1992 in interviews with former WO Norman T. Hatch, the 5th Division's photo section director. In mid-March 1945, Hatch, then twenty-four years old, received orders to leave Iwo Jima and report to the commandant in Washington. He arrived nearly three days later, still in combat dungarees, tired from a long series of connecting flights and wondering what the hell the commandant needed him for.

He quickly found out. Escorted into Vandegrift's office, he met with the general and two top media representatives, Alan J. Gould of Associated Press and Alan Bibble of *Time* magazine. All three needed Hatch to straighten out what had become known as the "two flags mess." Because of widespread media misconception that Rosenthal's photo was of the first flag raising, AP and *Time* needed to know the facts.

Hatch was able to produce his D-2 journal, a minute-by-minute record of everything that had happened on Suribachi during both flag raisings. His notes proved that the Rosenthal photograph was not posed. Gould promptly made a decision that, from that time on, the Associated Press would never claim that the Rosenthal photo was of the first flag raising.

Bibble was equally satisfied. *Time's* role in the "mess" involved the fact that its renowned correspondent, Robert Sherrod, had made a major error by claiming in a New York radio report that the Rosenthal photo was posed.[3] Sherrod's report had made the AP's editors so angry that they had threatened to sue Time-Life, Inc.

As the meeting progressed, Warrant Officer Hatch gave the commandant another big assist. He suggested use of the Genaust motion picture as a bargaining chip in the commandant's negotiations with the AP for future use of the Rosenthal photo. Hatch told Albee and Freeman:

> I knew that Bill Genaust had gotten the flag raising on movie film even though I hadn't seen it. I played a big role in this one, because the commandant turned to AP and said: "You know, we'd like to use that photograph. It's going to be wonderful publicity for us. . . ." And AP says, "We'll be very glad to let you use it. We'll even give you dupe negatives and the fee is only going to be $1 a print. . . ."
>
> Dead silence. Vandegrift turned to me and asked what do you think of that? I said I don't think we have to do that because we can put it out in color. . . . We have footage by Bill Genaust. He has the flag-raising in 16mm film. There is always one frame that is sharp. We can make color 8 by 10s from that.
>
> More dead silence. The commandant looked over to AP and Gould said: "Well, we'll be glad to give you the use of the Rosenthal photo. Just credit AP."[4]

Soon after that, Vandegrift issued his verbal order suspending publication of the Lowery photos. Also affected by the ban were flag photos taken on Suribachi by two other photographers, Sgt. Louis R. Burmeister of

the 5th Marine Division and Pfc George Burnes of the Army's *Yank* magazine.[5] When he returned home in 1945, Burmeister was disappointed because none of his flag photos had been developed or printed.

Vandegrift served as commandant from 1944 until his retirement in 1948. Although fully aware of the Genaust motion picture's contribution to the Corps, he made no effort to honor the sergeant—or Rosenthal—for their epic photography. *Life* magazine published Lou Lowery's flag-raising picture in its 26 March 1945 issue, but Vandegrift refused to let Marine Corps editors publish Lowery's photos until September 1947 when *Leatherneck* presented the whole series.

The commandants who served after Vandegrift let the Rosenthal photograph speak for itself and made no effort to censor the work of any of the other Suribachi photographers. During Truman's presidency, 1945 through 1952, one of the Corps' major goals was funding for the giant flag sculpture planned for Arlington National Cemetery. It kept a low profile on how its officers and enlisted men were dunned to dig deep into their pockets to help raise the $850,000 needed to pay for the hundred-ton bronze, which was so important to the Marine Corps' future.

At every opportunity, the Corps made it clear that not one penny of government money would pay the bill. Large sums were raised by public subscription. Because President ("Give 'Em Hell") Truman was an ex-Army man who repeatedly and bluntly criticized the Marine Corps and had signed legislation reducing its size,[6] the Corps did its best not to arouse his anger. Although, at first, he approved the Arlington sculpture, he later changed his attitude and was openly critical of its size.

In mid-1954, as time was growing closer for unveiling the massive sculpture that November, the White House declined to say whether President Dwight David Eisenhower would attend the dedication ceremony. Invitations went unanswered. Officials close to the Oval Office hinted that, very likely, the press of other, long-scheduled commitments would prevent the president from attending. These and other hints from the White House indicated that Eisenhower disliked the entire sculpture project, particularly its size. The president's appearance at the unveiling remained uncertain until the morning of the dedication on 10 November 1954, the 179th anniversary of the founding of the Marine Corps.[7]

All the big names of Washington and an audience of seven thousand fidgeted in the chill breeze at 1100, as they waited for the president to ap-

pear. The crowd was dwarfed by the enormity of the green-patina bronze figures high overhead. The helmets of the six flag raisers were the size of cars, and a Marine's outstretched hand and forearm were bigger than a six-foot man.

Finally, midway through the ceremony, the president arrived and took his place on the speakers' platform between Vice President Richard Nixon and Gen. Lemuel C. Shepherd, Jr., commandant of the Marine Corps. Eisenhower did not say a word to the expectant crowd. He stayed about ten minutes. As soon as the flag was run up the sculpture's slanting pole, he strode quickly away and disappeared with his contingent of aides and Secret Service bodyguards. Reporters, cameramen, and TV crews who tried to follow him were blocked by police and Marine guards.

The press cornered White House personnel who had remained and badgered them with such questions as: Why didn't the President speak? Why did he seem so glum? Was his quick departure some kind of put-down of the Marine Corps?

The reporters had to be satisfied with one answer for all of their queries: The president was late for his meeting with the Japanese ambassador.

Among the disappointed crowd were the three surviving flag raisers, Rene Gagnon, Ira Hayes, and John Bradley. They had hoped to shake hands with President Eisenhower but had to settle for meeting Vice President Nixon. They were seated in the front row of the VIP section. The surviving Marines who had raised the first flag, Harold Schrier, James Michels, and Charles Lindberg, were seated out of sight toward the rear of the assembly, but they did manage to shake hands with Nixon. Also seated out of sight were Joe Rosenthal and Lou Lowery.

Among the honored attendees were the mothers and widows of the six Marines who had raised the first and second flags and were later killed. Sergeant Genaust's widow, Adelaide, was not present, however, because no one in the Marine Corps had thought to invite her.

Rosenthal began his visit to the monument with feelings of pride and elation. Soon, he was perhaps the most disappointed of anyone there, the victim of a snub[8] more gross than anything he might have imagined. He attended with his slender, brunette wife Lee and their two small children, Anne and Joe Jr. Before the ceremonies began, Joe and his family went up to the monument and began to walk around it on an impromptu inspection tour. Although he did not say anything to the youngsters, Joe hoped

that they would have the fun of discovering his name on the great piece of art.

The children soon found and read, with some difficulty, the name of the sculptor, Felix de Weldon, displayed prominently on the base. Then, the family walked slowly around the monument with the children encountering and reading many of the words in big letters of glistening gold—French Naval War, War of 1812, Tripoli, Florida Indian Wars, Cuba, Nicaragua, Belleau Wood, Saipan, Tarawa, Tinian, Iwo Jima, Okinawa, Guam, Guadalcanal, Korea, and many more names of renowned Marine Corps battles.

The golden names went completely around the huge base of the monument. The Rosenthal family circled the base once, then twice, and never found the name they were looking for. The name of Joe Rosenthal, whose photo had inspired the great monument, was not there.

Joe wondered if the omission was an accident or if the snub was deliberate. Unwilling to call attention to himself, he did not try to find out. But, a further insult awaited Rosenthal, and it would come from—of all places—the White House. On 19 November 1954, Senator Earle C. Clements of Kentucky wrote a letter to President Eisenhower and asked that special commendations for heroism be issued for the six flag raisers depicted in the monument. He also requested that his constituent, flag raiser Franklin Sousley, who had died on Iwo Jima, be given special recognition.

The president immediately rejected both ideas. His reply to Clements, composed by his staff but signed by Eisenhower, stated that raising the flag was not an act of great heroism, and it seemed to imply that the president had a low opinion of the whole monument idea.[9]

There were also darker implications in the letter. It revived the old slur that Rosenthal's great photo of the war was a phony because, having missed the picture of the first flag raising, he had requested a second flag and posed the six men in the act of raising it.[10]

Officers on the commandant's staff, who knew the truth about Joe's photo, were outraged by the White House's failure to research the facts properly. In effect, the gist of their angry reaction was how could Eisenhower do this to the thousands of Marines who had died on Iwo Jima and had he forgotten that, quite possibly, the Marines who had secured Iwo Jima also had saved his life?

That incident involving Eisenhower is recognized as an intriguing footnote to the history of the battle of Iwo Jima.[11] While campaigning for the presidency in 1952, Eisenhower had promised the voters that, if elected he would visit South Korea to find out why the Americans and South Koreans were not winning the war. In November, two weeks after the election, he made good on his campaign promise and headed toward Korea. His four-engine, prop-driven Lockheed Constellation refueled on Guam and then took off for Japan on the route flown by the B-29 bombers in 1945. Halfway to Japan, the Constellation developed critical engine trouble and was in danger of crashing into the sea. The pilot was able to make a forced landing on Iwo Jima.

The Marines who fought the battle of Iwo Jima had made the island safe for forced landings. If they had not done so, Dwight David Eisenhower might not have lived to become president.

15

Nimitz: A Rock
of Gibraltar
in the Pacific

Chester William Nimitz was a quiet, soft-spoken Texan who rarely lost an argument or a sea battle. Friendly and courteous to everyone, whether ordinary seamen or presidents, he was such a rock-solid leader and strategist that President Roosevelt passed over twenty-eight senior admirals to name Nimitz commander of the Pacific fleet.[1]

That was in late December 1941; the Navy was in chaos following the Japanese attack on Pearl Harbor. After rebuilding the fleet, fifty-six-year-old Nimitz and his carefully chosen admirals went on to win the Pacific war with such epic victories as the battles of Midway, the Coral Sea, and Leyte Gulf. The latter was the biggest naval battle in history.

At Iwo Jima, Nimitz and his brain trust of admirals[2] knew they were in for a tough fight and prayed that it would be short. Back in Washington, the Joint Chiefs of Staff were more optimistic. Because of the island's Lilliputian size and the enormous size of the U.S. Navy and Marine Corps invasion forces, they indicated to Roosevelt and his circle of advisors that Iwo Jima might be captured in less than a week.

Of course, this was a gross miscalculation. Before long, Roosevelt was greatly disturbed by the outcry across the nation when the bloody battle raged on five times longer than anyone had anticipated. After five days of

mass killings of Marines, even Maj. Gen. Harry Schmidt, V Amphibious commander, still underestimated what had to be done. Asked by correspondent Robert Sherrod how long he expected the campaign to last, Schmidt said: "Five more days after today. I said last week it would take ten days, and I haven't changed my mind."[3]

As more American blood continued to be spilled—for ten days, fifteen days, twenty-five days—powerful minds in Washington came down hard on Fleet Admiral Nimitz and demanded answers. Nimitz was unruffled by such criticism. The miscalculation of a short battle was not of his doing, but it must have affected his thinking. Quite possibly, however, pressure from Washington could have influenced the admiral's decision in mid-March 1945 to issue two proclamations that Iwo Jima was secure and organized resistance had ended.

Such announcements were common practice during some of the Pacific island battles of World War II. At a certain point, the overall commander, usually Nimitz, decided that the enemy could not win, and the proclamations were ultimately correct in each case.

Iwo Jima, however, was a different story. After Nimitz's proclamations, large units of Japanese fighting men were still intact underground and determined to fight to the death. Because of this, Nimitz was openly criticized by Marine officers and enlisted men on Iwo, and many declared his proclamations to be premature and harmful to morale. On the other hand, military historians and scholars, who take unemotional views, have indicated that they were proper. During some island battles, the proclamations brought about early surrender of the enemy and saved American lives.

The controversy surrounding Nimitz's Iwo Jima proclamations was a mere droplet in the boiling stew of high-level disputes in which Nimitz was immersed year after year. He argued about war plans with just about everybody—brilliant admirals on his staff, Marine and Army generals, and his superiors in Washington, particularly irascible, hard-nosed Adm. Ernest J. King, chief of naval operations.

Resolving conflicts with others of high rank was part of the job of all top commanders of World War II, including Gen. Dwight D. Eisenhower in Europe. His years of arguments with stubborn British Field Marshal Bernard L. Montgomery were legendary. Some of Nimitz's longest-running and most significant disputes were with Gen. Douglas MacArthur, supreme commander of all U.S. Army units in the Pacific. Master of flam-

boyant phrases and more than a little egotistical, MacArthur was a superb strategist and spent years devising a master plan for the capture of Formosa.

As the war progressed, overall strategies changed. At one time, Nimitz had agreed with MacArthur and favored the Formosa invasion as a means of shortening the war. In 1944, however, Nimitz took a totally different view. In a San Francisco conference with Admiral King that MacArthur refused to attend, Nimitz argued quietly that Formosa be bypassed in favor of invading Iwo Jima and Okinawa.

This proposal came as a shock to King. Along with Gen. George C. Marshall, chairman of the Joint Chiefs, King had long believed that the capture of Formosa was essential. After listening to Nimitz for five hours, King rejected MacArthur's persuasive arguments and accepted the Nimitz logic that the capture of Okinawa and Iwo Jima, which were closer to Japan, would shorten the war.[4]

History proved that Nimitz was right. Although the Iwo Jima and Okinawa battles resulted in great and tragic losses of life, it became clear that far more Marines and soldiers would have perished in the longer, bloodier fight for Formosa. A huge island ruled by Japan from 1895 to the end of World War II, now known as Taiwan, Republic of China, its current population is 21 million.

Iwo Jima survivors who disagreed with the Nimitz proclamations nevertheless joined with other Marines in expressing their gratitude for these stirring final words in the admiral's 17 March 1945 communique: "Among the Americans who served on Iwo island, uncommon valor was a common virtue." Half a century later, that phrase stands out as one of the finest tributes ever paid to the men of the Corps.

After the war, conflicting statistics emerged concerning the numbers of Marine casualties that occurred in the weeks following Nimitz's proclamations. Some tabulations, widely circulated, said that there were fewer than 3,000. Ross, in doubling that figure, states: "Marines from privates to generals questioned his (Nimitz's) timing as tragically premature; they would suffer more than six thousand additional casualties before leaving the island."[5]

Ross, who fought at Iwo as an enlisted man, was a respected authority on the battle. Other authors, however, including Newcomb and Bartley,

did not mention the 6,000 figure. Newcomb and Bartley both gave the final tabulation as 3,885.[6]

For half a century, historians and scholars have been collecting an enormous amount of data about the battle for Iwo Jima and its aftermath. Some of the data are controversial and some contradictory, but most are fascinating in one way or another. It was not generally known, for example, that Iwo Jima, although more than 650 miles south, was (and still is) considered part of Tokyo. Decades before World War II, the Japanese government had officially designated Iwo Jima as located within the Tokyo city limits. In 1945, this was considered a psychological advantage for the defending generals and admirals because they could urge their men to fight furiously in defense of their homeland.

Although on a smaller scale than Iwo Jima, the seventy-six-hour battle for tiny Tarawa atoll in 1942 was as bloody in its way as the battle for Iwo Jima and resulted in 3,381 Marines dead or wounded. Some World War II analysts theorize that the badly planned Tarawa invasion was a waste of lives and the atoll should have been bypassed.[7]

A number of analysts indicate that Iwo Jima also should have been bypassed and its 23,000 Japanese defenders left to rot in their caves and tunnels. That theory has long been discounted by many military scholars, who note that, by the end of the war, 2,251 disabled B-29 bombers had made emergency landings on Iwo Jima. As a result, 24,751 Air Corps crewmen were not forced to crash at sea.[8]

For years before the invasion, battle planners had studied maps and aerial photos of other islands in the Volcano and Bonin chains. Because of their rough, mountainlike topography, none of them appeared to be as suitable as Iwo, where a Japanese airstrip was already built and another nearly finished.

The Seabees were wizards at building airstrips, piers, and bridges in quick order. On Iwo, for example, they swiftly removed three million yards of earth—including all of Hill 382—to construct a 10,000-foot landing strip. This produced postwar speculations that the Seabees could have constructed a B-29 emergency landing field on any other island, even if it was mountainous or hilly, within six weeks or so. Theoretically, such a strategy would have avoided the heavy loss of life on Iwo. Construction engineers familiar with the topography of the Volcano and Bonin islands,

Immortal Images

however, had said that this idea was not practical. Their studies indicated that massive earth movement on another island would have meant a delay of months, not weeks, and resulted in heavy losses of B-29 bombers.

From their bases on Guam, Saipan, and Tinian, the Superfortresses were forced to fly three thousand miles nonstop to Japan and back. Each flight was an ordeal of sixteen hours, and the crews were near exhaustion at mission's end. Some pilots of disabled B-29s made two or three emergency landings on Iwo Jima, and one pilot reportedly made five such landings.

The heavy losses of Marines on Iwo Jima tended to take attention away from the unexpectedly high number of Navy losses during the battle for the island. A total of 881 Navy men were killed, and 1,927 were wounded. Most of the Navy dead were victims of Japanese kamikaze attacks on the armada of 485 warships and support vessels in the vicinity of Iwo Jima. Among the ships hardest hit by kamikaze aircraft were the aircraft carriers *Saratoga,* which survived but suffered 123 killed and 192 wounded, and the *Bismarck Sea,* which turned over and sank, with the loss of 218 men. A kamikaze raid on the attack transport *Blessman* killed 42 Navy men and wounded 29. When a coastal gun shelled the destroyer *Terry,* 11 men were killed and 19 wounded.[9]

Two days before D-day, the Navy had sent ashore 102 Navy and Marine frogmen to determine if the beaches were safe for the invasion troops. The Japanese mistakenly believed that a major invasion was under way, and a furious battle resulted between the Japanese coastal guns and the U.S. Navy ships. The frogmen were put ashore by a fleet of vulnerable small boats, mostly LCIs (landing craft infantry) converted into gunboats. They were protected by cruisers moving in close to shore. The cruiser *Pensacola* was hit by six Japanese shells, with casualties of 17 killed and 120 wounded.

During the next ninety minutes, every small landing boat was hit or sunk; 43 crewmen were killed and 153 wounded. One commander, Lt. Rufus G. Herring, although wounded three times, saved his badly damaged small boat and was awarded the Medal of Honor. Of his crew, 21 were killed and 18 wounded. Ten other small boat commanders won the Navy Cross. Only one frogman was killed; all the others were recovered safely.[10]

Other naval casualties included 205 medical corpsman killed, 622 wounded; 51 Seabees killed, 218 wounded; and 2 doctors killed, 12 wounded.[11]

The Marines required thirty-six days of battle to secure the island. Army troops then came ashore to complete the mop-up and suffered considerably heavier losses than anticipated: 53 killed and 116 wounded. The heaviest toll occurred on 26 March, when the Japanese launched a well-planned final raid just before dawn. They killed 44 sleeping Army Air Corps fighter pilots and other personnel and wounded 88. The Army's 147th Regiment, which continued to battle holed-up Japanese after the Marines left, suffered casualties of 9 dead and 28 wounded.[12]

Despite Iwo's tiny size, Admiral Nimitz did not underestimate the enemy. He made certain of victory by amassing an awesome invasion fleet of more than 800 ships and a quarter of a million men. The expeditionary forces that went ashore totaled 111,308 men—75,000 Marines plus Navy men assigned to shore duty and Army and Air Corps personnel. In addition to 485 ships at Iwo Jima, another 400 ships were part of Task Force 58, which mounted fast carrier strikes on Japan to keep its ships and planes occupied while the Iwo invasion was under way. Ship crews totaled nearly 140,000.[13]

For months prior to the invasion, all Marine and Navy units that would be part of it maintained an unprecedented level of secrecy about ship and troop movements. Nevertheless, there were leaks.

The most outrageous breach of security occurred two months before the invasion, when the *Honolulu Advertiser* published two photographs, released by the Army Air Corps, on 22 December 1944. Captioned "Bombs Away!" one photo showed a U.S. bomber over a target clearly identifiable as Iwo Jima, with Mount Suribachi at the narrow southernmost point.[14]

The gigantic invasion fleet was easily tracked by Japanese submarines. From Tokyo, in her propaganda broadcasts aimed at demoralizing U.S. troops, the notorious Tokyo Rose[15] boasted that the landing forces would include the 3d, 4th, and 5th Marine Divisions. Although the Japanese did not nail down the exact invasion day, they came close. The high command on Iwo was alerted to expect the invasion between 14 and 20 February.

From time to time, Headquarters Marine Corps has been asked about the current location of the two flags raised on Mount Suribachi. The first

one was presented to Col. Harry ("the Horse") Liversedge, commander of the 28th Regiment, whose men raised both flags. Later, it went on display in the Marine Corps Museum at Quantico.

The second, larger flag received more attention. In a ceremony on 9 May 1945, it was flown over the U.S. Capital in Washington and then taken on a tour of U.S. cities as a feature of the Seventh War Bond Drive. Later, it was sent to Hollywood and flown in the 1949 John Wayne movie, *Sands of Iwo Jima*. Afterward, it went on display in the museum at Quantico. Since the 1970s, both flags have been displayed in the Marine Historical Center, Washington, D.C.

Throughout the war, some high-ranking civilian leaders and some leaders of the other armed forces criticized the Marine Corps for the high losses it suffered in many of its Pacific island battles. The nationwide Hearst newspapers and the influential *Chicago Tribune* recommended that, to save lives, the Army should spearhead the eventual invasion of the Japanese mainland because its losses in battles of the Pacific islands were consistently lower than Marine casualties. The newspapers demanded that General MacArthur command the invasion forces.

Gen. Holland M. Smith states in his memoirs that there never was any doubt about MacArthur being overall commander of the mammoth U.S. Army and Marine Corps ground forces that would invade Japan. Code-named Olympic, the first stage of the invasion was scheduled for November 1945, with the landings to be made on the southern coast of Kyūshū, Japan's southernmost island.[16]

The second phase of the invasion, on the main Japanese island of Honshū, was scheduled for February 1946. General Smith made it clear that MacArthur agreed that Marines would spearhead both landings because they were amphibious invasion experts who moved fast after landing and were never defeated in such battles. Heavy losses were a natural consequence of these operations.

Smith continues: "General MacArthur insisted that a large-scale invasion approximating the magnitude of the European invasion was necessary to reduce Japan. The Joint Chiefs of Staff in Washington and our Allies were of the same opinion."[17]

The invasion of Japan was expected to be the bloodiest of all World War II battles because of fanatic resistance by the populace. A million American casualties were projected by some battle planners. Although General

MacArthur sought to be named supreme commander of the Pacific, the title went instead to Admiral Nimitz.

After the war, Nimitz became chief of naval operations in Washington. MacArthur, named supreme commander in Japan for the Allied powers, directed the occupation forces, instituted land reform, and restored the country's shattered industry.

The multitudes who visit the great Iwo Jima sculpture near Arlington are not aware of this fascinating oddity: sculptor Felix de Weldon began preliminary work on it nine days *before* Joe Rosenthal saw his own photograph of the flag raising or even knew it existed.

Born in Vienna, Austria, de Weldon was both art scholar and artist. He studied art in Europe and revered the works of its greatest painters and sculptors. After emigrating to the United States, he joined the Navy during the war. The Navy recognized his talent and assigned him duties that included painting and sculpture. While painting murals at the Navy's air base at Patuxent, Maryland, on Saturday, 24 February, de Weldon happened to see Rosenthal's photo shortly after it arrived on the base's wirephoto machine. Because of its perfect composition, de Weldon decided that the photo could be the basis for a classic piece of sculpture. The idea was so exciting that he began at once to mold the figures out of wax. Starting on his project that evening, he completed the model during the early hours of the next morning. That was the Sunday when millions of Americans found the Rosenthal photo on page one of their newspapers.

Slightly built, de Weldon was a thirtyish sailor of nearly the lowest rank. Capt. T. B. Clark, commander of the Navy base, was so impressed by de Weldon's small model that he showed it to two admirals. They were equally impressed and arranged for Marine Commandant Vandegrift to see the wax model. Vandegrift was delighted with it. He made arrangements for de Weldon to be transferred temporarily to the Marine Corps and gave him a studio at Corps headquarters.

In a few weeks, de Weldon completed a larger plaster sculpture of the flag raising that he painted bronze. A couple of months later, he was invited to the White House to show the sculpture to President Truman. By then, de Weldon envisioned making a mammoth version similar to huge military sculptures that he had seen in Europe. The Marine Corps and Navy Department approved of the idea and gave him the go-ahead.

A unique series of circumstances kept Rosenthal from knowing about his soon-to-be famous photograph. He shot the photo on Friday, 23 February, which was Thursday in the United States. He sent the negative with others by mail plane to Guam for processing. The photo was transmitted to the States via radiophoto machine. On Saturday (U.S. time), the Associated Press was relaying the photo to U.S. newspapers and other outlets, including military publications. That was when de Weldon saw it. Meanwhile, Rosenthal remained on Iwo Jima for another week. He did not see his photo or learn about worldwide reaction to it until 4 March, when he arrived on Guam—nine days after he shot the picture.

Felix de Weldon became a wealthy man and pursued an extravagant life-style. He was paid high fees for large sculptures of the flag raising that he made for several Marine Corps bases and other sites throughout the United States. He also turned out vast numbers of souvenir versions of the flag raising, some quite expensive but others popularly priced. One of Washington's most prominent and sought-after sculptors, he earned large commissions for busts of Nimitz and other admirals, generals, Supreme Court justices, cabinet members, and President Truman.

The sculptor, however, did not remain wealthy during the later years of his life. His financial troubles began when he was unable to repay a $1.5 million loan for the care of his wife, who had died of Alzheimer's disease. In June 1993, when he was eighty-six years old, de Weldon declared bankruptcy. An auction was held in Washington to liquidate his studio and assets, but it was considered a failure. For example, a white plaster model of the Iwo Jima monument went for $100, and other works were sold for $25 to $1,000 each. The three dilapidated buildings comprising de Weldon's nineteenth-century brick studio and the land they sat on went for a paltry $30,000.

"Disgraceful," de Weldon said. "In any other country someone like me becomes a national treasure. Except in the rich United States, they try to ruin somebody who created many heroic monuments."[18]

After dedication of the Marine Corps War Memorial, the reaction of the nation's art critics was negative. This was largely because the monument was a colossal example of art realism at a time when realism was falling out of favor with the critics. Marling and Wetenhall, both art experts, compiled evaluations by leading critics. Among their example is the headline on the front page of The New York Times, 31 March 1955: "Esthetic Numbness in Official War Monument Is Criticized."[19]

In an April 1955 article, art critic Charlotte Devree called the monument "artistically appalling" and added that "the statue was bad art . . . worse than that, however, it bore a close resemblance to the sculptural monuments of the Nazis and Soviets."[20]

Marling and Wetenhall explain that, although de Weldon became "the darling of Washington society . . . and one of the most prolific monument-makers of this or any other era . . . he never became part of the art world. He remained an outsider, a virtual pariah. . . . His work was not collected by important art museums. Textbooks on American art omitted all reference to his name." These authors disagree sharply with critics who despised de Weldon and the statue. They highly praise the statue as "an art of heroic realism, a sculptural tour de force in which size equalled power and accuracy equalled truth."[21]

16

A Plot against the
Stars and Stripes

Some of the Japanese Navy men who served with Sr. Capt. Samaji Inouye on Iwo Jima thought he was a maniac, but others believed him to be a superior leader who inspired his men to perform unforgettable acts of bravery. Late in the Iwo operation, he was promoted posthumously to rear admiral.

Every day, as Inouye watched the Stars and Stripes flying atop Mount Suribachi, his fury increased. He became obsessed with the idea of fighting his way back to the volcano to return the banner of the Rising Sun to the summit. His aides quote him as saying, "We shall destroy their banner. We shall replace it with ours in the name of the great Emperor and the great people of Japan."[1]

Details of the forty-nine-year-old captain's plot were revealed later by two Japanese men and by American historians and authors who had obtained access to archives in Tokyo. The Japanese men were the captain's orderly, PO Riichi Koyatsu, who survived the ordeal and surrendered, and photographer/author Fred Saito, whose pictures included portraits in uniform of Inouye and other high-ranking officers of the Iwo command.

Inouye was commander of the well-trained Naval Guard Force manning the island's long-barreled shore guns that sank or damaged many

U.S. warships. His command also included batteries of dual antiaircraft guns that were quite effective against U.S. planes.

Koyatsu and Saito described Captain Inouye as a thundering, arrogant, and temperamental swashbuckler. A champion swordsman, he boasted to his men of his powers as a fighter and lover of beautiful women. He was a heavy drinker of both whiskey and sake. He inspired his men with fiery *Bushido* (warrior's code) speeches that placed high value on a warrior's honor and low value on his life. When one of his young lieutenants did something dishonorable, Inouye flew into a rage, brandished his saber with both hands, and threatened to behead him on the spot. The captain's aides had to wrest away the saber and calm him down.

In the second week of March, Captain Inouye and Maj. Gen. Sadasue Senda, commander of Japanese Army artillery on Iwo, planned an ambitious counterattack against U.S. Marine forces who were squeezing the Japanese into a narrow sector near Hill 362C and the coast on the island's northeast side. Inouye's remnants of naval troops numbered nearly 1,000, but Senda was able to call together less than 150 soldiers. The two commanders assembled their officers and outlined their strategy to recapture Suribachi. Late at night, their troops would break through the Marine lines and battle their way about $3\frac{1}{2}$ miles south to the extinct volcano. On the way, they would cross the two biggest airstrips, Motoyama No 1 and Motoyama No. 2. The captain was certain that the airfields would be lightly defended by undisciplined service troops and that his men could blow up the B-29 bombers undergoing repairs.

Around dawn or before, they would climb Suribachi, tear down the U.S. flag, and raise the red-and-white Rising Sun as an inspiration to all of the Japanese fighting men on the island. They knew that the mission was nearly impossible, but they might succeed and certainly, in any event, would demonstrate their *Bushido* courage to their emperor and the world.

General Senda radioed word of the scheme to General Kuribayashi in his blockhouse headquarters near Kitano Point, less than a mile away. The commander, reacting angrily, declared the plan impractical and stupid. He radioed back an order that Senda and Inouye must cancel the attack immediately. Throughout the Iwo campaign, Kuribayashi had opposed banzailike charges as a waste of lives.

Inouye and Senda consulted. They decided to ignore their commander's order.[2]

On 8 March, as twilight fell across Tachiiwa Point near the northeastern shore, it became apparent to Marines of the 23d and 24th regiments that there was unusual activity behind the nearby Japanese lines. The Marines, who were dug in for the night, did not know that the eighth day of every month had special significance for the Japanese because that was the date of the Japanese attack on Pearl Harbor in December 1941 (a day later than in the United States because of the International Date Line). Well aware of the date, Captain Inouye planned to make it as memorable as possible for his men—and also for all of the Marines in his sector that he intended to kill.

At first, the Marines heard only the enemy's muffled voices and what might have been the movements of boots and equipment. Because they often heard such sounds at night, they did not suspect that this night would be different.

Suddenly, a deafening barrage of artillery crashed down on the two Marine regiments. It continued on and off for an hour and a half. Then, around 2230, large numbers of Japanese, poorly equipped survivors from a mixture of many shot-up units, began boldly to infiltrate the Marine lines. Some of the sailors carried only crude spears. A few had light Nambu machine guns, but many had rifles and grenades. Some of the strongest had strapped awkward land mines across their chests. They intended to blow up Marines along with themselves.

Military analysts who dissected the Senda/Inouye battle plans after the war agreed with General Kuribayashi's decision that the assault was foolish but admitted that it was courageous. Quietly and slowly, the sailors crawled into the American lines. One platoon-sized cluster sneaked within a dozen yards of the command post of the 23d Regiment's 2d Battalion before the Marines discovered them and alerted other units with shouts and curses.

The rest of Inouye's forces—hundreds of men plus some of Senda's troops—came charging in as they shouted the traditional battle cry, "Banzai! Banzai!" Some hurled grenades that blew Marines to shreds. In the madness and chaos that followed, the Marine companies hurled up flares and star shells to light the sky and rocky terrain. They hammered the Japanese sailors and soldiers with machine guns, rifles, and 60-mm mortars. Many Japanese dropped in their tracks, but more kept charging at the Americans.

A few Japanese wore Marine helmets and green dungarees that they had taken from dead bodies. Some carried stretchers and, in well-rehearsed English, screamed: "Corpsman! Corpsman!" The Marines had heard that trick before and were not taken in.

Throughout the dark hours of the night, the battle continued. Company E of the 23d Regiment, catching the heaviest blows of the counterattack, used up twenty cases of grenades, an unknown quantity of machine-gun and rifle ammunition, and two hundred rounds of mortar illumination shells. Between 0100 and 0200, the company's position became precarious because the Marines ran out of ammunition. Additional supplies were brought through the darkness in a Jeep and trailer. The vehicles were fired on, but the supplies got through to Company E.

Meanwhile, the Japanese succeeded in spreading the action beyond the 23d and 24th regiments to outlying units of the 25th Marines of the 4th Division. At times, both Americans and Japanese stumbled in confusion as individual firefights broke out on all sides.

The turmoil was eventually lessened by hundreds of large star shells, fired from U.S. warships offshore, that could light up more of the rocky terrain than the smaller mortar shells. The bright white light exposed throngs of enemy and Marine troops, most of them crawling on their bellies as they sought cover.

The star shells enabled Marine artillery spotters to determine most of the Japanese positions. Barrages from 105-mm and 155-mm howitzers pounded acres of rock-strewn ground, followed by second and third barrages that saturated the area. Marine Capt. Raymond Henri, a combat correspondent, describes the action:

> The night came alive with the noise and lights of a determined firefight. Red tracer bullets shot across the flats. Jap rockets hurtled through the air, leaving a quarter-mile trail of golden sparks. Star shells of green and yellow as well as white hung in the sky.
>
> The battle kept up all night. Individual men in foxholes didn't know what was happening. They waited for Japs to appear and killed them as fast as they came. Men with telephones whispered into their instruments and tried to discover how strong the enemy attack actually was. Machine guns chattered incessantly. Grenades exploded.
>
> A sergeant, peering into the darkness, saw a Jap rise from the gloom and charge at him with a saber. The sergeant dodged and shot the ene-

my in the side with a pistol. Men in a group of foxholes engaged in a grenade-tossing contest with a squad of Japs. The Japs tossed theirs too far. They went over the heads of the Marines and exploded harmlessly behind them. The Marines threw theirs with better aim. One hit a man wired with a picric acid charge. He blew up, a human bomb, killing the companions nearest him.[3]

The morning light revealed an awesome carnage. Most of the enemy bodies were in and around the positions of the 2d Battalion of the 23d Regiment, but many were also spread out in the adjacent sector of the 24th Regiment. During the mopping up that continued until noon, the Marines had killed more Japanese sailors and a few soldiers. A body count revealed nearly 800 dead Japanese, one of the biggest single-day tolls of the battle for Iwo. About 650 men had died at the center point of the attack.

The Inouye/Senda foray, believed to be the largest Japanese counterattack of the entire Iwo campaign, cost the Marines 90 men killed and 257 wounded, a large number for one night but far lower than Senda and Inouye had hoped for.

Riichi Koyatsu became separated from his captain during the bedlam and bloodshed. He said that he heard the captain charging ahead with shouts, followed by his sailors. As Marine bullets riddled their ranks, the captain shouted "Banzai! Banzai!" at the top of his lungs and that was the last heard of him. If Inouye's body was found, it was never identified as his.

One of the Japanese survivors commented with regret, "It's a pity he could not reach the American position for a full display of his final swordsmanship."[4]

After the slaughter, about 200 Japanese sailors were still alive, huddled in small groups away from the Marine lines. Koyatsu located some of the men, and they asked him in low voices, "What do we do now?" They knew the captain was dead and General Senda was missing, so they asked one another, "Do we still go to Suribachi?"

One replied: "To Suribachi or anywhere, we have to get the hell away from here!"

It was apparent to all of them that fighting their way to Suribachi or any of the airfields was beyond their abilities. Newcomb summarizes their catastrophe:

At daybreak, a lieutenant, once a Navy flyer, gathered them together. "You are now remnants," he said. "Navy discipline will continue. From now on, I am your commanding officer."

But their fighting was over. Each night the lieutenant sent out patrols of three to five men. They never returned. Others went into caves and some died of wounds, sickness or thirst. Some drank urine and died. The lieutenant lasted for weeks, until April 29, Emperor Hirohito's birthday, when he told the others, "We will steal a B-29 and fly to the homeland. You others do as you please after we're gone."[5]

The lieutenant left, accompanied by a doctor, an ensign, and a petty officer. Koyatsu did not accompany them and never knew what happened to them. He hid in a cave and made nightly trips to an American garbage dump for food.

In June, Koyatsu and three others decided to escape from Iwo on a makeshift raft, but they did not succeed. A U.S. Army corporal, part of the mopping-up force, stopped them at gunpoint, and they surrendered.

During the early morning darkness and confusion of 9 March, General Senda and some of his soldiers had managed to work their way through the Marine lines. They kept going until they linked up with Japanese troops trapped in nearby Cushman's Pocket, named for Lt. Col. Robert E. Cushman, commander of the 2d Battalion, 9th Regiment, 3d Marine Division.

The grinding battle for the pocket continued for more than two weeks. Trapped in the pocket with Senda was forty-four-year-old Baron Takeichi Nishi, member of an old and wealthy Japanese family. He was also Japan's most famous horseman and winner of the Gold Medal for horsemanship at the 1932 Olympics in Los Angeles.

During the second week of the fighting, the baron and some of his men escaped to high ground on the nearby east coast. Nishi's fate after that is unknown. It is believed that he committed suicide with a pistol, after first asking his adjutant to turn him toward the Imperial Palace.

On 14 March, decimated elements of the 4th Marine Division overran Cushman's Pocket and destroyed its defenders. Two wounded Japanese privates reported that, as the end neared, General Senda calmly unholstered his pistol and fired a bullet into his temple.[6]

A Genius
of Defense

What kind of man was Tadamichi Kuribayashi, commander of the Japanese forces on Iwo Jima, that he could do what no other Japanese general did in World War II—inflict more casualties on the U.S. Marines than his own troops suffered?

He was acknowledged as a genius of defense. The Japanese had devoted years to constructing Iwo's tunnel defenses in depth, but Kuribayashi accelerated the projects. In only eight months, he succeeded in converting the entire island of Iwo Jima into the equivalent of a mammoth battleship, bristling with guns. The work was facilitated by the island's layers of semisoft sandstone, which made tunneling less difficult.

Kuribayashi was also a master of military psychology. He knew how to get into the minds of his men and convince them that they were supermen who would defend the island to their last breaths. In hundreds of tunnels, caves, and pillboxes on Iwo Jima, the general posted a mimeographed list of six vows that each solder was ordered to memorize. Titled "Courageous Battle Vows," it was often loudly recited by groups of soldiers and sailors in unison:

1. Above all, we shall dedicate ourselves and our entire strength to the defense of this island.

2. We shall grasp bombs, charge enemy tanks and destroy them.
3. We shall infiltrate into the midst of the enemy and annihilate them.
4. With every salvo, we will without fail kill the enemy.
5. Each man will make it his duty to kill ten of the enemy before dying.
6. Until we are destroyed to the last man, we shall harass the enemy with guerrilla tactics.[1]

General Kuribayashi was fifty-four years old and quite tall for a Japanese, nearly five feet, nine inches. Beefy, broad, and brown, he weighed about two hundred pounds. His face was round, he wore a small mustache, and his dark eyes were intense. Radio Tokyo described him as having the traditional potbelly of a samurai warrior and the heart of a tiger.

Born in 1891, Kuribayashi came from a warrior family.[2] Five generations of his ancestors fought in the armies of six emperors. Because of his ferocity and self-discipline, he was handpicked by Emperor Hirohito for the task of defending Iwo Jima. The emperor knew that Kuribayashi would fight to the death, if necessary, and had the ability to convince the nearly 23,000 men under his command that they too would fight to an honorable death and never surrender.

Most of Kuribayashi's training and service had been in the calvary, but he had a thorough knowledge of all branches of Japan's armed forces. He spoke university English and had a good understanding of American slang. From 1928 to 1930, he had served as deputy military attaché at the Japanese Embassy in Washington. He traveled extensively throughout America and studied cavalry tactics at Fort Bliss, Texas.

As he traveled from state to state, he was so impressed with America's industrial might that, in a letter to his family, he wrote: "The United States is the last country in the world that Japan should fight."[3]

During the undeclared Russian-Japanese war of 1938–39 along the Manchurian border, Kuribayashi commanded a cavalry regiment that served with distinction. Promoted over officers of higher rank, he rose rapidly to lieutenant general and was given command in 1943 of the First Imperial Guards Division, an elite group that guarded the Imperial Palace. He was so highly regarded that he was granted an audience with the emperor, a reward accorded to only a few generals.

One day, he was summoned to the office of Prime Minister Hideki Tojo and informed that the reward of commanding Iwo Jima had been be-

stowed upon him. "The eyes of the entire nation will be focused on the defense of this island," Tojo said. "Among all generals, you are best qualified for the task."[4]

Although he pretended outwardly to be pleased with the assignment, Kuribayashi confided to his brother that he considered Iwo a death assignment. He had heard rumors that another lieutenant general had been chosen for the Iwo command but talked his way out of it. Kuribayashi told his brother that he would not take his samurai sword to Iwo Jima. He added, "I may not return alive from this post."[5]

When Kuribayashi arrived on Iwo Jima in June 1944, he was appalled by the state of the defenses. The troops were disorganized, and work on the underground fortifications was sadly incomplete. On 15 June, two U.S. Marine divisions, supported by an Army division, invaded the island of Saipan, only seven hundred miles from Iwo. The invasion galvanized the general and his army and naval forces into furious construction. From June into February of 1945, his thousands of soldiers, sailors, and Korean laborers worked nonstop day and night. With extraordinary speed, they built a fortress of unprecedented size, most of it underground. Minimum specifications for the man-made caves called for thirty-five feet of earth overhead, more than enough to resist any shell or bomb.

Tunnels were five feet wide and five feet high with concrete walls and ceilings. Like honeycombs, the networks extended in all directions. One construction engineer boasted in his diary that it was possible to walk underground for over four miles from Mount Suribachi to Kitano Point on the far north. But no one did it, he added, because it was too easy to get lost.

Dozens of tunnels were built on two or three levels with many entrances. The larger rooms, some constructed over warm sulfur deposits, required air shafts as long as fifty feet to disperse foul air. To protect against flamethrowers, the tunnels and caves were built with frequent sharp turns, some at ninety degrees. Electricity and running water were piped in.[6] Hundreds of pillboxes were built in all shapes and sizes, interconnected and mutually supporting. Some had steel-reinforced concrete walls from three to five feet thick.

Partially aboveground were nearly one thousand concrete blockhouses and major gun sites. They were so well constructed that seven months of aerial bombing, followed by massive shelling from eight battleships,

nineteen cruisers, and forty-four destroyers wrecked only two hundred of them. Hundreds of mortar and machine gun nests were untouched.

In his memoirs, Gen. Howlin' Mad Smith speaks of Kuribayashi:

> His ground organization was far superior to any I had seen in France during World War I and observers said it excelled German ground organization in World War II. The only way we could move was behind rolling artillery barrages that pulverized the area. Then we went in and reduced each position, using flamethrowers, grenades and demolitions. . . . Some of his mortars and rocket launchers were cleverly hidden. We learned about them the hard way, through sickeningly heavy casualties. . . . Every cave, every pillbox, every bunker was an individual battle, where Japanese and Marines fought hand to hand to the death.[7]

The efficiency of Kuribayashi's defense tactics is underscored by U.S. Marine casualties. The 28th Regiment's flag-raising 2d Battalion, which captured Suribachi, went into battle with 1,400 men and received 288 replacements, for total manpower of 1,688. At the end of the battle only 177 men were left, and one-third of those had been wounded. The 25th Regiment's 3d Battalion arrived with 900 men and lost all but 150. Many platoon and company units suffered 105 to 115 percent casualties because so many of their replacements were killed or wounded.

Kuribayashi fought a classic battle of retreat. His forces included tanks, but he never allowed them to engage Marine tanks in battle. Instead, he buried his tanks to convert them into pillboxes that rained fire on advancing Marines.

Declaring them a waste of men, Kuribayashi permitted no wild banzai attacks, although two were launched without his consent. The first, on 8 March, cost the lives of 800 Japanese troops and 90 U.S. Marines. The second, on 26 March, resulted in 262 dead Japanese and 53 dead Americans.

As the Marines slowly advanced week after week, Kuribayashi moved his command center to new underground positions. On 16 March, he sent a radio message to Imperial General Headquarters: "The situation is now on the brink of the last. At midnight of the seventeenth, I shall lead the final offensive. . . ." At the conclusion of the message, he said: "I take the liberty of adding the following clumsy poem:

Immortal Images

Shells and bullets are gone, and we perish,
 Remorseful of failure to fulfill assignments.
My body shall not decay in the field
 Unless we are avenged;
I will be born seven more times again
 To take up arms against the foe.[8]

On the day after this message was sent, Marines of the 5th Division located what was believed to have been Kuribayashi's last blockhouse before he moved his command center to a cave closer to Kitano Point. The abandoned blockhouse, located in what was known as Bloody Gorge, was a huge masterpiece of concrete and steel. Marines battered it for two days with howitzers and fifty-pound blocks of TNT, but they could not eliminate it. Finally, engineers from the 5th Pioneer Battalion blew it to bits with more than four tons of explosives that rocked the island.

On 20 March, the Marines raised a third flag to signify that the battle was nearly over. This flag was erected on a tall pipe on the artillery-blasted rocky summit of Hill 165 near Kitano Point on the northern coast, approximately $4\frac{1}{2}$ miles from Mount Suribachi. The site is about two hundred yards from the cave where General Kuribayashi was believed to have spent his final days.[9]

The third flag was put up without ceremony by nearly exhausted elements of the 5th Division, the same division that had raised the two flags on Suribachi twenty-five days previously. The battles for Hill 165 and nearby enemy strongholds began on 11 March and continued until 29 March, when the Marines eliminated the last 500 die-hard Japanese soldiers in that area.

During these last battles of the campaign, the 5th Division's lists of dead and wounded mounted high in the hundreds. Each morning, the young Marines knew that some members of their squads would die that day, but they never quit. U.S. intelligence studies indicate that Kuribayashi, still in radio contact with the Japanese high command, learned of the division's high casualty toll and was pleased with how efficiently his troops killed Marines before they too were killed.

The Japanese employed a nearly flashless, smokeless powder for their rifles and machine guns that made it almost impossible for the Marines to to pinpoint the source of enemy fire. When each pocket of Japanese, often as small as two or three men, was eliminated, the Marines slowly and

dangerously moved on to the next pocket. As they had from D-day on, the Japanese operated in interlocked caves and rocky crevices, which resulted in the illusion that each small compartment was defended by ghosts.

General Kuribayashi's exact movements during his final weeks were a mystery to the 5th Division's top intelligence units that tried to track and kill him. A report from one Japanese prisoner source indicated that, on 3 March, a Marine patrol, possibly from the 26th Regiment, came very close to discovering the general as he rested in a cave on the eastern edge of Bloody Gorge. As the patrol passed, one of Kuribayashi's aides blew out a candle and concealed him under a blanket.[10]

Before they died, members of Kuribayashi's staff managed to burn his records and other official papers stored in caves. After the war, American analysts probed other Japanese files and were able to piece together an account of what might have been the general's last movements.

Kuribayashi was thought to be still alive on 21 March when his headquarters made a radio report to Japanese military leaders on the island of Chichi Jima, about 150 miles north of Iwo. The message, similar in tone to others from Kuribayashi, said in part: "My officers and men are still fighting. The enemy front line is 200 or 300 meters from us and they are attacking. . . . They advised us to surrender by loudspeaker, but we only laughed."

Two days later, at 1700, another report was radioed to Chichi Jima. Believed to be Kuribayashi's final message, it said: "All officers and men of Chichi Jima, goodbye."

U.S. Marine intelligence officers believed that the general died in a cave somewhere in the vicinity of Bloody Gorge and Kitano Point. His body was never found nor the body of his next in command, Adm. Toshinosuke Ichimaru, commander of the naval forces on Iwo.

After Bloody Gorge was overrun, Marine officers interrogated three badly wounded Japanese enlisted men. They indicated that General Kuribayashi had died in the honorable samauri tradition by plunging a hara-kiri knife into his lower belly, but this was never confirmed.[11]

A different and possibly more authentic description of Kuribayashi's death was offered by Taro Kuribayashi, the general's son. Half a century after World War II, the younger Kuribayashi, an architect, corresponded with author Charles W. Tatum. In a letter, dated 7 November 1994, to

Tatum from Japan, Taro Kuribayashi wrote the following account of his father's final day:

> As for Dad's last hours, I believe the true facts are: From sunset of March 25, 1945 to the dawn of 26 March, surviving Imperial Japanese Forces launched their last all-out attack with my father at the top (in the lead). After midnight on the top of the west precipice, the Japanese forces were obliged to stand still (take cover) under the onslaught of showering shells. . . . Sergeant Oyama, who was seriously wounded in the last combat with my father, fell unconscious and was hospitalized by the U.S. After having served as a POW, he came back and testified . . . his dreadful account of the night to me.
>
> My father believed it a shame to have his body discovered by his enemy even after his death, so he had previously asked . . . two soldiers to come along with him, one in front and the other behind, with a shovel in hand. In case of his death he had wanted them to bury his body then and there.
>
> It seems my father and the soldiers were killed by shells and he was buried at the foot of a tall tree in Chidori Village along the beach near Osaka Mountain. Afterwards, General Holland Smith spent a whole day looking for his body to pay respect accordingly and to perform a (ceremonial) burial, but in vain.[12]

18

Heroes for Eternity

Presidents Dwight Eisenhower and Harry Truman were U.S. Army men who had no great love for the Marine Corps. Eisenhower condemned the Marine monument near Arlington, saying it was too monstrously big. Asked by Senator Earle C. Clements to honor the six flag raisers with commendations, the president said that they were not heroic and flatly refused.

Truman liked the monument, but he resented the arrogant way that the Marine Corps publicized it. He criticized the Corps at every opportunity and signed legislation to reduce its size.

Eisenhower and Truman are gone, but the monument depicting the flag raisers still stands. Long after we are gone, the six figures will continue to lift America's flag toward the sky. Multitudes followed by multitudes will look up in admiration. Although pacifists might not admire the theme, even they can admire the beauty of the moment—a moment captured at 1/400th of a second that will live forever.

Who were the six? Were they heroes? Does it matter? Yes, it does. We need to examine the circumstances of the sacrifices made by these men and their compatriots. And, we need to know why some who perform

great deeds are honored as heroes and others who have performed the same or similar deeds are not honored.

Three of the six young men portrayed in the Marine Corps War Memorial died in battle. The lives of two were shortened by the aftereffects of battle. Only one, Navy Corpsman John H. Bradley, was successful in putting his life back together after the war.

Bradley was a war hero in every sense of the word. Day after day, the twenty-one-year-old corpsman treated wounded Marines of Company E, by then badly depleted. Many of their wounds were gruesome. After raising the two flags atop Mount Suribachi, the company battled yard by yard through jungles of sandstone northward toward Kitano Point. The Marines were riddled by hidden snipers, mortar blasts, and slugs from Nambu machine guns. The company's original strength of about 250 men was eventually reduced to about 60, half of whom were replacements.[1]

After three weeks of treating every imaginable kind of wound, Bradley himself was wounded. Pfc Rolla E. Perry saw Bradley moments after he was hit. "I was passing a big hole," Perry said, "and there sat Bradley with both legs bleeding badly. There were five other Marines around him that he was treating, giving no thought to himself."[2]

The next day, Bradley was evacuated from the island. He required lengthy hospitalization that was begun on Saipan, continued in Hawaii, and completed at Naval Hospital, Bethesda (Maryland). For his heroic deeds on behalf of others and for bravery under fire, he was awarded the Navy Cross, the nation's second highest military award. For reasons unknown, the secretary of the navy waited two years before awarding this medal.

Bradley was the only one of the six flag raisers to win a medal for heroism. Pfc Ira Hayes deserved a medal for his remarkable act of bravery, but he did not get one. Twenty-two-year-old Hayes, a full-blooded Arizona Pima, was nicknamed "Chief" by his fellow Marines. By coincidence, his act of heroism was also witnessed by Perry, who recalled that it happened during the last days of the fighting:

> We were advancing, and I saw to my right a Marine from another company coming up the line. As he passed in front of me, I was amazed to notice that he had an unexploded shell stuck in his left arm. It was a big one, about eight inches long and three inches around. The man passed in front of Hayes and the Chief ran up to him, put his left arm

around his body, and with his right hand pulled the shell out. He threw it as far as he could. When it hit the ground, it exploded.[3]

No one recommended Hayes for a medal, although he probably saved the Marine's life and possibly the lives of a corpsman and doctor who later treated him. After the war, Americans did not remember Hayes as the broad-shouldered paratrooper who had fought so well in three Pacific island campaigns and won the respect of the Marines who served with him. Instead, they pitied Hayes because the media portrayed him as a hopeless alcoholic who could not cope with his fame as a flag raiser. Pity was the last thing Hayes needed. It made his drinking problem worse.

The other four flag raisers were also heroic. Like Hayes, a carpenter, and Bradley, an apprentice mortician, they were not professional warriors but amateurs, who had been quickly trained and hurried into battle: a highway laborer from Pennsylvania, a truck driver from Texas, a textile mill worker from New Hampshire, and a factory worker from Kentucky. Two of them had been drafted. All six fought for their country in the same manner as professional military men, and three died with honor. Like all of the brave men who fought for Iwo Jima, the six deserve to be elevated high on the monument and outlined against the sky for eternity. Only the flick of a shutter separated them from thousands of others who fought on the island—and millions of others who fought in the war. A still camera and a motion picture camera happened to capture them, but they, not the two cameramen, lifted the flag high and thus earned their rightful places on the monument.

In taking a closer look at these six men, the reader must understand that not one of them asked to be memorialized as supersized, three-story-high heroes near Arlington National Cemetery. Another fact not to be overlooked is that the three who died on Iwo Jima never knew that Rosenthal's photo would result in their being immortalized in bronze.

The following are the names and positions of the six men portrayed in the sculpture:

1. Pfc Ira H. Hayes, on the far left, arm stretching high, poncho hanging from his belt. He survived the battle.
2. Pfc Franklin R. Sousley, second from the left, with slung rifle. The youngest of the flag raisers at age nineteen, he was killed in action on 21 March 1945.

3. Sgt. Michael Strank, barely visible on Sousley's left. He was killed in action on 1 March 1945 at age twenty-six.
4. Navy Pharmacist's Mate Second Class John H. Bradley, second from right, with empty canteen cover hanging from his belt. He survived the battle.
5. Pfc Rene A. Gagnon, his helmet barely visible beside Bradley. He survived the battle.
6. Cpl. Harlon H. Block, far right, straining at the foot of the pole. He was killed in action on 1 March 1945 at age twenty-one.

Ira Hamilton Hayes, born on 12 January 1923 at Sacaton, Arizona, on the Gila River Indian Reservation, was the son of Pima Native Americans Joe E. and Nancy W. Hayes.[4] He dropped out of high school after two years to serve briefly in the Civilian Conservation Corps (CCC), a federal program that provided jobs during the Great Depression of the 1930s. After leaving the CCC, Hayes worked as a carpenter. In August 1942, he enlisted in the Marine Corps Reserve and, after boot camp training, volunteered for the paratroops.

Hayes was with the Marine paratroops (who made no combat jumps) and fought in the Pacific island battles of Vella Lavella and Bougainville. He landed on Iwo Jima on 19 February 1945 with the 28th Regiment of the 5th Marine Division. Although in the thick of the battle for six weeks, he was not wounded. In 1955, Hayes died of acute alcoholism and exposure at the age of thirty-two. He is buried in Arlington National Cemetery.

Franklin Runyon Sousley was born in Flemingsburg, Kentucky, on 19 September 1925. After graduating from high school in June 1943, he moved to Dayton, Ohio, where he worked for a short time as a factory worker for a refrigerator manufacturing company. Drafted into the Marine Corps in January 1944, Sousley went through boot camp in San Diego and was then transferred to the 5th Marine Division at Camp Pendleton. He was assigned to Company E, 2d Battalion, 28th Marines, and trained with the unit at Pendleton and Camp Tarawa, Hawaii.

Sousley landed on Iwo Jima on D-day. Armed with a Browning automatic rifle, he fought in the battle for Mount Suribachi and then battled northward for three weeks in slow, grinding advances across miles of

rocky terrain. He was killed in the fighting around Kitano Point only a short time before the battle was formally declared ended and Company E was pulled out of the combat zone. He is buried in Fleming County, Kentucky, beneath a huge stone monument depicting the flag raising.

Michael Strank, born in Conemaugh, Pennsylvania, on 10 November 1919 (coincidentally the Marine Corp's 144th birthday), was the son of Vasil and Martha Strank, natives of Czechoslovakia. After graduating from high school in 1937, he served for eighteen months in the CCC and then became a state highway laborer. He enlisted in the Marine Corps in October 1939.

Advanced to sergeant in 1942, Strank was sent to the South Pacific, where he volunteered for action with Carlson's Raiders, an elite fighting group. He fought in the invasion of Pavuvu Island in the Russell Islands and in the seizure of Empress Augusta Bay on Bougainville in the Solomon Islands. In early 1944, he was reassigned to the 5th Marine Division and landed on Iwo Jima on D-day with Company E, 2d Battalion, 28th Marines.

After the fall of Mount Suribachi, he fought in the advance northward across the island. While attacking Japanese positions around Hill 362A, Sergeant Strank and other Marines were pinned in a ravine for four hours by heavy enemy artillery and mortar fire. He decided to send a runner to notify company headquarters of his position. While drawing a map in the sand for the runner, Strank was killed by a mortar blast. He died on the same day and in the same rocky area as did Corporal Block. Strank is buried in Arlington National Cemetery.

Harlon Henry Block, the son of Edward Frederick and Ada Belle Block, was born in Yorktown, Texas, on 6 November 1924. After graduating from Weslaco (Texas) High School in 1943, he worked as a farm and oil field laborer until he was drafted into the Marine Corps. He graduated from Parachute Training School at San Diego and was sent to the Pacific with the 1st Marine Parachute Regiment.

Block fought as a rifleman during the latter part of the Bougainville campaign in December 1943. After the paratroops were disbanded, he returned to the States and was assigned to the 5th Division at Camp Pendleton for training with Company E, 2d Battalion, 28th Marines. Promoted

to corporal, he landed on Iwo Jima on D-day and fought in the battle for Mount Suribachi.

Corporal Block thrust the heavy metal pipe into the volcanic sand when the six raised the flag. After Suribachi was secured, he fought toward the north with Company E. He and fellow flag raiser Strank were killed in the heavy fighting around Hill 362A and Nishi Ridge on the same day, along with scores of other enlisted men and six officers of the 5th Division. He is buried in Weslaco, Texas.

Rene Arthur Gagnon, of French-Canadian descent, was born in Manchester, New Hampshire, on 7 March 1926. The son of Henry and Irene Yvonne Gagnon, he attended high school for two years and then took a job in a textile mill. In May 1943, he joined the Marine Corps. After serving as an MP with the 5th Division's Military Police Company at Camp Pendleton, Gagnon was transferred to Company E, 2d Battalion, 28th Marines.

At age nineteen, he landed on Iwo Jima on D-day and fought as a rifleman and company runner during the battle for Suribachi. On 23 February, Gagnon was given the second flag and told to take it along with fresh batteries for the flag patrol's walkie-talkie, to the summit. After helping to raise the flag, he fought successfully through the entire six-week battle and left the island physically unhurt.

When he returned home from the war, however, Gagnon was unable to deal with the pressures of his overnight fame as a flag raiser, and he was bedeviled by memories of battle ordeals. He suffered from acute alcoholism for the rest of his life. Fired from several jobs, he literally drank himself to death. He died in 1979, at the age of fifty-three, in his hometown of Manchester. A bronze replica of the flag raising is on his headstone in Arlington National Cemetery.

John Henry Bradley was born in Antigo, Wisconsin, on 10 July 1923, the son of Mr. and Mrs. James Bradley. While he was a boy, the family moved to Appleton, Wisconsin, where he graduated from high school in 1941. He enlisted in the U.S. Navy in 1943, shortly after completing an eighteen-month mortician apprenticeship with a local funeral director.

The Navy put him through three courses of medical training, first at Hospital Corps School, Farragut, Idaho, and then at the Naval Hospital,

Oakland, California. Assigned to the Marines as a pharmacist's mate second class, he received his final corpsman training at the Fleet Marine Force Field Medical School, where he learned the techniques of treating men in combat.

On 14 April 1944, Bradley joined the 28th Regiment of the 5th Marine Division. Iwo Jima was his first and only campaign. He landed with the regiment on D-day and treated wounded Marines in combat for the next twenty-one days. Seriously wounded on 12 March, he was hospitalized for eight months before being medically discharged from the Navy on 13 November 1945. During the next four decades, Bradley avoided publicity and worked as a mortician and funeral director in his family's funeral home in Antigo. The last survivor of the six flag raisers, he died on 11 January 1994, at the age of seventy, in Antigo after suffering a stroke. He is buried in Queen of Peace Cemetery, Antigo.

When Iwo Jima had been secured, President Roosevelt ordered that the three surviving flag raisers, Hayes, Gagnon, and Bradley, be returned safely to the States and not be subjected to further danger in combat. The Treasury Department selected the Rosenthal photo as the major symbol of its Seventh War Bond Drive and requested that the three men tour America to help sell war bonds. Genaust's motion picture, shown in theaters, auditoriums, and rallies across the land, was also part of the sales pitch. For a time, until he grew weary of all the hoopla, Rosenthal participated in the tour.

Keyes Beech, a young Marine combat correspondent on Iwo, was chosen to escort the two Marines and the Navy corpsman from city to city. Bradley traveled on crutches; further hospitalization and leg surgeries were postponed until after the tour.

"It was a circus," Beech recalled during a magazine interview in 1985. "The three weren't really needed on the tour and I knew they felt awkward being trotted out like a vaudeville routine. Gagnon seemed the weakest of the three. Bradley was a solid guy with a sense of humor. He was my right hand. The Chief, Ira Hayes, was a great guy, but he disappeared the night before a big rally at Chicago's Soldier Field. The police found him drunk."[5]

Wherever they appeared, the flag raisers were treated to mass adulation. At Washington's Griffith Field, they were honored on the opening day of the baseball season. As Speaker of the House Sam Rayburn pre-

pared to throw out the first ball, the program was suspended for a few minutes. A voice on the loudspeaker called the crowd's attention to three men, two Marines and a sailor in uniform, standing near home plate.

"Ladies and gentlemen," said the loudspeaker, "you've all seen the picture of six Americans raising our flag on Iwo Jima! Three of them survive! These are the three!"[6]

Twenty-four thousand fans rose to their feet and gave Hayes, Bradley, and Gagnon a tremendous, long-sustained ovation.

At first, the three enjoyed the celebrity life—nice hotel rooms, good food and booze, attention wherever they went. They met President Truman, Secretary of the Treasury Henry Morgenthau, Jr., Commandant Vandegrift, and lots of movie stars. The tour continued for nearly three months, but after a while, it became exhausting and boring.

Hayes wrote a letter to his mother in June 1945 from New York's swank Waldorf-Astoria, where he was staying: "It was lots of fun for a while, but we found out it would not be so easy. We done the same old stuff. . . . I couldn't stand much more, especially newspaper reporters and photographers."[7]

There was extra pressure on Hayes because he soon realized that one of the six flag-raisers had been misidentified as Sgt. Henry O. Hansen, who had been killed on Iwo. Every time Hansen's name was mentioned at bond rallies and in newsreels, the Chief felt a chill. He knew that Hansen had been part of the first flag-raising, not the second. It was the Chief's good buddy Harlon Block, also killed in action, who was bent over near the foot of the flagpole. When Hayes informed the bond tour managers of the misidentification, he was told to keep quiet and not cause any trouble on the tour.[8]

Eventually, the correction was made and Corporal Block properly honored, but the way it was handled made the Chief feel that parts of the tour were cheap and phony. His conscience was deeply troubled, and he had trouble sleeping at night. He cringed every time a speaker repeated the lie that the six had to battle enemy snipers and machine gunners before they could raise the flag. He resented the way Gagnon, the most handsome of the flag raisers, did not object to the lies and even claimed, incorrectly, that he personally had shot Japanese during the climb to the summit with the second flag. Alcohol helped Hayes to relax and get a few hours sleep. Also contributing to the Chief's feelings of guilt was the fact that not only were the first flag raisers not honored, but they were ignored. He knew

too well that they were the ones who had fought off the enemy. They had been in far greater danger atop the summit than the second group, who climbed up later. Equally bad, day after day, night after night, the Chief was wined and dined like a duke or a king, while good friends who had died heroically on Iwo received no honors, not even a single line of credit in the newspaper.

Because of his drinking, Hayes did not finish the tour, but Bradley and Gagnon stayed till the end. After that, Gagnon went on doing interviews and making public appearances because he enjoyed being lionized as a hero and celebrity. Bradley, however, retreated to his hometown of Appleton, Wisconsin, became a funeral director, and stayed out of the public eye.

In 1985, when he was sixty-one years old, Bradley reluctantly agreed to be interviewed by magazine writer Daniel R. Bronson. "I don't do interviews or go anywhere," Bradley told him, "because people think I'm trying to capitalize on the picture. I had to close myself off to live a normal life. If you let people wag your tail, they'll get you. They drove poor Ira to his grave, and there were all sorts of twisted stories about Rene. . . . A lot of blood was spilled on Iwo Jima. To be called a hero for what happened in that photo is silly. . . . I guess you could say I wish I'd never been in that picture."[9]

Bronson also interviewed Lou Lowery, the Marine sergeant who had taken photos of the first flag raising, and Chuck Lindberg, one of the men who raised that flag. Lowery was then sixty-seven years old and retired. Lindberg, at age sixty-four, was the last survivor of the men in Lowery's best-known flag picture.

"It's a shame," Lowery said, "that the fellows who did the dirty work and risked their lives didn't get credit . . . but look at all that was done for some guys who just *replaced* a flag!"[10]

Lowery was bitter because, although forty years had passed, the U.S. government still had not erected any monument or statues to honor the first flag raisers. He noted that the only monument to their memory was in Monticello, Florida, home of Sgt. Ernest Ivy ("Boots") Thomas, one of the first flag raisers who was later killed on Iwo Jima. Funds for the monument, erected in 1981, were raised by private citizens.

Lindberg was equally bitter: "I'm an easy going guy, but you could get hysterical over the way we were ignored. When they dedicated the big Iwo Jima Monument in 1954, Gagnon, Hayes, and Bradley were there with Joe

Rosenthal. I was there with Hal Schrier, Jim Michels, and Lou Lowery. Only one reporter talked to us the whole time. We were ornaments."

Added Lindberg: "What really irritated the heck out of me was the 1945 bond rally at Soldier Field, Chicago. I'd been shot in the arm on Iwo and was sent to Great Lakes Naval Hospital. Some of us were well enough to go when the rally came to Chicago. When Gagnon started to tell how they'd battled their way up Suribachi, it really got to me!"[11]

Bickering, criticism, and insults are as much a part of the aftermath of heroism as monuments and accolades. In *Paul Revere,* Esther Forbes (1894–1967) touched on this: "Most American heroes (of the Revolutionary period) are by now two men, the actual man, the image and the debunked remains."[12]

Finley Peter Dunne (1867–1936) put it another way in his essay "Fame," when he had his imaginary Irishman, Mr. Dooley, say: "When ye build yer triumphal arch to yer conquerin' hero, Hinnissey, build it out of bricks so the people will have something convanient to throw at him as he passes through."[13]

Iwo Jima Today:
26 Feet Higher

The guns of Iwo Jima have been silent for more than half a century. Day and night, the island is as solemn as a cathedral. Only a few Americans are here—in eternal sleep. Officially listed as missing in action, most of them presumably are entombed in collapsed tunnels and caves. The remains of the other Americans who died on Iwo Jima, nearly seven thousand Marines and Navy and Army men, were returned to the United States during the 1950s for reburial.

An estimated thirteen thousand Japanese soldiers and sailors still lie entombed and undisturbed in mile after mile of tunnels deep below the surface. Entombed with them are thousands of tons of live ammunition—disintegrating artillery and mortar rounds, grenades, and rotting wooden cases of rifle rounds—too dangerous to be touched.

Because more than twenty-one thousand of their bravest countrymen died here and the remains of so many might never be returned home, the Japanese regard the entire island as a shrine, a hallowed place visited regularly by Japanese families. They come to pay homage to their fallen kin, to glorify them in Buddhist ceremonies, and to purify the few bones they find.

The breezes may be gentle or swift atop Mount Suribachi, but no flags fly there during most days of the year. Because of an agreement between

the United States and Japan (an agreement that some old Marines term outrageous), the Stars and Stripes can be flown on only four occasions each year: Memorial Day, the Fourth of July, Veterans Day, and Invasion Day (February 19). The flag restriction stirs anger in elderly Marine survivors of the battle who want Old Glory to fly continually, the way it did for almost a quarter of a century before the United States transferred control of Iwo to the Japanese government in 1968.

Geologically speaking, Iwo Jima is a comparatively new island. It was formed by a cataclysmic undersea explosion perhaps less than 10,000 years ago. It is still so seismically active that some Japanese volcanologists believe another eruption may blow it apart in the next few decades. They base this theory on evidence that in the last fifty years pressure from molten magna has thrust the island upward over twenty-six feet.[1]

During drought years, the island is brown and dry. In rainy years, however, nearly all of Iwo turns lush green, with junglelike growths concealing the monstrous scars and deformities of war. Low tangles of underbrush, vines, and stunted trees soften the sharp angles of rock-strewn gullies, small hills, and cliffs that were blasted by U.S. Marine artillery and the big guns of the U.S. Navy. Here and there can be seen a spindly palm tree or two, a lonely papaya tree, and a stand of leafy, evergreen live oaks, surprisingly tall and handsome.

Although the island is basically dry except for rainwater, certain species of flowers manage to exist, kept alive by morning and night mists and occasional rains. Some are flat vines, snaking over the parched soil, with small blossoms, mostly bright yellows, a few reds and virginal whites. Animal life includes lizards, rodents, scorpions, and a few hardy goats, believed to be descendants of goats brought to Iwo by Japanese residents before the war.

Much of the island is now flat and uninviting. In 1945, American Seabees and Army construction engineers flattened prominent hills to build the large airstrip for B-29 landings. In recent decades, Japanese engineers have eliminated more prominences while constructing many buildings and other facilities.

Except for a new road to nearly the top, Mount Suribachi is largely the same as it was in 1945. Marines who fought there call it a "carbuncle on the ass end of the world," but Japanese artists who come to paint or photograph it have a different opinion. To them, it is a worthy brother of Mount

Fujiyama—beautiful and spiritual, often crowned with mists from the heavens, a massive stone memorial to the soldiers who lie within.

For more than forty-eight years, beginning shortly before the battle ended in 1945, the U.S. Coast Guard manned Iwo's Loran weather station, presently located on the northern tip of the island at Kitano Point. It was the last permanent U.S. base on Iwo Jima. On 1 October 1993, its staff of twenty-six transferred operation of the station to the Japanese Coast Guard.

Equipped with a 1,350-foot steel tower, the station is near the site of the battle of Bloody Gorge, where the Marines destroyed the last organized Japanese resistance. Also nearby is the final headquarters cave of General Kuribayashi.

Japan now controls everything on the island. The landing strip and many other airport facilities are operated jointly by the Japanese Maritime Self-Defense Force and the Air Self-Defense Force. The number of Japanese stationed on the island ranges between four hundred and six hundred. The maritime officers who command the base cooperate cordially with visiting Americans, mostly Navy flight personnel on temporary duty. At times, both day and night, the island's solemn silence is shattered by the thunder of jet squadrons from U.S. aircraft carriers that use the 8,700-foot airstrip to practice simulated carrier landings.

In recent years, the Japanese government has spent the equivalent of hundreds of millions of dollars on improvements, including the construction of apartmentlike complexes that can house five hundred Navy pilots, flight officers, and enlisted men. The two-story structures are built with thick concrete walls and stout roofs to withstand typhoons.

Other new installations are a tall airport control tower, large typhoon-proof hangars, a modern administration building with walls of windows overlooking the airstrip, steel tanks to store fresh water brought from Japan, a water purification system, parking lots, engine repair shops, fuel depots with dozens of huge steel storage tanks painted white, solar panels that energize seismological relays to detect earthquakes, and a modest network of paved asphalt roads that connect with rough roads of light-brown dirt.

Perhaps the best road on the island is the recently resurfaced one-lane asphalt strip that coils to the top of 556-foot-high Suribachi. Although it is steep with many dangerous hairpin turns, both shoulders are marked

with broad white warning lines. As vehicles slowly wind their way up, passing sheer rocky cliffs, their occupants cannot help but marvel at the Marines who once scaled Suribachi's heights. They had to contend with enemy gunfire while bending under the weight of 70-pound flamethrowers, loaded backpacks, M1 rifles, and heavy bandoliers of ammunition.

Steam and sulfur fumes rise from vents in the center of the crater. Suribachi (Japanese for "bowl") last erupted in 1727. Some geological charts still list it as a live volcano.

Feelings about Suribachi and Old Glory run deep in former Marines who survived the battle of Iwo Jima. For most of them, it was the biggest event in their lives. Now in their late sixties or in their seventies, or even older, they are immensely proud of Rosenthal's photo and their parts in winning the terrible battle. None of the scores of other terrible battles of World War II, great or small, has produced anything like the flag picture, which is still known to millions of people throughout the world.

Incidents that occurred in February 1993 at the annual reunion of the Iwo Jima Survivors Association in Wichita Falls, Texas, illustrate the bitterness harbored by some of the survivors about what they call "the ugly way" the U.S. government betrayed them when it gave the island back to the Japanese. Hundreds of white-haired ex-Marines and a scattering of venerable ex-Navy corpsmen came to the three-day reunion to shake hands, have a few beers, share good and bad memories of the battle, and pay tribute to the thousands of their comrades who never returned home. During one of the meetings, some of the men grew angry and many wept when they were told that Old Glory no longer flies continually on Mount Suribachi. One covered his ears to avoid statements he didn't want to hear.

This reunion marked the forty-eighth anniversary of D-day on Iwo. Advised to bring their families "to keep alive the memory of Iwo Jima," the survivors were accompanied by wives, sons, daughters, and grandchildren. They came from every state, as well as Canada and Mexico.

They were eager to reunite with men who knew their feelings. Only another survivor could understand the real meaning of Iwo Jima, the truth of the way it was, the never-ending fear, the exhaustion, what it was like to fight an unseen enemy, the stark reality of long lines of white crosses that marked the graves of so many friends, what it was like to be one of the miracles—to leave Iwo alive, a survivor.

Forty-eight years ago, these men had been young and strong. They went without sleep for seventy-two hours or more but still had vigor and

spring in their legs. Leaping gullies and running up steep rocky hills, they lugged rifles and heavy loads of grenades, their waists and shoulders circled with ponderous belts of ammo. They pretended not to be afraid when enemy artillery rounds whizzed close overhead in a broken rhythm that seemed to say: "It's for you! It's for you! It's for you!"

Now, many were balding, paunchy, and a bit bent over because of bad backs or hips. Others were still able to stand straight and tall, the way they once did in proud formations at Pendleton. Some rode in wheelchairs or limped along on artificial limbs. Beneath sports jackets and slacks, the wrinkled skin of former enlisted men and officers was ugly and discolored with old scars from bullets and shards of hurtling steel.

Among the reunion speakers was Coast Guard Lt. Jan Proehl, who had been commander of the Loran weather station on Iwo Jima during 1991–92.[2] During her speech, she gave the veterans detailed descriptions of what Iwo Jima was like at that time—the nine-hole golf course, softball games between U.S. Navy and Japanese armed forces personnel, two tennis courts, and the unusual rituals of Japanese families who visit Iwo to collect the bones of their dead.

Representatives of the families are permitted to enter tunnels that have been cleared of explosives. The bones they find are taken to one of the larger, open-air monuments where they are carefully cleansed in water, dried, and purified in fire. The ashes are boxed and taken back to Japan.

After her informal talk, thirty-four-year-old Lieutenant Proehl asked for questions from the audience. She was surprised when the majority of them dealt with the subject of the return of Iwo Jima to Japan. She was asked such questions as: Why did Japan take over? Does America still own part of the island? Will we ever get Iwo Jima back for a military base? Is Japan building a monster military base on Iwo so some day it can start another war? How many Marine graves are still there?

Proehl's responses included the following facts: Iwo Jima is not a "monster" military base, and the Japanese have stated repeatedly that they do not intend for it to become one. It is part of Japan's outer ring of self-defense islands. The United States returned Iwo Jima to Japanese control in 1968. It also gave up jurisdiction over the other islands in the Volcano and Bonin chains.

Then, Lieutenant Proehl said, "By agreement with Japan, the U.S. flag flies only on four days of the year. On special occasions, Old Glory flies for part of a day."

A stir ran through the audience. No American flag on Iwo nearly all year? Impossible!

Lieutenant Proehl explained that the Japanese flag is subject to the same agreement and flies atop Suribachi on only the same days.

The audience stirred again with angry comments, such as: Crazy, crazy deal! The Japanese flag shouldn't fly at all! We took that damn island and they killed thousands of our best guys!

Although not prepared for so much muttering and griping, the lieutenant went gamely ahead. "Why should we keep the island?" she asked. "We didn't keep Normandy or the other World War II battle sites that we captured. I know there's a lot of blood there and it's hard for me to explain all the reasons for giving it back. But in recent history, with hardly any exceptions, America has always given back anything it takes in war."

The point was also made in 1970 by Gen. Leonard F. Chapman, Jr., then commandant of the Marine Corps. Speaking at an official Washington ceremony marking the twenty-fifth anniversary of the battle for Iwo Jima, Chapman said: "If that island had not been returned to its natural base of culture, then the purpose of American participation in World War II would have been conquest—and that is not the American way."

I have compiled a number of facts about Iwo Jima, past and present, that are based on personal interviews with Lieutenant Proehl,[3] a 1968 *National Geographic* article,[4] and my personal observations during a trip to the island in early 1994.

The United States never claimed ownership of any part of Iwo Jima. From 1945 to 1968, Iwo and the other nearby islands in the Volcano and Bonin chains were administered by the U.S. Navy, although Japan retained "residual sovereignty." Japan claims that its ownership of the islands goes back to 1593, when a Japanese warrior prince landed in the Bonins and claimed them in the name of the emperor.

The most pleasant and hospitable island in the Bonin chain is Chichi Jima, 150 miles north of Iwo Jima and comparable in size. During World War II, five thousand Japanese troops were stationed there, and it was heavily fortified with naval coastal guns, blockhouses, and tunnels. Its seven thousand civilian inhabitants were evacuated to Japan but returned after the war. When U.S. planes bombed Iwo Jima in the summer of 1944, they sometimes raided Chichi as well. In one attack on its harbor, twenty-one Japanese seaplanes were destroyed, three freighters were damaged, and a hangar was set on fire.

The first Americans to land on Chichi were seafaring New England Yankees during the 1830s and 1840s. They married native women and settled down. Some of their descendants still live there and speak both English and Japanese. The intermarriages produced progeny who are a blend of Japanese, Polynesian, and American heritages. Many of the women are classic beauties, and some of the men have strong American-like faces. Most of the last names are Japanese, but there is a sprinkling of Webbs, Robinsons, Gilleys, and Washingtons. Some first names are Ruth, Anna, Jesse, and Charlie.

I traveled to Iwo Jima in March 1994 to see how it has changed in half a century and to complete research for this book. Because it is a closed Japanese military island, few American civilians are permitted to visit. Without the cooperation of the U.S. Navy and the Japanese government, I could not have gone. Travel arrangements were made by my longtime friend, journalist Thomas B. Mechling, cofounder of Washington Watch Editors. He accompanied me under the auspices of the U.S. Navy and Marine Corps World War II Commemorative Committee headed by Capt. Jack Gallant, USN (Ret.).

We left Tokyo on a small U.S. Navy twin-propeller plane that regularly flies Navy technicians to the island to make routine tests of aircraft fuel stored in refinery-sized tanks. Tokyo was cold and windy, but the weather warmed up during our journey south. The 680-mile flight took three hours.

When we arrived, Iwo was shrouded in mist after a morning rain. We flew low over Suribachi, which gave me an entirely different perspective than the one I had that morning in February 1945 when I landed on the black beach. Although the cliffs and crater of Suribachi were only a few hundred yards away from our landing area, they had been invisible in the smoke and dust of continual shelling by battleships offshore.

Seen close up from the air half a century later, Suribachi was magnificent. Patches of leafy greenery brightened the interior of the crater and spread along the irregular rocky rim. The volcano's steep sides were mostly outcroppings of huge weatherworn rocks, in shades of brown and beige, washed clean by rains. Defying gravity, plants had sprouted in vertical crevices among the rocks. As if painted by the sure hand of an artist, the foamy white surf outlined the coal black beaches around Suribachi's base.

In the spacious, brightly lit offices of the air terminal, we were greeted by Japanese maritime officers in white uniforms. They invited us to lunch,

but we declined because the Navy had limited our visit to $3\frac{1}{2}$ hours (which we managed to stretch to $4\frac{1}{2}$).

Although Iwo is a fascinating place for World War II history buffs, it will never be accused of being a tourist trap. There are no restaurants, hotels, souvenir shops, or taxis, and visitors are advised to bring their own drinking water. In the time allotted us, we covered most of its $7\frac{1}{2}$ square miles. For our tour, the Japanese loaned us a Blue Whale, the nickname for a large rectangular van used for island travel.

Our driver and guide was Brent L. Saucerman, age twenty-eight, of Midland, South Dakota, a U.S. Navy petty officer stationed at Atsugi Naval Air Facility, Tokyo. Saucerman is the Navy's leading Iwo historian, and he makes frequent research trips to the island. He is a knowledgeable and articulate guide and drove us everywhere on the island, often over rough dirt roads.

From the air terminal, we traveled about two miles on a nearly straight asphalt road to the base of Suribachi and then up a series of sharp hairpin turns to the top. There was little wind around the base, but on top we were hit by nearly gale-force wind that blew continually. The sky at midday was overcast and gray, much like it was the day that Joe Rosenthal and Bill Genaust had shot their flag pictures. The gale was so blustery that, at times, we had difficulty steadying our cameras. On a clear day, it's easy to see all of the island from Suribachi, but mists concealed the most distant parts when we were there.

During my visit, there were five large monuments, four Japanese and one American, at the site of the flag raising on the summit. Now, however, there is another, smaller American monument at the site. This was installed in 1995 in honor of Genaust. The large one, constructed decades ago, honors the men of the 2d Battalion, 28th Regiment, 5th Marine Division, who raised both flags on 23 February 1945. On top of its white concrete base is a large replica of the Stars and Stripes in flat metal, flanked by twin replicas of the 5th Division's reddish-orange and dark-blue Spearhead V emblem. Directly below Old Glory is a metal bas-relief of Rosenthal's photo, but his name is not there. The base also displays a pair of large, three-dimensional metal replicas of the U.S. Marine anchor-chain emblem and the historic phrase of Admiral Nimitz in metal letters: "Among the Americans on Iwo Jima, uncommon valor was a common virtue."

Mechling and I were disappointed to see that because of years of high winds, rainstorms, burning sun, and the high sulfur content of Iwo's air, all of the monument's metal parts were black with tarnish. The neglect was so advanced that, from a few yards away, the details were invisible. Old Glory and the Rosenthal bas-relief looked like flat sheets of black metal.

The Japanese monuments are not subject to weathering because they are solid granite with carved Japanese characters. Two are polished black granite, and the peace legend on one states that Iwo Jima is "the island that keeps telling the futility of war."

When we noticed beer cans and ashtrays at the base of the largest Japanese monument, we thought that someone, possibly visiting U.S. servicemen, had set them there as a mark of disrespect. "Not so," Saucerman explained. "Japanese visitors don't leave flowers or wreaths. Instead, they bow in respect as they set down canned drinks, sake and water bottles, food, and sometimes unsmoked cigarettes or even butts. These are the traditional gifts that you will find at nearly all the Japanese monuments on the island."

Whipped by stiff winds, a sudden heavy rainstorm forced us to retreat from the summit and run to the shelter of our Blue Whale. Saucerman then drove us down a slope that took us within walking distance of the black beach. The loose volcanic sand was clean, soft, and free of trash. Driven by the gale winds, the surf was high and thundered against the beach. A Marine invasion landing in that kind of surf would have resulted in disaster.

Next, we visited the site of a large coastal gun hidden in a recess at the base of a cliff. Its long steel barrel seemed intact, but its concrete blockhouse was blasted into junk. On a plain nearby, we walked around the island's unusual commanding officer's bunker—the fuselage of a medium bomber reinforced with layers of concrete and stones.

As we drove to other sites, Saucerman—who frequently explores the tunnels—told us of various findings that have been made on Iwo in recent years. Occasionally, a Marine dogtag is found on the beach or in a tunnel and is turned over to the U.S. Navy. In addition to weapons, items found in the tunnels include Japanese opium pipes and beer and sake bottles.

Sometimes the mummified remains of Japanese soldiers are discovered in the tunnels near warm sulfur deposits and hot sulfur springs. One

searcher came across the skeletons of two soldiers lying in a bunk. Beside them, seated in a chair, was the shrunken mummy of a soldier in a tattered uniform. It is believed that perhaps the island's strong sulfuric fumes caused the mummifications.

No one knows for certain how many miles of tunnels exist. Early estimates had indicated the total at eleven to fifteen miles. A much higher estimate of nearly thirty miles was provided by sensitive infrared cameras on satellites that photographed heat patterns in the tunnels from high altitudes.

Saucerman has compiled a list of twenty-two scenic sites on the island (see Appendix). Among the most interesting are Warbler Hell and the Million Dollar Hole. Warbler Hell is a giant sulfur crater nine hundred feet in diameter and thirty feet deep. Like craters in Yellowstone Park, it warbles and hisses as it produces a continual flow of sulfurous gas and steam.

Million Dollar Hole actually consists of three extinct craters. When the battle ended, Marines dumped large quantities of surplus military equipment and vehicles into the deepest hole. In 1981, a group of U.S. Coast Guard men attempted to rappel on ropes to the bottom. They aborted the venture after descending two hundred feet because of bad air and extreme heat.

With Saucerman leading the way, we used flashlights to explore several caves and long tunnels that were free of explosives. Some were cool, others quite warm. One of the warmest and largest was Hospital Cave, which had accommodated hundreds of wounded Japanese soldiers and sailors. It was the only tunnel where we saw artifacts that the Japanese have not disturbed. Piled along one side of the tunnel were empty medical boxes, pots, a kettle, a half-buried steel drum, rusty scissors, and heaps of dirt and rocks.

The Iwo Jima Museum is not very large, but it is unique because of its location—inside a partly wrecked, thick-walled concrete bunker near the airstrip. On display are hundreds of pieces of rust-encrusted Japanese military equipment, everything from knives and heavy machine guns to dented helmets and sets of unbroken chinaware. The single narrow room is well lighted and equipped with glass display cases. On the wood-paneled walls are large military maps that were used by the Japanese commanders. By far, the museum's most fascinating exhibit was something we had never seen or heard of before—ceramic suicide grenades. Made of white or

orange ceramics, they were spherical and slightly smaller than a man's fist. The explosive charges had been removed.

"It is thought," Saucerman said, "that these grenades were used by hundreds, possibly thousands, of soldiers trapped in the tunnels. They were made of ceramics because toward the end of the war, Japan had a critical steel shortage."

After returning home, I sent a report to Gen. Carl E. Mundy, Jr., commandant of the Marine Corps, about the large U.S. Marine flag monument atop Mount Suribachi. I explained that it was badly weathered and tarnished and noted that, in contrast, the four Japanese monuments nearby were carved granite, which will remain pristine and untarnished for generations to come.

I stated that, although only a comparative handful of Americans will visit our flag monument in future years, it will be seen by thousands of visiting Japanese. Doubtlessly, the Japanese will be pleased by how well their government maintains the memorials honoring their thousands of Iwo Jima dead. They might also wonder, as they pass our monument, why the United States has neglected it and allowed it to deteriorate over the years. This is the monument from which Old Glory is permitted to fly four times a year.

A couple of months passed before I received a reply to my report. Gen. Edwin H. Simmons USMC (Ret.), director of the Marine Corps History and Museums Division, assured me that the monument would be cleaned up and beautified in time for the fiftieth anniversary observances in 1995. The work was done early that year and turned out well, with all the brass portions shining brightly. There was no assurance in the general's letter, however, that the monument would be refurbished with materials that will not tarnish or corrode during the decades to come.

Permanent weatherizing is the very least that the United States can do for the small but historic piece of America that remains atop the volcano in honor of the seven thousand U.S. troops who died on Iwo Jima.

20

Truths versus Untruths

No cameraman in the history of photography has suffered the abuse that has been heaped upon Joe Rosenthal by prominent Americans. A humble man of highest professional ethics, Rosenthal might never escape being wrongly labeled a fraud. One can safely predict that ill-informed critics will continue to tarnish his reputation well into the twenty-first century.

When President Dwight D. Eisenhower signed a letter dated 29 November 1954 to Senator Earle C. Clements of Kentucky rejecting Clements's request for commendations for the six flag raisers, he revived the old slur that Rosenthal had posed his photo and thus implied that the flag raisers themselves were part of the sham.

The Eisenhower-Clements correspondence has been long buried in the archives. In a future decade, a scholar or probing journalist might encounter it in Box 106 in the Eisenhower Library, Abilene, Kansas,[1] and gain five minutes of fame (or notoriety) by publishing it as "new evidence" and again revive the old cry of "fake."

Because William Genaust's motion picture, as part of Iwo Jima's history, is intertwined with the Rosenthal legend, it too will continue to be called a fraud.

Four particularly galling examples of such abuse occurred within the last two decades, many years after Rosenthal first offered incontrovertible proof that his photo was not posed. In 1982, one of America's largest newspapers, the *Los Angeles Times* accused him of posing the Marines who raised the flag.[2] (The *Times* later refused to print a retraction.) In 1988, a major book on American news photography made the same accusation in more extensive and darker terms.[3] In January 1994, the *Los Angeles Times* repeated the falsehood but offered no evidence to support it. A week later, Jack Anderson, in his nationally syndicated column, fabricated stories about the photo and even accused the flag raisers of lying.

Rosenthal threatened no legal action. He just shrugged off the false charges as he had done much of the time in the past. From the 1940s through the 1960s, when he was younger and healthier, Joe's blood had boiled whenever an author or reporter printed such untruths. He sometimes asked for and received retractions, but usually he did not. It was not his nature to hassle people.

Quite often, Rosenthal's journalist friends have come to his rescue by arranging for corrections in the media. Generally, they have cited the proof in Genaust's motion picture.

Rosenthal is proud of his many decades of professionalism and a lifetime of never violating his journalistic ethics. He desires only to clear his name and reputation, but this has not happened. Now weary and ailing, Rosenthal no longer thinks about asking for retractions and corrections. He does not want the bother. He knows that no matter how many corrections are made, before long the old lie will jump out again, resurrected by a young journalist eager for a scoop or approved by a magazine or television editor too lazy to demand proper research.

The 1982 *Los Angeles Times* column, mentioned above, contains a particularly blatant misstatement about Rosenthal:

> The photographer who captured the spirit of combat in the Pacific in World War II with the historic photograph of Marines raising the flag on Iwo Jima will be honored under legislation signed by President Reagan. The bill, sponsored by Rep. John L. Burton (D-San Francisco), directs the Interior Department to have Joseph Rosenthal's name inscripted on the base of the Iwo Jima Memorial in Arlington, Va. The sculpture, by Felix de Weldon, is based on the photograph. Rosenthal, now 71 and retired since 1980 from the *San Francisco Chronicle,* was an

Associated Press photographer when he arrived on Iwo Jima, Feb. 23, 1945. He was too late to see the Marines erect a small flag atop Mt. Suribachi a few days after their initial landing on the island. But he asked the Marines to "re-create" the scene, using a larger flag. The photo won a Pulitzer Prize and the Marine Band played at Rosenthal's retirement party.[4]

When longtime Los Angeles resident Harrold Weinberger, then eighty-three years old, saw the lie, he was outraged. In addition to the "re-create" error, the article was inaccurate about the date of Joe's arrival on Iwo. He had landed on D-day with the assault troops, not on 23 February when the flags were raised. The more Weinberger thought about the enormous circulation of the *Times* (which meant that this fallacious story had been printed more than one million times), the angrier he became.

After Weinberger cooled off, he sat down and composed a letter to the editor that politely corrected the errors in the *Times* account. He presented a short but accurate history of how the two flags were raised and photographed. He explained that he had personal knowledge of the incidents because he had served as a U.S. Marine photo section supervisor on Iwo Jima with Rosenthal and had met Joe on the beach shortly after his descent from Suribachi with the film that was to become historic.

Weinberger added: "I am pleased that Joe Rosenthal's name will be inscribed on the Iwo Jima Memorial. I am shocked by your fictitious and libelous statement that Rosenthal asked the Marines to 're-create' the scene using a larger flag. That statement is a libel and an insult to Rosenthal, the United States Marines and to Sgt. William Genaust, U.S.M.C., who shot the motion picture of the flag going up."[5]

The *Times* made no reply and did not print his letter. This indifference caused Weinberger to accelerate his decades-long efforts to obtain unblemished recognition of Rosenthal and Genaust in all forms of the media.

Twelve years later, on 13 January 1994, the *Los Angeles Times* again failed to research the facts properly and repeated its falsehood about the Rosenthal picture. In its obituary about John Bradley, the last survivor of the six flag raisers, the *Times* declared that the photo was "actually a staged second raising with a bigger flag." At that time, I asked the newspaper to publish a correction,[6] but the *Times* did not even reply to my letter.

Perhaps the worst bag of tricks was displayed by Jack Anderson in his nationally syndicated Sunday column of 19 January 1994. After men-

tioning the death of Bradley, Anderson went on to create a network of fabrications about the photo and the men in it. Each was an example of careless research. Anderson made it appear that he had just scored an investigative scoop. He implied that by digging through recently declassified government documents, his news sources discovered a Marine Corps cover-up that had gone on for five decades. Since 1945, he said, the Corps concealed the fact that Rosenthal faked his famed photo and that the Corps forced the six men in it to lie.[7]

This was all untrue, of course. The facts had been out in the open for half a century and had never required declassification. All Anderson did was revive the hoary falsehoods about Rosenthal that had been kicking around in journalism's back alleys for decades.

The columnist based his account on two facts that apparently were new to him: There had been two flag raisings, and Rosenthal had photographed the second, larger flag. Embroidering those facts, Anderson states:

> In the interest of Marine public relations, the AP photographer accompanied a hand-picked group of men for a staged flag-raising hours after the original event. The second group held the flag in place and Rosenthal snapped 18 shots of the dramatized event. . . . The incident was kept secret for decades. Not only the top brass who gave the orders but the enlisted men who posed with the flag never revealed the truth. For a time, their superiors even forced them to lie about it.[8]

Anderson received a fire storm of mail from U.S. Marines and non-Marines alike, who knew the truth. After a two-month delay, he published an apology that did little to put out the flames. The errors, of course, were not his fault, he said; he had relied "too heavily" on what now seemed to be faulty sources.[9]

Anderson's account appeared in so many newspapers that Rosenthal, then eighty-two years old, decided it was time to come out of his shell and take action. He wrote a letter to Anderson that was a model of courtesy and restraint. In words precise and clear, Rosenthal emphasized that on 25 February 1945—only two days after the flag raisings—*The New York Times* had published a front-page news story from Associated Press correspondent Hamilton Faron, who reported that there had been two flags.

"His dispatch," Rosenthal continued, "got widespread publication. . . . Year after year, the matter has been rehashed in articles almost too nu-

merous to count, and in a large number of books that include long passages about the two flags up there. Rather than 'the incident was kept secret for decades,' as you suggest, perhaps too much effort has been devoted to rewriting the event."[10]

Of all the books that discuss Rosenthal's photograph, only one—a large, prestigious volume printed on glossy paper—casts doubt on his ethics and integrity by callously ignoring the facts. A comprehensive history of American news photography titled *Eyes of Time: Photojournalism in America,* the book traces its progress from the daguerreotypes of the 1840s to the great photos of World War II, the high-impact color photography of the Vietnam War, and the tragic images of AIDS victims and starving Ethiopians during the mid-1980s. Author Marianne Fulton presents a classic collection of 370 black-and-white news photographs and 44 color news photos, including World War II photographs by such masters of black-and-white art as Edward Steichen, Margaret Bourke-White, Carl Mydans, David Douglas Duncan, Robert Capa, W. Eugene Smith, Alfred Eisenstaedt, and Joe Rosenthal.

Fulton's lengthy text includes articles and anecdotes about the photographers and their work. Two of Rosenthal's photographs are in the book—the flag raising and a darkly moody but superb shot of Marines sprinting from their landing boat and climbing a black sand terrace of Iwo Jima on D-day.

The articles about Capa, Mydans, Duncan, Bourke-White, and the other World War II photographers are positive, factual, and complimentary. Only one article, the one about Rosenthal, is negative and damaging to the photographer. It begins with praise, but instead of being a tribute, like the others, it degenerates into a commentary of damning implications and misstatements. It reads, in part:

> "Old Glory goes up on Mt. Suribachi, Iwo Jima," arguably the most famous photograph to come out of World War II, is an excellent example of the photograph as icon. People believed in the spirit it conveyed and were cheered by its sense of victory over adversity. It had an immediate, overwhelming impact on the nation. The powerful message of the men surging forward with the wind-whipped flag to raise in the sands of Iwo Jima as the fighting continued was communicated instantly. . . .
>
> Questions of its authenticity, whether it had been set up, were there from the beginning, however. Rosenthal maintains that it is a candid

view of soldiers raising the second, unofficial flag. *Life* editors rejected the photograph when it first came in. The composition looked too perfect to be true: they suspected it might be posed. Checking into it, they were told, contrary to Rosenthal, that the photographer himself was responsible for the larger flag and had in fact restaged the event. *Time* used it, as did hundreds and hundreds of magazines and newspapers. Because of the tremendous significance given to the photograph, *Life* published it three weeks later. The magazine reasoned that, whatever the circumstances under which it was taken, it had become to the nation, and to the marines, a symbol of their heroism. "Old Glory" was accorded iconic value because people believed in its truthfulness. Believing came first. In 1945, Rosenthal was awarded a Pulitzer Prize for the photograph.

The image's separate existence as a symbol obscures the issue of credibility. Certainly AP believed it to be authentic. No news organization can risk jeopardizing its own believability with the public—witness the initial reaction of *Life's* editors. . . . It (the photo) clearly transcended its creation as one news photograph by one man . . . and was embraced with nearly religious fervor. The editors of *U.S. Camera* wrote: "In a sense, in that moment, Rosenthal's camera recorded the soul of a nation."[11]

Fulton is associate curator of photographic collections at the International Museum of Photography at George Eastman House, Rochester, New York. She has prepared more than fifty photographic exhibitions and lectures nationally and abroad on twentieth-century photography. Because of her expertise and long list of professional credits, Fulton's condemnation of Rosenthal is difficult to accept. Her research on Rosenthal was apparently incomplete.

When I interviewed Rosenthal in late 1993, I asked him if he had kept any records since 1945 of the number of times the media had revived the old false charges. "No," he said, "but I could fill a warehouse with all the lies and mistakes printed about the picture."

Only once did Rosenthal hire attorneys and start legal proceedings to force a retraction. That was in 1960 when he was forty-nine years old and had the energy to fight the irresponsible attacks on his integrity in the NBC-TV show "The American." The one-hour documentary starred burly actor Lee Marvin, a former Marine, in a portrayal of flag raiser Ira Hayes. Because of the many untruths and clumsy distortions in the script, the sto-

ry of the alcoholic Pima Native American was by far the most unfair, most damaging, and most flagrant attack ever mounted against Joe and his photo.

People across the nation who watched "The American" were given these erroneous "facts": the act of six courageous men raising a flag was a re-created fake, the photo was therefore a fake, and the Arlington monument was a fake. The story line of the show insisted that the Marine Corps itself had perpetrated the fakery by forcing Hayes to lie about the flag raising, which turned him into a guilt-ridden boozer who drank himself to death at an early age.

Reaction to the show came swiftly the next day, with most of the calls and letters to NBC expressing displeasure. Many who saw the show were bewildered. Some felt disillusionment and betrayal. The show resulted in others becoming skeptics when they lost their long-held faith in a symbol of America's wartime greatness. The image that had stirred them so deeply in 1945 was claimed to be nothing but a Marine Corps publicity gimmick.

Because the Genaust motion picture was one of the big patriotic moments in the show, it was seen as part of the deceit. The erroneous implication was clear: The Marine sergeant helped his friend Rosenthal to set up the six men in their pose and then joined Rosenthal in filming them.

For the first time in his life, Joe was willing to go into court to defend his professional ethics in public. His attorneys told him that the case was solid because the libel was there on film and had been witnessed by a vast audience. The case dragged on for eighteen months.

"It took so long," Joe told me, "and got so involved that NBC offered to settle out of court. I could see it going on for many more depositions, on and on. So we settled for an apology, compensation for my attorneys, and compensation for me."[12]

The dollar amount of the settlement was not revealed. Friends of Joe said that he gave much of his part of the money to charity. He would never forget the men who had died by the thousands on the island, and he had no desire to profit from the blood they had shed.

Critics of the photo even showed up on Mount Suribachi four decades after the battle. Nearly three hundred former Marines, survivors of the fighting, returned to Iwo Jima in February 1985 for a reunion and to honor the memory of friends they had lost. Their tour included a visit to the

top of the volcano to view the Marine Corps monument that displays a re-production of the Rosenthal photo on a metal plaque.

As the group gazed at it, a few of the men criticized the photo and called it a posed phony. "The first flag picture was authentic," declared one cranky elderly veteran, more outspoken than the others. "This one came later and was faked."

An unidentified Marine Corps officer with the group offered a polite correction. "Both photos were genuine and unstaged," he explained. "This one was judged the best and became historic."[13]

The officer's explanation did not convince the critic. As the group moved on, he continued to berate the Rosenthal photo to anyone who would listen.

Bill Genaust was spared the criticism, accusations, and negativism endured by Rosenthal. If he had lived, there would have been less criticism because Genaust and Rosenthal would have united in defense of their work.

In a perfect world, Genaust would not have been killed and Rosenthal would not have been harassed for a lifetime by critics great and small. Rosenthal would have been long honored by his country because, in 1/400th of a second, he had affirmed forever the greatness of the United States, its people, and their flag. Because the world is inexplicable, however, Rosenthal has yet to be honored formally by either the American government or the Marine Corps.

This does not trouble him. Rosenthal has peace of mind. His critics will not live forever, but he knows that his photograph will. In his humility, he understands better than anyone else what happened atop Mount Suribachi at midday on 23 February 1945.

Joe Rosenthal said it long ago:

> I can best sum up what I feel by saying that of all the elements that went into the making of that picture, the part I played was the least important. To get that flag up there, America's fighting men had to die on that island and on other islands and off the shores and in the air.
>
> What difference does it make who took the picture? I took it, but the Marines took Iwo Jima.[14]

AFTERWORD

Iwo Jima,
the Netherworld

Tiny Iwo Jima is one of the Volcano Islands in the Pacific near Japan. The word *volcano* is derived from Vulcano, one of the islands north of Sicily. Vulcano has several volcanoes that have been active throughout recorded history. It is a tiny island of eight square miles, about the same size as Iwo Jima.

During classical times and in Roman religion, Vulcano was thought to be the entrance to the Netherworld, the domain of Vulcan, the Blacksmith God, also known as the God of Fire and Metalworking. Volcanoes were the natural chimneys of his subterranean smithies, the most famous of which was beneath Mount Etna, where Vulcan manufactured swords, daggers, and armor for gods and heroes—and thunderbolts for Jupiter.

Thus, U.S Marines who fought with flamethrowers in the hell tunnels of Iwo Jima were in the Netherworld of the Blacksmith God of Fire.

That is not the island's image today. When people view the Rosenthal and Genaust pictures, they see beauty and bravery, not blood and brutality.

Historical Points of Interest on Iwo Jima

The accompanying map of Iwo Jima, as it is today, identifies the invasion beaches, Japanese airstrip, sulfur pits, existing World War II defenses, peace monuments, and other areas of historical interest.

1. **U.S. Coast Guard Loran (long-range aid to navigation) Station** Established in 1945, the radar/weather station at Kitano Point was manned by the U.S. Coast Guard for forty-eight years. It was the last formal American presence on Iwo Jima. In October 1993, its staff of twenty-six men departed, and the structures and 1,350-foot tower were transferred to the Japanese Coast Guard. The station had been rebuilt in 1955 after Typhoon Louise destroyed 98 percent of Iwo Jima's facilities. During the battle in 1945, a group of ravines west of the station became known as Bloody Gorge, site of the final Japanese resistance.

2. **Headquarters Cave** Lt. Gen. Tadamichi Kuribayashi, commander of the Japanese forces, maintained his headquarters here in a large cave with an elaborate system of tunnels.

3. **Sandstone Monument** Joe Rosenthal's flag-raising photograph is

177

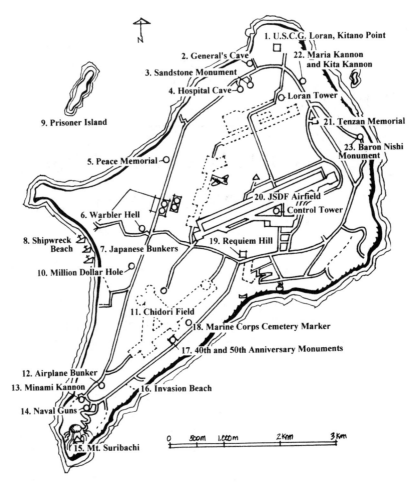

Iwo Jima, as it is today, and points of historical interest. (Map by Milt Reppert)

depicted in a large rock sculpture carved in 1945 by Waldon T. Rich, 31st Naval Construction Battalion, U.S. Navy.

4. Hospital Cave This immense cave accommodated hundreds of wounded Japanese soldiers and sailors. When the U.S. Marines first entered, they discovered the mummified remains of fifty-three Japanese servicemen.

5. **Peace Memorial** Consisting of several structures, the Japanese memorial is located over the site of Iwo Jima's prewar civilian cemetery.

6. **Warbler Hell** Approximately nine hundred feet in diameter and thirty feet deep, this is one of the largest active sulfur pits on Iwo Jima. Growing at the rate of three feet annually, it produces a continuous, noisy flow of gas and steam.

7. **Japanese Bunkers** Three concrete bunkers were part of the defenses constructed to guard the west beaches.

8. **Shipwreck Beach** In September 1945, the U.S. Navy sank eight surplus American, Russian, and Japanese ships, in the shape of a square, to provide a breakwater for small landing boats.

9. **Prisoner Island** Known as Kangoku Iwa, the island was used before the war to house civilian prisoners.

10. **Million Dollar Hole** A series of three extinct craters, into which U.S. forces reportedly dumped more than $1 million worth of surplus vehicles and other military equipment after the war. One of the holes is said to be more than two hundred feet deep and intensely hot and gaseous near the bottom.

11. **Chidori Field** Also known as Motoyama Airfield No. 1, it is now heavily overgrown with shrubs and weeds. Constructed in 1933 and later expanded, it was the second largest Japanese landing strip on the island. Japanese fighter planes based on Motoyama No. 1 made numerous raids on U.S. bases in the Marianas Islands and destroyed many B-29 bombers. While the battle for Iwo still raged, members of the 31st Seabees (Construction Battalion) began rebuilding the airfield and extending it to 10,000 feet so that disabled B-29 bombers could land there.

12. **Airplane Bunker** The Japanese built a reinforced concrete and stone bunker around the fuselage of an American or Japanese medium bomber. For a time, Maj. Gen. Graves B. Erskine, commander, 3d Marine Division, used it for his field headquarters.

13. **Minami Kannon** Representing Kannon, the Buddhist of Peace, this monument is dedicated to the Japanese war dead inside and around Mount Suribachi. Seventy-two Japanese monuments were erected on Iwo Jima by the Reverend Tsuenezo Wachi and the Japanese Iwo Jima Association.

14. **Naval Guns** Two of the four large Japanese guns originally covering the east and west beaches are located here. They were brought to Iwo Jima by Reverend Wachi, then a navy captain and island commander prior to General Kuribayashi's arrival.

15. **Mount Suribachi** *Suribachi* is Japanese for "mortar," a bowl used to grind grains into powder. The crater resembles an upturned bowl. In places, its steep vertical slope is 80–85 degrees. The volcano last erupted in 1727, but steam and sulfur fumes still rise from a vent in its center. The Japanese monuments atop Suribachi include three dedicated to kamikaze pilots who died during the battle for Iwo Jima.

16. **Invasion Beach** Approximately 2.5 miles long, this stretch of black sand is where the 4th and 5th Marine Divisions landed on D-day.

17. **Fortieth and Fiftieth Anniversary Monuments** Located near the beach between the landing areas of the 4th and 5th Marine Divisions, these monuments mark the sites of the 1985 and 1995 reunions. On these two occasions, former U.S. Marines returned to Iwo Jima to commemorate the battle and remember their comrades who had died.

18. **Marine Corps Cemetery Marker** This is the site of the former cemetery of the 3d and 4th Marine Divisions, which contained the remains of 3,160 men. Nearby was the 5th Marine Division cemetery, in the form of a cross, which contained the remains of 2,280 men. The remains of nearly 7,000 U.S. casualties were removed from the island prior to the return of Iwo Jima to the Japanese in 1968.

19. **Requiem Hill** Members of the Tokyo City Fire Department raised $200,000 for construction of this large memorial to the war dead of both nations.

20. **Japanese Self-Defense Forces Airfield** This modern airfield, 8,700 feet long, is equipped with a large air terminal building and tower. Nearby are battle sites designated by the U.S. Marines as Turkey Knob, the Amphitheater, and Meat Grinder. Just south of the airfield is a wrecked Japanese blockhouse containing the Iwo Jima Museum.

21. **Tenzen (Heavenly Mountain) Memorial** Known as Hill 362C, this was the site of two large Japanese Navy guns. The valley to the south was the site of the battle of Cushman's Pocket.

22. **Maria Kannon and Kita Kannon** Erected in 1952 by the Reverend Mr. Wachi and his association, this is the only Christian Japanese monument on Iwo Jima.

23. Baron Nishi Monument Member of an old and wealthy Japanese family, Baron Takeichi Nishi was Japan's most renowned horseman. At the 1932 Olympics in Los Angeles, California, he won the Gold Medal for horsemanship. He was trapped in Cushman's Pocket, where he died at the age of forty-four, probably a suicide.

Source: Adapted from the U.S. Navy map and from U.S. Navy and Coast Guard notes compiled by PO Brent L. Saucerman, USN.

NOTES

Preface: A 556-Foot Climb into History

1. According to *Encyclopedia Americana*, 529, deaths of Americans in the armed forces during World War II totaled 407,318, which included 292,131 battle deaths and 115,187 deaths resulting from disease and accidents. Total war deaths, military and civilian, in all of the countries involved in the war were so difficult to summarize that estimates still vary in reputable reference works. Half a century later, historians tend to agree that the death toll worldwide was more than 50 million.
2. Wheeler, *Iwo*, 108, lists D-day casualties and says that 40,000 Marines were ashore.
3. Sherrod, *On to Westward*, 180.

Introduction: In Joe Rosenthal's Own Words

1. Author's note: The nearly life-sized carving of the flag raising is on a sandstone cliff near Kitano Point in the island's northernmost area. It was carved in July 1945 by Seabee Waldon T. Rich of the 31st Construction Battalion, U.S. Navy. He copied the Rosenthal photo from a page in *Life* magazine. The Marines are painted white, and the flag is red, white, and blue.
2. Author's note: According to *Simon and Schuster Encyclopedia of World War II*, 536, the flag monument is the largest bronze sculpture in the world.

3. Pfc Rene A. Gagnon, USMC, one of the six flag raisers photographed by Rosenthal.

Chapter 1. Mistakes and Misjudgments

1. On 17 March 1945, Admiral Nimitz's final communique of the Iwo Jima campaign stated: "Island officially secured at 6 P.M." Ross, *Iwo Jima: Legacy of Valor,* 329, quotes a 3d Division machine gunner as commenting in disbelief: "If this damned place has been secured, I wonder where in hell all the Nip fire is coming from?"

 Wheeler, *Iwo,* 228–29, quotes from a letter written by Pfc H. C. Hisey of the 28th Marine Regiment's Headquarters and Service Company: "It makes me mad when I think that the people back home believe this island was secured a week ago and that all the Marines have left. These people would think differently if they could see all the wounded still being brought in."

2. Bartley, *Iwo Jima: Amphibious Epic,* 193, notes: "In April and May, however, aggressive patrol and ambush activity by the Army's 147th Infantry netted 1,602 Japanese killed." He states that in twenty-four days of the final phase, starting 11 March, Marine losses increased by 3,855.

 Wheeler, *Iwo,* 234, states that "as late as May 17, when Donald C. Palmer, a Navy aviation radioman, arrived for duty on Iwo, the mop-up by the Army was continuing." He quotes Palmer: "There was a story going around that Jap officers were still sneaking out of caves at night and using their swords to cut up Americans right through the sides of tents. I put my cot in the middle of the tent and slept with my .38 under the pillow."

3. U.S. casualty figures are from Smith and Finch, *Coral and Brass,* 226.

Chapter 2. An Impeccable Record

1. Harrold Weinberger, interview with author, 18 February 1983.

2. Marling and Wetenhall, *Iwo Jima: Monuments, Memories and American Hero,* 257 n., note that Capt. Edward Steichen, the U.S. Navy's No. 1 photo authority, took pains to downplay possible criticism of the Rosenthal photo. They quote author Robert Sherrod as saying that "Steichen asked him to suppress word that Rosenthal's picture was not of the first flag-raising—for the good of the Marines."

3. In Smith and Finch, *Coral and Brass,* 22, Smith explains how he received his nickname "Howlin' Mad." In 1906, his troops in the Philippines bestowed the name on him when, as a twenty-four-year-old second lieutenant, he led them on a record-breaking, sixty-five-mile forced march through the jungle. He notes: "I suppose I did use tempestuous language to keep the men moving."

4. Ross, *Iwo Jima: Legacy of Valor,* 99.

Chapter 3. The Mysteries of Art and War

1. Karal Marling and John Wetenhall make the point that Richard Wheeler, writing in *American Heritage Magazine,* 6 June 1964, implies that the photo of the first flag raising was superior to the second. Also, Marling and Wetenhall, *Iwo Jima: Monuments, Memories and American Hero,* 157 n., quote Wheeler as saying the second was less "impromptu and dangerous."
2. Wheeler, *Iwo,* 233, supplies additional details on the military career of Dave Severance, who rose from private to colonel. He served as a paratrooper and then company commander on Iwo. In a lengthy interview in *Military History Magazine,* February 1995, 39–44, Severance describes how his Company E fought on Iwo and raised the two flags on Suribachi. His 3d Platoon, the most decorated in Marine Corps history, was awarded the Medal of Honor, two Navy Crosses, a Silver Star, seven Bronze Stars for Valor, and seventeen Purple Hearts.
3. Newcomb, *Iwo,* 166. The second flag was ordered by Maj. Gen. Keller E. Rockey, commander of the 5th Marine Division, who radioed Johnson to substitute a larger flag.
4. Rosenthal, interview with author, 18 September 1983.
5. As quoted by Rosenthal in ibid. Also, see Marling and Wetenhall, *Iwo Jima: Monuments, Memories and American Hero,* 177.
6. Quoted in Marling and Wetenhall, *Iwo Jima: Monuments, Memories and American Hero,* 177.
7. Quoted by Rosenthal in interview with author, 18 September 1983.
8. Ibid.
9. Joe Rosenthal, letter to President Ronald Reagan, 4 November 1983. For full text of letter, see chapter 10.

Chapter 4. Heartbreak

1. Details and quotations in this chapter are from Adelaide Genaust Dobbins' personal interviews with author, 25 and 26 June 1983.
2. The date of 3 March 1945 in the commandant's letter was incorrect. Later reports stated that Sergeant Genaust was missing in action beginning on 4 March 1945.

Chapter 5. He Never Knew

1. Isely, *U.S. Marines and Amphibious War,* 438, 443, analyzes the Marine losses. He places blame for the unusually high Marine casualties on two factors: (1) inadequate preinvasion bombing for months by the U.S. Seventh Air Force; and (2) Vice Adm. Richmond Kelly Turner's decision, approved by Adm. Raymond A. Spruance, to reduce the fleet's preinvasion bombardment from ten days to three. Isely states that

the Air Force bombing had little adverse effect on Iwo's defenses and "only increased the problem facing the Marines by causing the underground positions to be made more elaborate than they might otherwise have been." Turner's decision for three days of bombardment was based on terrain studies by his naval staff, with which Marine terrain studies strongly disagreed. According to Isely, Gen. Holland M. Smith in his memoirs (see Smith and Finch, *Coral and Brass*) shows little consideration for the Navy's point of view: "Thus," concludes Smith, "we were defeated—a group of trained and experienced land fighters, our full realization of the necessity for naval gunfire based on many previous island operations—again overridden by the naval mind."

2. This was also the day that Joe Rosenthal arrived at press headquarters on Guam after eleven days of photographing combat scenes on Iwo Jima.
3. Statistics on B-29 emergency landings in Ross, *Iwo Jima: Legacy of Valor*, xiv.
4. Weather conditions in ibid., 284.
5. Colonel Dickson's letter is in personal file of Adelaide Genaust Dobbins.

Chapter 6. The Most Difficult Letter

1. Copy of letter is in personal file of Adelaide Genaust Dobbins.
2. Adelaide Genaust Dobbins, interviews with author, 25 and 26 June 1983.

Chapter 7. The Strangest Battle of the Century

1. According to Newcomb, *Iwo Jima*, 223, during the fighting on 3 March for Nishi Ridge, the 5th Marine Division suffered 518 casualties, including the deaths of 8 officers and 127 enlisted men. This was the worst loss for a single day since D plus 2 and would not be equaled for the remainder of the Iwo Jima campaign.
2. From 1950 to 1980, the total number of reported casualties increased by 7,707. According to Connor, *The Spearhead*, 121, the combined landing forces at Iwo Jima suffered 20,979 total casualties (1950 figures). In 1954, Bartley, *Iwo Jima: Amphibious Epic*, 218–21, listed total casualties at 24,891, an increase of 3,912 since 1950. Those were official Marine Corps numbers supplied to the foregoing authors. Decades later, the "final figure" was increased by an additional 3,795 to an official 28,686. That total was reported by Newcomb, *Iwo Jima*, 296, in 1965 and by Wheeler, *Iwo*, 234, in 1980. In December 1994, Headquarters Marine Corps reported to this author that the figure of 28,686 remains unchanged.
3. Ross, *Iwo Jima: Legacy of Valor*, 95.
4. Newcomb, *Iwo Jima*, 33–34.

5. Account of General Smith is from Ross, *Iwo Jima: Legacy of Valor,* 31–32.
6. Quoted by Bob Campbell in conversation with author.

Chapter 8. No Time for Cameras

1. Quoted in Henri et al., *U.S. Marines on Iwo Jima,* 154.
2. Ibid.
3. Ibid., 153.
4. Account of the debate about the use of poison gas is from Newcomb, *Iwo Jima,* 239–41. Also, see Garand and Strobridge, *Western Pacific Operations,* 614, who quote General of the Army George C. Marshall as stating that, following the terrible losses at Iwo Jima, he was "prepared to use gas at Okinawa."
5. Ross, *Iwo-Jima: Legacy of Valor,* 257.
6. Wheeler, *Iwo,* 195.
7. Accounts of Johnson's death and quotations are from Ross, *Iwo Jima: Legacy of Valor,* 257, 258. The enlisted men who worshiped Colonel Johnson included Pfc Raul V. Paredes, who joined three other young Marines and a Navy corpsman in a historic feat: they were the first Americans to climb Mount Suribachi. Paredes told their story during an interview with author, 14 June 1995. The four members of Company F, 2d Battalion, Paredes, Cpl. Leroy Weingarten, Pfc Jerald W. Heins, and Pfc Charles Ihde, and Corpsman Edwin E. Hickerson (later killed in action) volunteered for the dangerous mission on the night of 22 February, while the mountain was still under total enemy control. The volunteers were ordered by Capt. Arthur Naylor to scale the steep rocky slopes in the darkness and locate a cave being used by Japanese artillery spotters to direct devastating shell fire at Johnson's units dug in around the base of Suribachi.

Paredes recalled the mission: "We went maybe halfway up the mountain before we located the cave. We set up an observation post on a ledge above the cave entrance. I was on watch about 1:30 A.M. when I saw a Japanese soldier crawling toward us. I fired two rounds, wounded him, but he got up and tried to push me off the ledge. I emptied my M1 and he fell, thank God."

When he saw a second soldier crawling into the cave entrance, Paredes shot him in the head and killed him. After that, Suribachi was the scene of bloody confusion. Machine gunners in the 3d Battalion were unaware that Marines were there and opened fire on them. Paredes messaged Captain Naylor, who immediately phoned the 3d Battalion and stopped the firing. He then sent a squad of Marines up the mountain to join the patrol. Sporadic firefights went on through the night. "We killed at least twenty Japanese," Paredes said. "In the morning we went down to the cave entrance, examined the man I shot in the head and discovered that he was a suicide

Jap, loaded with explosives. A few hours later, a bigger patrol climbed Suribachi, the flags went up—and the rest is history."

8. Garand and Strobridge, *Western Pacific Operations*, 627, list total 5th Marine Division casualties from D-day, 19 February, through 3 March as follows: killed, 48 officers, 952 men; wounded, 161 officers, 3,081 men; missing, 2 officers, 47 men.

9. According to Murphy, *Heroes of World War II*, 284–87, Harrell's life took another violent turn in 1964. At the age of forty-two, he suffered an attack of post-traumatic syndrome, probably related to his Iwo Jima ordeal and its aftermath, and his mind snapped. Involved in a bitter love triangle, Harrell picked up an M1 rifle from his gun collection, killed his neighbor and his neighbor's wife, and then killed himself.

10. During the wars against Native Americans in the 1800s, U.S. Army troop commanders were far more generous in awarding the Medal of Honor for valor. According to historical researcher Stanley O. Shelton, interview with author, June 1995, during one day of fighting in the Battle of the Little Bighorn in Montana in 1876, Medals of Honor were awarded to twenty-two soldiers. His brother, Bill Lee Shelton, also a historical researcher, interview with author, June 1995, states, that in 1870 during one day of fighting along the Wichita River in Texas, fourteen men of the 6th U.S. Cavalry were awarded Medals of Honor. The War Department later formally rescinded many of the awards after investigations determined that the acts of heroism were not up to the highest standard.

11. Newcomb, *Iwo Jima*, 224.

Chapter 9. No Interviews!

1. Joe Rosenthal, telephone interview with author, 17 December 1993.
2. Data from *Current Biography*, 516–18.
3. Jeremiah O'Leary, *Washington Times*, 29 June 1992. Column.
4. *Current Biography*, 516–18.
5. Quoted in ibid.

Chapter 10: Efforts to Honor Rosenthal and Genaust

1. Joe Rosenthal, telephone interview with author, 17 December 1993.
2. Ibid., 18 September 1983.
3. Ibid.
4. Ibid.
5. Rosenthal sent the author a copy of his letter to President Reagan.
6. General Kelley's certificate honoring Sergeant Genaust was undated.

Chapter 11. Of Wars, Movies, and Genealogy

1. The Genaust memorial plaque is on a white concrete pedestal erected atop Mount Suribachi on the site where Joe Rosenthal and Sergeant Genaust shot their flag-raising pictures. The construction was completed in February 1995 by a team of Marines from Camp Smedley D. Butler, Okinawa, which maintains all of the American monuments on Iwo Jima. Involved in the project were Col. Thomas B. Guiney, who designed the base; Capt. Mark Roberts, project director; Cpl. Maximino Pinon of the 9th Engineer Support Battalion, who did the construction; and Lt. Robert L. Dunsmore, USN, liaison officer. Mark Lambert of the U.S. Embassy in Tokyo obtained permission from the Japanese government for the plaque to be erected on the extinct volcano.
2. Harrold Weinberger, interviews with author, various dates, 1983–95; and with Vergun, various dates, 1992. Quotations from Vergun interviews are used with permission of Weinberger and Vergun.

Chapter 12. Heroes among the Hills

1. Account of Garrett and the Marine is from Newcomb, *Iwo Jima*, 202.
2. Ibid.
3. Account of Jacobson's heroism is from Wheeler, *Iwo*, 179.
4. Smith and Finch, *Coral and Brass*, 10, offer a unique, unsolicited Japanese tribute to the spirit and dedication of U.S. Marines in combat. While being interrogated by Marine intelligence officers, Major Yoshida, a Japanese staff officer captured on Saipan in 1944, said: "The Japanese can never hope to defeat a nation that produces soldiers like your Marines. In the Japanese army, we revere the spirit of *Yamato Damashii,* which means the "Spirit of Old Japan," and our soldiers will die for it. We have learned that the American Marine also reveres the spirit of his country and is just as willing to die as the Japanese soldier. Moreover, the Marine is a better soldier than the Japanese. His individuality is stronger, his training and fighting technique better. He has arms, ammunition and engineering equipment far superior to ours. Had I not believed this, I would not have surrendered."
5. Account of Watson's heroism is from Ross, *Iwo Jima: Legacy of Valor,* 230–31.
6. Accounts of Pierce, Wahlen, and Willis are from ibid., 266–67.
7. Bartley, *Iwo Jima: Amphibious Epic,* 220.
8. Ibid.
9. Ibid.
10. Incident is from Newcomb, *Iwo Jima,* 106.
11. Ibid., 107.
12. Quoted in Henri et al., *U.S. Marines on Iwo Jima,* 76.

13. Jesse Bradley, interview with author, 24 September 1993.
14. Morison, *History of Naval Operations in World War II*, 54.
15. Quoted in Henri et al., *U.S. Marines on Iwo Jima*, 87.
16. Account of "Tojo" is from Morison, *History of Naval Operations in World War II*, 69.
17. Newcomb, *Iwo Jima*, 287.
18. Account of McLean is from Henri et al., *U.S. Marines on Iwo Jima*, 152.

Chapter 13. Adelaide and the Flag-Raising Movie

1. Adelaide Genaust Dobbins, interviews with author, 25–26 June 1983.

Chapter 14. Putting the Blame on General Vandegrift

1. Albee and Freeman, *Shadow of Suribachi*, 83–90.
2. Ibid.
3. "Time Views the News," radio broadcast, New York, N.Y., 14 March 1945.

 In a 1992 interview, as cited in Albee and Freeman, *Shadow of Suribachi*, 78, Sherrod revealed to the authors that Lou Lowery was the source for his radio report claiming that the Rosenthal photo was posed. Recalling a meeting he had with Lowery in 1945, Sherrod said: "Lowery was very bitter about his photograph not being used because it showed the first flag raising, while Joe's showed the later event. It was Lowery who led me into the error on the Rosenthal photo. I should have been more careful. I accepted the version of a man who was boiling mad. I got it from Lowery. He said it was posed."

 Soon after the Sherrod incident, Lowery's attitude changed. As the years passed, he became one of Rosenthal's most valuable defenders and best friends.
4. Albee and Freeman, *Shadow of Suribachi*, 85.
5. Ibid., 62–65. The seven photographers atop Suribachi at various times during the two flag raisings included Joe Rosenthal, Bill Genaust, Lou Lowery, Bob Campbell, Louis R. Burmeister, and George Burnes. The seventh man, according to Albee and Freeman, was "an anonymous Coast Guard photographer," whose photo offers "the most comprehensive view of the terrain in the vicinity of the flag."
6. Truman, *Memoirs* 1:509–10. Also, see Marling and Wetenhall, *Iwo Jima: Monuments, Memories and American Hero*, 12–13.
7. Marling and Wetenhall, *Iwo Jima: Monuments, Memories and American Hero*, 10–12.
8. Ibid., 7–8.
9. Ibid., 15–16.
10. For more information about Eisenhower's letter, see ibid.
11. Ross, *Iwo Jima: Legacy of Valor*, 355.

Chapter 15. Nimitz: A Rock of Gibraltar in the Pacific

1. Ross, *Iwo Jima: Legacy of Valor,* 3.
2. Adm. Raymond A. Spruance was overall commander of the Iwo Jima operation; Vice Adm. Richmond Kelly Turner, commander of the expeditionary force; Rear Adm. W. H. P. Blandy, commander of the fleet that bombarded Iwo prior to the invasion; Maj. Gen. Harry Schmidt, commander of the V Amphibious Corps, which included the Marine landing forces; Lt. Gen. Holland M. Smith, commander of the Marines.
3. Newcomb, *Iwo Jima,* 171.
4. Ross, *Iwo Jima: Legacy of Valor,* 14–16.
5. Ibid., 41.
6. Newcomb, *Iwo Jima,* 296; Bartley, *Iwo Jima: Amphibious Epic,* 193.
7. For example, see Ross, *Iwo Jima: Legacy of Valor,* 28.
8. Totals of emergency landings and crewmen are from ibid., xiv.
9. Navy casualties in Newcomb, *Iwo Jima,* 296.
10. Account of frogmen is from Ross, *Iwo Jima: Legacy of Valor,* 48, 49.
11. Newcomb, *Iwo Jima,* 296.
12. Army casualties totaled from figures in ibid. and Ross, *Iwo Jima: Legacy of Valor,* 336.
13. Henri et al., *U.S. Marines on Iwo Jima,* 21.
14. Ross, *Iwo Jima: Legacy of Valor,* 41.
15. After the war, Tokyo Rose was identified as Iva Ikuko Toguri d'Aguino, born in Los Angeles, California, on 4 July 1916 and a graduate of the University of California, Los Angeles. In July 1941, she went to Japan on a visit. During World War II, Japan considered her an enemy alien because she refused to give up her U.S. citizenship and ordered her to do radio propaganda broadcasts in English aimed at demoralizing U.S. troops in the Pacific. She was one of twenty women who made such broadcasts. After the war, the United States accused d'Aguino of treason and brought her to trial. Found guilty, she served $6\frac{1}{2}$ years in prison and was released in 1956. President Gerald Ford pardoned her on 20 January 1977, after many U.S. groups, including veterans of the U.S. Army's 41st Infantry Division, rallied to support her claim that Japan forced her to make propaganda broadcasts.
16. Smith and Finch, *Coral and Brass,* 3, 4.
17. Ibid.
18. Quoted in *Washington Post,* 30 June 1933.
19. Marling and Wetenhall, *Iwo Jima: Monuments, Memories and American Hero,* 277 n.
20. Quoted in ibid.
21. Ibid.

Chapter 16. A Plot against the Stars and Stripes

1. Quoted in Newcomb, *Iwo Jima*, 257–60; and Garand and Strobridge, *Western Pacific Operations*, 677–80.
2. Wheeler, *Iwo*, 211.
3. Henri et al., *U.S. Marines on Iwo Jima*, 214–16.
4. Newcomb, *Iwo Jima*, 213.
5. Ibid., 259.
6. Ross, *Iwo Jima: Legacy of Valor*, 344.

Chapter 17. A Genius of Defense

1. Quoted in Henri et al., *U.S. Marines on Iwo Jima*, 7, 8.
2. Biographical details and quotation from letter are in Wheeler, *Iwo*, 8–11.
3. Quoted in ibid, 10.
4. Ibid.
5. Ibid.
6. Newcomb, *Iwo Jima*, 15, notes that because Iwo Jima had no natural sources of water, it was rationed severely, even for months prior to the American invasion. Rainwater was collected in cisterns. Water was for drinking only; the only bathing allowed was in the sea.
7. Smith and Finch, *Coral and Brass*, 259.
8. Kuribayashi's message and poem quoted in Newcomb, *Iwo Jima*, 272.
9. Bartley, *Iwo Jima: Amphibious Epic*, 185–86.
10. Ibid., 190.
11. According to Wheeler, *Iwo*, 233, Kuribayashi died in the traditional hara-kiri ceremony. He knelt, bowed three times, and plunged a knife into his abdomen. Col. Kaneji Nikane stood over him and, with great force, brought a sword down on the back of Kuribayashi's neck.
12. Quoted in Tatum, *Iwo Jima: Red Blood, Black Sand*, 285, 286. Tatum was an eighteen-year-old machine gunner with Company B, 1st Battalion, 27th Marine Regiment, 5th Marine Division. He fought for fifteen days before being evacuated.

Chapter 18. Heroes for Eternity

1. Wheeler, *Iwo*, 277.
2. Quoted in ibid.
3. Quoted in ibid., 228.

4. Data in the Hayes's biography and in the biographies of the other five flag raisers are primarily from Nalty, *U.S. Marines on Iwo Jima.*
5. Quoted in Bronson, "Picture That Will Live Forever."
6. Ibid.
7. Letter quoted in ibid.
8. Marling and Wetenhall, *Iwo Jima: Monuments, Memories and American Hero,* 111.
9. Bronson, "Picture That Will Live Forever."
10. Quoted in ibid.
11. Quoted in ibid. In mid-March 1995, during the fiftieth anniversary observances of the battle, seventy-four-year-old Lindberg returned to Mount Suribachi, where he was honored as the last survivor of the twelve men who raised the two flags. Hundreds of Americans, among them U.S. Marine survivors and their families attended the ceremony, as did many Japanese, including survivors of the battle.
12. *Bartlett's Familiar Quotations,* 132.
13. Ibid., 109.

Chapter 19. Iwo Jima Today: 26 Feet Higher

1. M. E. Stanley, "Tokyo's Sulfur Island," *Pacific Friend* (Tokyo), 23 (June 1995): 22–27.
2. Details of presentation are from Jan Proehl, interviews with author, 24 and 25 October 1993 and 6 January 1994.
3. Proehl interviews.
4. See Paul Sampson, "The Bonins and Iwo Jima Go Back to Japan," *National Geographic,* 134 (July 1968): 128–44.

Chapter 20. Truths versus Untruths

1. Marling and Wetenhall, *Iwo Jima: Monuments, Memories and American Hero,* 246, n. note the existence of Eisenhower's letter in Box 106, File OF3-R-4-A (Office Files) Eisenhower Library.
2. *Los Angeles Times,* 14 October 1982. Newsmakers column.
3. Fulton, *Eyes of Time.*
4. *Los Angeles Times,* 14 October 1982. Newsmakers column.
5. Harrold A. Weinberger, letter to *Los Angeles Times* 14 October 1982. (A copy of this letter is in author's files, courtesy of Weinberger.)
6. Author, letter to *Los Angeles Times,* 13 January 1994.
7. Jack Anderson, 19 January 1994. Syndicated column.
8. Ibid.
9. Jack Anderson, "Classic Photo Misrepresented," 20 March 1994. Syndicated column.

10. Joe Rosenthal, letter to Jack Anderson, 9 February 1994. (A copy of this letter is in author's files, courtesy of Rosenthal.)
11. Fulton, *Eyes of Time,* 161, 167.
12. Rosenthal, interview with author, 17 December 1993.
13. Officer's comments cited in Marling and Wetenhall, *Iwo Jima: Monuments, Memories, and American Hero,* 235.
14. Rosenthal and Heinz, "The Picture That Will Live Forever."

BIBLIOGRAPHY

"Adelaide Genaust Dobbins, Widow of Sergeant William H. Genaust, Receives His Marine Corps Certificate." *Orlando Sentinel,* 1 May 1984.

Albee, Parker Bishop, Jr., and Keller Cushing Freeman. *Shadow of Suribachi.* Westport, Conn.: Praeger, 1995.

Anderson, Jack. "Classic Photo Misrepresented." Annapolis *Capital,* 19 January 1994. Column.

———. "Correction of 19 January 1994, Column." Annapolis *Capital,* 20 March 1994.

Arthur, Robert A., and Kenneth Cohlmia. *The Third Marine Division.* Washington, D.C.: Infantry Journal Press, 1948.

Associated Press. "Japanese Return to Iwo Jima to salvage Battle Metal for Shipment to Japan." Iwo Jima, 23 February 1954.

———. "Huge Monument Dedicated to Marines." Washington, D.C., 10 November, 1954.

———. "U.S. Flag Lowered, Iwo Restored to Japan." Iwo Jima, 26 June 1968.

———. "Remains of 197 Americans Removed from Tunnels, Caves." Iwo Jima, 28 March 1992.

Bartlett's Familiar Quotations. New York: Permabooks, 1957, 278.

Bartley, Whitman S. *Iwo Jima: Amphibious Epic.* Washington, D.C.: Historical Branch, U.S. Marine Corps, 1954.

Bronson, Daniel R. "The Picture That Will Live Forever." *Us* (25 February 1985): 24–29.

Congressional Medal of Honor Library, World War II. 2 vols. New York: Dell, 1986.

Bibliography

Connor, Howard M. *The Spearhead: The Fifth Marine Division in World War II.* Washington, D.C.: Infantry Journal Press, 1950.

Current Biography. New York: H. W. Wilson Publishing, 1945, 516–18. Biography of Joe Rosenthal.

Encyclopedia Americana. International ed. Danbury, Conn.: Grolier, 1982.

Frank, Benis M. "The Man Who Took the Picture on Iwo Jima." *New York Times,* 16 November 1991. Letters.

———. "Does Book on Iwo Jima Memorial Bash a Marine Icon?" *Fortitudine* (Winter 1991–92): 10–11.

Fulton, Marianne. *Eyes of Time, Photojournalism in America.* Boston: Little, Brown, 1988.

Garand, George W., and Truman R. Strobridge. *Western Pacific Operations in World War II.* Vol. 4. Washington, D.C.: Historical Branch, U.S. Marine Corps, 1971.

Henri, Raymond, W. Keyes Beech, David K. Dempsey, Alvin M. Josephy, Jr., and Jim G. Lucas. *The U.S Marines on Iwo Jima.* Nashville, Tenn.: Battery, 1987.

Hoyt, Edwin P. *How They Won the War in the Pacific: Nimitz and His Admirals.* New York: Weybright and Talley, 1970.

Isely, Jeter A. *The U.S. Marines and Amphibious War.* Princeton, N.J.: Princeton University Press, 1951.

"Iwo Jima after 40 Years." *U.S. News & World Report,* 25 February 1985, 39–41.

"Iwo Jima Sculptor's Studio Sold." *Washington Post,* 30 June 1993.

"Iwo Jima Vet Charles W. Lindberg Takes Pride in Photo." *Staten Island Sunday Advance,* 29 May 1988.

"Joe Rosenthal Joins Group Seeking Honors for Sergeant William H. Genaust." *Long Beach (Calif.) Press-Telegram,* 4 March 1983.

"Joe Rosenthal 'Recreated' Flag Photo." *Los Angeles Times,* 14 October 1982.

Kirby, S. Woodburn. *The War against Japan.* 3 vols. London. Eng.: London Publishing, 1957–61.

"Lee Walch Is Bride of Joe Rosenthal." *San Francisco Chronicle,* 6 October 1946.

Los Angeles Times, 18 April 1987. Obituary, Lou Lowery.

Manchester, William. *Goodbye, Darkness, a Memoir of the Pacific War.* Boston: Little, Brown, 1979.

"Marine Corps Awards Certificate to Sergeant William H. Genaust." *Orange County (Calif.) Register,* 22 February 1984.

Marling, Karal Ann, and John Wetenhall. *Iwo Jima: Monuments, Memories and the American Hero.* Cambridge, Mass.: Harvard University Press, 1991.

Maslowski, Peter. *Armed with Cameras: The American Military Photographers of World War II.* New York: Free Press, 1993.

Morison, Samuel Eliot. *History of United States Naval Operations in World War II.* Vol. 14. Boston: Little, Brown, 1960.

Murphy, Edward F. *Heroes of World War II.* Novato, Calif.: Presidio Press, 1990.

Nalty, Bernard C. *The U.S. Marines on Iwo Jima: The Battle and the Flag-Raisers.* Washington, D.C.: Historical Branch, U.S. Marine Corps, 1967.

Newcomb, Richard F. *Iwo Jima.* New York: Holt, Rinehart & Winston, 1965.

New York Times News Service. "Iwo Jima Becomes Link in Japan Defenses." Iwo Jima, 25 December 1979.

"Photographers Joe Rosenthal, Bob Campbell Win Awards for News Photos." *San Francisco Chronicle,* 6 February 1953.

Potter, E. B. *The Great Sea War.* Englewood Cliffs, N.J.: Prentice-Hall, 1960.

Proehl, Carl W., and David Dempsey. *The Fourth Marine Division in World War II.* Washington, D.C.: Infantry Journal Press, 1946.

"Reagan Signs Bill to Put Joe Rosenthal's Name on Marine Memorial." *San Francisco Chronicle,* 14 October 1982.

Rosenthal, Joe, and W. C. Heinz. "The Picture That Will Live Forever." *Collier's* (18 February 1955): 62–66.

Ross, Bill D. *Iwo Jima: Legacy of Valor.* New York: Vanguard, 1985.

St. John, Philip A. *The Battle at Iwo Jima and the Men Who Fought There.* Paducah, Ky.: Turner Publishing, 1990.

Sampson, Paul. "The Bonins and Iwo Jima Go Back to Japan." *National Geographic* (July 1968): 128–44.

"Sculptor's Tragedy: Felix de Weldon Bankrupt, Wife Has Alzheimer's Disease." *Los Angeles Times,* 30 June 1993.

Sherrod, Robert. *On to Westward: War in the Central Pacific.* New York: Duell, Sloan and Pearce, 1945.

Simon and Schuster Encyclopedia of World War II. New York: Simon and Schuster, 1978.

Smith, Holland M., and Percy Finch. *Coral and Brass.* New York: Bantam, 1987.

Stanley, M. E. "Tokyo's Sulfur Island." *Pacific Friend* (Tokyo), 23 (June 1995): 22–27.

"Still Photos from Sergeant William H. Genaust's Flag Motion Picture." *Washington Daily News,* 22 May 1945.

Tatum, Charles. "The Death of 'Manila John' Basilone." *Leatherneck* (November 1988): 54–59.

Tatum, Charles W. *Iwo Jima: Red Blood, Black Sand.* Stockton, Calif.: Charles W. Tatum, 1995.

Truman, Harry S. *Memoirs.* 2 vols. Garden City, N.Y.: Doubleday, 1955.

Vergun, David. "He Was the Marine behind the Camera: Hal Weinberger." *Fortitudine* (Fall 1993): 21–25.

Wheeler, Richard. *Iwo.* New York: Lippincott & Crowell, 1980.

INDEX

Index

ABOUT THE AUTHOR

Born in Butte, Montana, in 1920, Tedd Thomey is a graduate of the University of California at Berkeley. He has worked as a reporter for the *San Francisco Chronicle* and as an editor and columnist for the *Long Beach* (Calif.) *Press-Telegram*. He is the author of eighteen books, including nine novels and nine nonfiction works. He has also coauthored a play, *The Big Love,* based on his book of the same title, which was produced on Broadway in 1991. He resides in Long Beach, California.